shopping around

shopping around

feminine culture and the pursuit of pleasure

hilary radner

ROUTLEDGE

New York · London

Published in 1995 by

Routledge
29 West 35 Street
New York, NY 10001

Published in Great Britain by

Routledge
11 New Fetter Lane
London EC4P 4EE

Printed in the United States on acid-free paper.

Portions of Chapter 1 appeared in somewhat different form in *Genders,* Summer 1990 (University of Texas Press), under the title "Quality Narcissism." A portion of Chapter 4 was included in "Extra-curricular Activities: Women Writers and the Readerly Text," *Women's Writing in Exile,* eds. M. L. Broe and A. Ingram, University of North Carolina Press (1989). Reprinted by permission of the publishers.

Library of Congress Cataloging-in-Publication Data

Radner, Hilary.
 Shopping around : feminine culture and the pursuit of pleasure /
Hilary Radner.
 p. cm.
 Includes bibliographical references and index.
 ISBN 0-415-90539-7. — ISBN 0-415-90540-0 (pbk.)
 1. Feminism—United States. 2. Gender identity. 3. Femininity
(Psychology) 4. Femininity (Philosophy) I. Title.
HQ1410.R33 1994
305.42—dc20 94-27495
 CIP

British Library cataloging in publication data is available.

For
Virginia Honoski Radner

CONTENTS

ACKNOWLEDGMENTS

I would like to thank a number of people whose encouragement and support made this project possible: my colleagues at the University of Notre Dame, the Institute for Scholarship in the Liberal Arts at the University of Notre Dame, my girl friends, Lauren Allard, Judith Barry, Rod Buxton, Beverly Butcher, Christina Creveling, Ann Cvetkovich, Johanna Drucker, Moya Luckett, Valerie Hammond, and Susan White, and my family, Annette Brownlee, Charlotte Kuh, Ephraim Radner, Roy Radner, and Ami Radunskaya. I owe a special debt to Patrick Gallagher, Jasmin Habib, and Ron Hogan whose diligence and enthusiasm made my task lighter. I would also like to thank Eric Zinner and Michael Esposito for their understanding, intelligence, and tact. To Tom Schatz, under whose guidance I began this project, I would like to express my deepest gratitude. And finally, I would like to thank my editor William Germano for his irony, wit, and patience.

PREFACE

I would like to begin with a quotation from Helen Gurley Brown that appeared in her 1964 book *Sex and the Office*.

> Fooling with make-up is supposed to be only for narcissistic beauties. The truth is, a plain girl frequently has a wretchedly unattractive soul but her soul takes on luster when she uses make-up or has her nose fixed or puts on her wig. I know all about what fixing can do for the average girl. When I'm on a television show in my padded bra, capped teeth, straightened nose, Pan-Cake, false eyelashes and wig I may not be natural, but I'm absolutely glorious! (36–37)

Helen Gurley Brown is perhaps best known for publicly popularizing the notion that nice girls "do it." Less obvious is the connection between "doing it" à la heterosexual and the narcissistic investment that produces the moment of *pleasure* that Brown extols above—a pleasure generated outside the scene of heterosexuality. I propose to ask what might in fact be the relationship between feminine consumer culture and *pleasure*—between "the beauty system"[1] and "the beauty fix."[2]

I chose Helen Gurley Brown's work as the moment of departure in my discussion because the discursive formation that she articulates as a media persona constitutes a cultural reworking of feminine identity. Symptomatic of this repositioning of the feminine was the publication of *Sex and the Single Girl* in 1962. The title of this book is misleading: its discourse marks out an arena of reproduction that is primarily narcissistic—in which the woman reproduces, not another, or for another, but herself for herself. It is this self which the "single girl" learns to reproduce on a daily basis under

the tutelage of Brown (who in 1965 became, and still is today, the editor of *Cosmopolitan Magazine*). Importantly, Gurley Brown devotes the bulk of the book to the problem of embodiment in which the task of the single girl is that of constructing herself as feminine through the disciplined use of makeup, clothing, exercise, and cosmetic surgery.

This system, the beauty system, as Dean MacCannell and Juliet Flower MacCannell point out, in spite of its surface heterosexuality, is fundamentally autotelic in its relationship to feminine subjectivity and its pleasures.

> (T)he woman remains obsessively concerned with her physical appearance as the only basis she has for any claim she might wish to make as a woman, even claims she might wish to make for or against herself as a solitary woman, which is rapidly becoming the only 'relationship' she is culturally allowed. (234)

MacCannell and Flower MacCannell continue that the beauty system, far from disappearing in the face of feminist enlightenment, "is moving in the direction of a more logical and rational elaboration of values around its contradictions," specifically the contradiction between two distinct discourses designated as "Love" and "Beauty" (226). The equation Beauty gets you a Man, gets you Happiness has been rewritten as Man gets you Happiness, gets you Beauty (230). In other words, the production of a self that might be termed beautiful cannot be simply understood in terms of a heterosexual imperative.

My opening quotation from *Sex and the Office* illustrates that to construct *herself* as beautiful, to reproduce *herself* as the image of the beautiful and to mistake that image as the *self*, produces a moment of gloriousness in which the role of the man is, to use MacCannell's and Flower MacCannell's term, "marginalized." In the case of Brown in front of her televisual image, his role is so marginal that the single girl might be tempted to do without him completely. Yet, as glorious as she may feel in observing herself thus "imaged,"—she nonetheless faces the threat of unmasking, in which her prosthetic and ultimately monstrous femininity will be revealed. Not until twenty years later will the technologies of exercise, plastic surgery, liposuction, and even tattooing enable the woman to rewrite the body itself, in her attempt to "fix" that instance of "gloriousness" described by Gurley Brown. "Fixing" as a moment of pleasure is ultimately a consumer "fix" and depends upon the manipulation of consumer products as technologies that function to reproduce and circulate

an image that a woman will claim as her self through a rewriting of a body that must be continuously rewritten, kept up, and made over.

The recent controversy over "beauty" and "beauty bashing" in the words of the high fashion magazine *Allure* is evidence of a general concern and malaise that surround this topic. The popular Third Wave Feminist, Naomi Wolf, claims that one of the purposes of the beauty system (or what she calls "the beauty myth") is "to effect a widespread suppression of woman's true sexuality" (132). In simple terms, Wolf claims that because the beauty myth and its manifestations in the media stress physical perfection, this discourse instructs woman that to enjoy heterosexual pleasure she must be beautiful according to the impossible standards of this myth. In making this argument, Wolf fails to take into account that the lure of the beauty system is precisely to move feminine pleasure into another space, certainly other than heterosexuality, in which the masculine gaze is no longer the linchpin in the mechanisms whereby she produces identities.

Wolf's pejorative characterization of the beauty myth can be seen as a simple grammatical inversion of the celebration of gender bending and masquerade that is typified by Madonna and her reception in both the academic and popular press. Yet when we invoke the trope of masquerade to define femininity as do so many, we should perhaps recall that the case on which Joan Rivière based her famous commentary was that of a highly successful academic. This academic suffered from homeovestism in the terms of psychoanalyst Louise Kaplan (268-283). That is to say that after a highly successful academic performance, "Janet," as Kaplan calls her, was compelled to assume an exaggeratedly feminine position vis-à-vis her colleagues. "In contrast to the magisterial style with which she had commanded and captivated her audience, there suddenly appeared at the back of the auditorium a flirtatious girl, a silly chatterbox, a pure and simple coquette" (270). This homeovestism, this masquerade of femininity, had as its objective to prove that she was precisely that which she was not.

It is within the context of these paradoxical propositions in which a woman is most feminine when she is not herself—when she is a reconstructed television image or when she enacts an elaborate masquerade—that I wish to pose the issues that I address in this volume: the contradictions inflicted by feminine identities in which femininity is defined through a specular relationship to an image in which it is precisely the woman herself who must take command of this image—of these images—even as she subjects her body to the rigorous disciplines of reconstruction. *Dux femina facti!* Through an investigation of the figure of the

Shrew as the woman who speaks, who takes charge of language, I attempt to elucidate the configurations of contemporary feminine culture as they revolve around the problems of speaking and appearing, in particular within the tradition of the romance, but also as this issue informs the new disciplines of the body geared towards the production of a feminine self that is endlessly reconstructable. I emphasize the contradictory trajectories whereby women seek pleasure and construct identities as a fragmented intertextual process that works upon, against, and through the body. Feminine culture represents, in the words of Cathy Griggers, "the fractal structure of the fragmented desires and multiple social identities" of women as a heterogeneous group—heterogeneous not only among themselves but within themselves (95). This is not a book about shopping. Rather it is about the notion of identities defined not as a moment but as trajectories of perpetual movement within the confines of a specific social and cultural architecture—itineraries of dissatisfaction but also of pleasure in the movement itself, of returning and departing, only to return again— in the activity of "shopping around."

1

SPEAKING OUT
SHREWISH BEHAVIOR

The "New Woman" Meets Shakespeare: on TV

My thighs are thinner, not thin. Thinner. The results were nowhere near as dramatic as I expected. In other words, perfection was not an option. But trying on bathing suits—or anything else, for that matter—is less traumatic than it used to be.

So was it worth the pain? Yes, but not for the reason you'd think. I felt all my life that my thighs were punishing me. Now I've punished them. Perhaps this is the real satisfaction of having liposuction: doing something truly vicious to a body part you hate.

—*Mademoiselle*, June 1994

In the above quotation from *Mademoiselle*, a young woman ponders on the return on her investment in a self deconstructed as a series of body parts (Irving, 164). The article, a series of confessions by women who have undertaken some form of cosmetic surgery, reflects on the "worth" of this investment in a self that is fundamentally narcissistic. Feminist scholar Susan Douglas remarks in more general terms that "women of the 1980s were urged to take care of themselves, and to do so *for* themselves" (245). She explains: "narcissism was more in for women than ever, and the ability to indulge oneself, pamper oneself, and focus at length on oneself without having to listen to the needy voices of others was the mark of upscale female achievement" (246). She continues: "Though I write about what emerged in the 1980s in the past tense, I feel awkward about doing so,

because the ad strategies established then are still in high gear, and we watch their effects with sorrow, anger, and empathy" (247). The 1994 article quoted above testifies to the vitality of this paradigm of feminine value, in which the woman's worth is still determined by the body—but it also underlines the contradictory trajectories that mark out this value. If *Glamour* tells its readers that "much of the hiring process is a beauty contest," according to Brad W. Harper, of Nelson Harper and Associates, "an outplacement firm in Phoenix" (Kennedy, 152), the *Mademoiselle* article quoted above seems to suggest that the determination of value is a far more complicated process than simply getting a job—rather, value itself is produced narcissistically. The beauty contest becomes displaced upon the body itself as a disassembled series of parts in which each part must be conquered and tamed, a contest in which there are no clear winners because "perfection" is "not an option."

It is this disjunction between worth, self, representation, and economic condition that characterizes the position of the "New Woman"—the "Self" to which Condé Nast has dedicated its most recent additions to its list of women's magazines, which includes the time honored *Vogue* and *Mademoiselle*. Indeed, the above quotations from two Condé Nast publications, *Mademoiselle* and *Glamour,* suggest that the issues of feminine representation and the representation of the feminine remain the crucial hinge of feminine identity, even in a postmodern culture.[1] Though the "child-wife" has been replaced by the "power wife," and the new glamour queen is the working woman, it would seem that the appearance of success is as important if not more important than accomplishment. The professional woman has been re-feminized in that the ability to "appear professional" (appearance as the sign of her femininity) takes precedence over the ability to act. Competence (for a woman) still depends on her "looks," thus preserving a dichotomy that dictates that, in the now familiar words of John Berger, "men act and women appear."

In the United States, the media (television in particular) appear to offer a space of privilege (or at least its representation) that seems to reply to the women's movement precisely by containing its demands, offering the appearance of privilege to some women as a means of denying it to most women. That space becomes both a moment of access and a moment of closure. This representation of apparent privilege as part of dominant discursive structures (i.e. within the discursive structures that reproduce dominant as opposed to oppositional cultures) evolves around two issues: the inscription of this position of privilege within an institutional struc-

ture that remains largely patriarchal and the representation of this position as the capacity to act as a consumer.

The inscription of privilege in terms of a privileged appearance creates a "feminized" position that does not threaten existing institutions: a patriarchal discourse in which the feminine is inscribed as the object of the masculine gaze; an economic discourse in which the feminine is inscribed as the prototypical consumer.[2] Thus even the obvious narcissism of the New Woman as a position from which a woman might speak for herself (in which she is encouraged to invest in her self rather than an other) always has the potential for reinscription within a patriarchal structure in which the masculine gaze functions as the linchpin, and in which a woman's function as feminine is to appear rather than to speak. In the words of Douglas: "If you wore Hanes . . . you would feel the contradictions between feminism and prefeminism thread together smoothly as you pulled them up over your legs and hips and then strode confidently out into the world" (249). The cultural configuration that produced the new woman was structured by a contorted system of value, which dictated that "without male approval" women "would not have the acclaim on which narcissistic self-esteem rests" (249). Ultimately then Douglas asserts that "the appearance of female self-love and achievement was used to reinforce female dependence on male approval" (249).

The mechanism that defines a woman's function in terms of appearance (in which the ability to speak is categorized as unfeminine) operates most effectively through textual practice as a cross-media phenomenon, in which the articulation of femininity is overdetermined. The coincidence of Cybill Shepherd as fashion model and television star, and the resulting circulation of her image, illustrate the contradictions of this intertextual process of inscription. Juxtaposing her role in an episode of *Moonlighting* entitled "Atomic Shakespeare," first aired during the 1986–87 season, and Shepherd's appearance as covergirl during that same season in *Harper's Bazaar* throws into sharp relief the conjunction of class, culture, and consumerism in creating and containing this position of privilege. It is precisely this textual nexus (the complexity of this intertextual juxtaposition) that enables the system to work as a process of containment, in which feminine pleasure as a narcissistic moment (and its potential for thinking differently about feminine pleasure) is reinscribed within the patriarchal symbolic. This process of reinscription is highlighted through the evocation of Shakespeare and his privileged relationship with the canon of culture to which the edu-

cated class subscribes, the knowledge of which designates the educated class as such.

Foregrounding both canonicity and narcissism as two distinctive seemingly unrelated constellations of issues may seem arbitrary, but as an analytic strategy it should suggest that to attach a single meaning to a given text or to explain its operation in terms of a single governing function would be a mistake. Both textuality and practice are always overdetermined, produced by a combination of frequently contradictory demands or economies, both within and without any given text, in which any given practice does not operate in a vacuum but rather in tandem with any number of contingent practices. Only by unravelling the production of meaning and practice as they are generated intertextually, beginning with a television series in which the woman is portrayed as a professional, through the fashion magazine (in which literally the self-worth of the woman as model is measured by, resides in, her body) to a theory of feminine narcissism, is it possible to understand the complexity of this process of reinscription. A feminist reading of this process of inscription opens up a number of issues that move the discussion outside the arena of television and women's magazines.

Self-proclaimed feminist Susan Douglas ironically observes that the narcissistic strategies encouraged by the media, while seemingly empowering women to take control of themselves and their lives, are designed to "humiliate" them. She underlines the duplicity of a media configuration that suggests to a woman that: "If she has conquered her own adipose tissue, she could conquer anything. She was a new woman, liberated and in control" (261). Thus Douglas is led to conclude that the narcissism that the media triumphantly offers up to the "new woman" as her right and privilege is in fact a demand that women "be pathological, compulsive, filled with self-hate and schizophrenic" (263). Douglas explains: "The 'new woman' of the 1980s, then, perpetuated and legitimated the most crass, selfish aspects of consumer capitalism and thus served to distort and deny the most basic and revolutionary principles of feminism" (266). If indeed "in the post-feminist age, a woman's self-worth still resides in her body," as *Vogue* claims (Freedman, "Looking Good," 357), how then must the woman as speaking subject place herself within an economy that stresses appearance—what are the returns on her investment in this new "self," an investment that leaves her at risk—vulnerable to "self-hate," "pathological" compulsions, and even "schizophrenia"? In a post-feminist age how does a feminist define her self-worth; who are the heroines who

might speak for her, and for whom she might speak? What can she say about the romance, the story that traditionally defines a woman's value (her worth to herself) through a language that is posited in excess, beyond speech; how does this story tell itself, speak, in a post-feminist age?

We may begin by asking how the movement from Shakespeare to television show to women's magazine is effected? How does this trajectory delineate an arena in which feminine identity is both empowered, accorded a position of relative autonomy, of relative domination, and circumscribed within a social structure that in the final analysis maintains masculinity as the top in a relationship in which the feminine continues to define the bottom? The privileged woman moves among a number of discourses, shopping in the sense that she chooses among an array of possibilities and in that she always pays for what she gets. In the movement from canonicity to television, from voice to silence, from auto-eroticism to the romantic couple, the woman must define her worth by seemingly performing the impossible task of preserving her privilege to act as a professional, without relinquishing her identity as feminine, her "to-be-looked-at-ness," in Laura Mulvey's terms. Her membership within a class that defines itself as educated, distinct from the masses, becomes a first move in setting the empowered professionalized woman apart from the other mass of femininity. *Moonlighting* as a "quality" television show exemplifies this strategy—the strategy that sets quality television apart from the mass of television programming such as soaps and daytime talk shows, which, certainly not coincidentally, are identified as part of feminine or feminized culture.[3]

As a quality prime-time television series, *Moonlighting* must always announce itself as special, as different from run-of-the-mill network programming.[4] To redo Shakespeare as does the episode "Atomic Shakespeare," which offers a seemingly feminist version of Shakespeare's *The Taming of the Shrew,* becomes an initial sign of its difference.[5] The reference to a historically legitimate body of literature displaces the status of the episode from mass culture to high culture.[6] References to the classics on television shows, through PBS revivals and in network prime-time shows, are fairly common, as they are in all forms of popular entertainment. The *Moonlighting* episode distinguishes itself by using the Shakespearean play as the basis for the entire episode, clothing its regulars in Shakespearean garb and forcing them to speak in television's version of iambic pentameter. This strategy of reflexivity and parody characterizes the show as a whole, which from its inception satirized and reinvigorated the classic

detective genre and the romantic comedy. In its obvious invocation of its own significant intertextuality, *Moonlighting* typifies the category referred to as quality television.

Intertextuality is the narrative strategy that positions the romance of Maddie and David (the stars of *Moonlighting* played by Cybill Shepherd and Bruce Willis), which forms the spine of the program's cumulative narrative, as part of a quality conversation. This foregrounding of intertextuality produces a discourse that brings other texts, more legitimate texts—in this case Shakespeare—into play. This double process of recuperating both the mass culture text for the high culture viewer and the high culture text for a mass culture medium has a contradictory effect: "Atomic Shakespeare" invokes Shakespeare as the icon of high art while generating a critique of the hegemony represented by the Great Works model of cultural production in which legitimate culture is a sum total of "the best" as determined by academic institutions. As a text within the canon, *The Taming of the Shrew* constitutes a general category, a lexical entry available to the culture at large that is constantly re-narrativized, whether through the avant-garde, a television ad, or the format romance. It is reiterated endlessly because of its general familiarity, ambiguity, and legitimacy, which are both the products of the text's canonization, and that process through which it becomes canonized. The familiarity of the text is necessary if reiteration as reinterpretation is to have currency, if it is to be accessible to the culture at large. Ambiguity, either deliberate, as in the modernist text, or unintentional, because of a vocabulary and syntax that have become historically inaccessible, as in the classical text, encourages reinterpretation as analysis. Finally, a canonized work must be thought worthy of reinterpretation; the dominant class must recognize it as culturally valuable.

The endless discussions of Joan Collins' love life by such publications as *Star* and *The National Enquirer,* though the result of deliberate ambiguity (as a publicity strategy), do not make her "story" part of the canon because the conversation takes place within a popular (as opposed to educated) arena. Though knowledge of Joan Collins as a significant icon within the popular canon may generate conversation, this is a conversation that places its participants within a class deemed undesirable by the dominant intellectual class.[7] On the other hand, within this other class, the subject knowledgeable in what the intellectual deems trivia may gain status, prestige, and credibility. Thus, cultural knowledge as cultural capital, to use Pierre Bourdieu's terms, does not function in terms of a unitary hierarchy, but in terms of a complex grid of interlocking discursivities that

the subject negotiates strategically.[8] Further, the subject is never locked into a specific hierarchy but moves strategically between discourses and their defining hierarchies. In practical terms, the knowledge of the "canon" of feminine culture that confers credibility on the top salesperson of Bloomingdales or I. Magnin (that knowledge of "fashion" and its ancillary literatures that she or he translates into cash in the form of commissions, and a salary usually dependent on a minimum sale) is not the same knowledge that the college professor uses to ply her or his trade—or the same seemingly useless knowledge that the "educated" class exchanges in its rituals of recognition that signify the embrace of one of its "own." On the other hand, the saleswoman may move from a conversation about the Fortuny pleat's return to a discussion of Marcel Proust's literary style, from predictions of next season's skirt lengths to an evaluation of current mortgage rates, just as easily as she may exchange a black mini for a tweed jacket, a pair of Ray Bans for a set of horn rims—when the occasion warrants it and she wants to suggest that she is not just a saleswoman.[9]

Knowledge of the classics or of the specific canon of high culture (whether reiterated through the avant-garde, television commercials, or paperback romances) assumed by the episode constitutes a mark of class allegiance (denoted through education) for the viewer. *Moonlighting* and its viewer, in this case, are assured of the program's quality status. Their mutual insider knowledge of the classics designates both viewer and program as proper to a specific class. This enunciation of class initially obscures and troubles the specificity of gender in constructing a subject position for the episode's viewer. Mutability of the text predicated on its canonization permits it to function as part of an exchange system—a conversation—grounded in cultural literacy, overdetermined by economics and consumer relations. This exchange system is both regulated by and serves to regulate class positioning as an enunciative moment that is manifested as the ability to "speak" with authority. The ability to manipulate the codes of cultural literacy within the appropriate arena permits the intellectual class as a disparate heterogeneous group to maintain its status vis-à-vis the mass audience, a status that may appear to override gender.[10]

E. D. Hirsch, literary theorist and educator, comments in his book *Cultural Literacy* on the importance of these lexical entries, the sum of which, according to Hirsch, constitutes cultural literacy:

> Successful communication depends upon shared associations. To partic-
> ipate in the literate national culture is to have acquired a sense of the

> information that is shared in that culture. No adult-level discourse retreats to the rudiments of knowledge. If assumptions about rudiments could not be made, ordinary discourse would be so lengthy and intricate as to obscure its own point. (59)

In his desire for a utopian community that would not disrupt existing hierarchies of social control, Hirsch fails to recognize that the function of these "rudiments of knowledge" is to define class status and social privilege by maintaining cultural boundaries that are overdetermined by class and yet seemingly constituted through criteria that are independent of class (the privileges of education rather than birth and capital).[11] To talk about, or to interpret, a classic text is a sign of an education specific to a given class and, thus, the viewer who fails to recognize "Atomic Shakespeare" as significantly different from the original becomes déclassé, unable to participate in quality conversation. Accordingly, the educated viewer, who is "in" on the conversation, is reassured that she is culturally superior to the masses and that, though she may be watching television, she is not wasting time on trash. From Hirsch's perspective, her ability to participate in quality conversation is dependent on her knowledge of the canon, and permits her to signal her membership in "literate national culture."

A *Moonlighting* episode that "improves" our literate national culture by decrying the misogyny of the Shakespearean text, rejecting a phallocentric past in favor of an egalitarian if class-bound present, maintains simultaneously a duplicitous, in the sense of doubled, relationship to this national culture. The classic text is repositioned as both desirable and outmoded. This double movement is manifested by the specific relationship of the episode to its Shakespearean model, preserving the basic outline of the Shakespearean play while incorporating a significant departure. The happy marriage evolves through compromise on the part of both man and wife; Willis/Petruchio denies Kate's famous speech of submission with a declaration of his own. In Shakespeare's play, Kate concludes with a statement of wifely fealty:

> Such a duty as the subject oweth the prince;
> Even such a woman oweth to her husband;
> And when she is froward, peevish, sullen, sour,
> And not obedient to his honest will
> What is she but a foul contending rebel
> And graceless traitor to her loving lord?
> (*The Taming of the Shrew*, Act 5, scene 2, lines 177–182)

In "Atomic Shakespeare," a declaration by Petruchio replaces Kate's speech. Petruchio declaims:

> I was wrong and hath learned it from a woman
> One with much to teach.
>
> .
>
> For those with bodies soft and tender
> Have soft and tender hearts as well
> And all their gifts be so much more
> When allowed to be given freely.
> If this be offensive to men then so be it,
> For perhaps the time has come for offense.
> A mistake was made by all.
> For Kate never needed to be tamed,
> She merely needed to be loved.

The explicit criticism of the Shakespearean ending is an implicit criticism of current attitudes towards high culture—thus the episode would seem, at least superficially, to challenge the cultural hegemony favored by Hirsch, while at the same time appealing to precisely that group of viewers who are culturally literate according to Hirsch's standards. The frame, the sequences that open and close the *Moonlighting* episode, is crucial to establishing the stakes of the episode in terms of the cultural debate.

In the frame, the mother describes the show as trash to her child, and tells him to read Shakespeare instead. She, however, will spend her time watching *Moonlighting*, though she again verbally rejects the show at the end of the episode. She (like the culture to which she belongs) is quick to condemn television, but just as quick to consume the fare it offers. This doubled movement announces the duplicity and excess of the first movement, the excess of the mother who both denies and embraces popular culture, who sends her child away so that she may become one with him— because they will "read" the same story at the same time. Thus, we can only assume that she turns on the television once the boy has left the room, since we see her turn off the set again at the end of the episode. Throughout the episode, it is never clear whether we as the viewers are positioned with the mother (hence watching television) or reading with the male child, who interprets the play through a vocabulary with which he is already familiar, the vocabulary of television. To further complicate the issue, the description the mother gives of *Moonlighting* could apply equally well to *The Taming of the Shrew*. Both are, as the mother tells her

child, about a couple who argue all the time, but who, in fact, simply want to sleep with each other—but one, *Moonlighting,* is trash, the other "homework" and education. Which one have we watched? Which version has the child read?

Through this conflation of the popular and the educational, "Atomic Shakespeare" indicates the generic kinship between *Moonlighting* and *The Taming of the Shrew.* However, by foregrounding the issue of language, this kinship also suggests that perhaps *Moonlighting* is an improvement on the original because it offers a model of equality between men and women. In Shakespeare's play, Kate submits to Petruchio, formally assuming her position as his wife by relinquishing control of language: "But the sun is not when you say it is not/And the moon changes even as your mind" (Act 4, scene 5, lines 24–25). In the *Moonlighting* version the battle over language is repeated, but this time the woman's demands to have access to language as a speaking subject are seemingly granted. In the final act of "Atomic Shakespeare," Willis/Petruchio says to Shepherd/Kate: "I say 'tis the moon that shines so bright." She calmly replies: "I believeth that thou art mistaken." It is then Petruchio who re-considers and admits his obvious error.

The scene seems to vindicate the shrew who is defined as such through her unnatural control of language, but also through her inability to remain silent to the extent that she is controlled by language (language speaks her—just as she speaks it). The scene justifies the shrew and her right to shrewishness by pointing to the rigidity and absurdity of the Shakespeare oeuvre as a whole, an interpretation encouraged by an ongoing series of parodic references to the Shakespearean discourse. This parodic thematic addresses not only the substance but the structure of the Shakespearean play,[12] questioning the superior nature of the cultural fare it offers. More crucial is the episode's criticism of the inherent sexism of the period again through parody: "If you're a man you gotta love the sixteenth century," claims Petruchio in the first act. Later he reiterates: "Be this not the time that men are men and women are property!"

This explicit criticism of the sexism inherent in the literary canon creates a position for the educated woman, who is encouraged to situate herself with the television text against the canon. Thus, the text invites a consolidation of masculine/feminine positions, defined through its antagonism towards the canon; however, this complicity with her class, this turning away from gender as the mark of identity, is not without its own price. To privilege even this apparent parity of positions within the

narrative is to fail to see the complexity of the relations of power inscribed through language within the episode. Thus, for example, the masculine position as articulated through the text is further distinguished from the feminine through the intervention of Cybill Shepherd as star—as a possible object of identificatory (feminine) and voyeuristic (masculine) pleasure. However, Petruchio's initial assumption of power (within the television episode—Petruchio/David is naturally empowered as one of the show's premises) is never problematized, permitting Petruchio to seemingly dismantle the masculine/feminine hierarchy while reconstituting a couple that is still virtually if not actually within the law—in which the word "taming" is replaced by the word "love." Shepherd/Kate as shrew is still the inadequate woman who "needs" a man. She is defined, identified, through her body, which is "soft and tender," a body that invites his gaze by promising "gifts" (which are no doubt constituted through the feminine body itself), while announcing her vulnerability. The position of mastery thus offered the feminine viewer is only a manifest position of power, already undermined by the ubiquity of a masculine law as the final patriarchal word.

Petruchio/Willis then occupies the problematic position of the male feminist, in which he dictates feminism to the culture at large. He speaks for *her,* as part of his seduction of the feminine in anticipation of the "gifts" (in the form of her beauty) that he might receive. Petruchio's seduction and capitulation necessitates that his chosen object *be* beautiful in order that she may always appear beautiful *as if* for his pleasure, held in the male gaze. This is not to say that Shepherd's position on *Moonlighting* does not represent a site of resistance in terms of a tradition of comedy heroines on television. A report by the United States Commission on Civil Rights published in 1977 comments that:

> The women in situation comedies still tend to be subordinate to the men in their lives. Mary calls her boss "Mr. Grant" even though everyone else calls him "Lou." Edith scoots into the kitchen to fetch Archie a beer and rarely fails to have dinner on the table by 6 p.m. Louise Jefferson's desire to seek employment has been both criticized and impeded by her husband, George. (23)

Before the late 1960s and 1970s, "the portrayal of women was limited primarily to supportive roles such as the homemaker-mother of the situation comedies" (23). In this sense, Maddie's position as the "boss" in the series as a whole, and Petruchio's capitulation in the "Atomic Shakespeare"

episode, represent comparative positions of empowerment. Nonetheless, the radical departure from the Shakespearean model represented by Petruchio's concluding speech (cited above) will always be undermined by the position of power accorded Petruchio.

In a similar vein, the feminist novelist and critic Marilyn French remarks, in her position as intellectual: "the comedy of the play depends on assent to the legitimacy of Petruchio's claim to 'own his wife'" (*Shakespeare's Division of Experience*, 77).[13] This comment holds true in the *Moonlighting* version to the extent that it is the initial assumption of power that permits Petruchio to reverse the hierarchy of power. In "Atomic Shakespeare" as well as *The Taming of the Shrew* Petruchio's position is critical: "Audience sympathy for him and his position is essential if the play is to be seen as comic and agreeable" (French, 77). And thus, the *Moonlighting* episode and the Shakespearean play conclude "with a harmonious synthesis of unabused masculine and inlaw feminine principles" while celebrating "the outlaw aspect" through comedic deconstruction (French, 80).[14] This contradiction is symptomatic of the complexity of the representation of power in the series as a whole, in which Shepherd's position as a beautiful woman, a visibly "soft and tender body," produces another series of discursive paradoxes.

Indeed, the representation of power as language in the series as a whole is rewritten through Cybill Shepherd's image as the beautiful woman as body. Shepherd's position as a beautiful woman, the privileged object of the gaze as the visible sign of her femininity, creates a discursive paradox characteristic of the "contradictory nature of female spectatorship," in Tania Modleski's terms (*The Women Who Knew Too Much*, 6). Here, the woman is addressed as a viewer both through a double identification with the subject of enunciation of the parodic discourse as non-gendered (in which class temporarily seems to take precedence over gender) and with the object of the camera gaze, Cybill Shepherd, as gendered, as specifically feminine. In light of the above, we might do well to examine the obvious assumption that *Moonlighting* somehow offers a feminist critique of Shakespeare's play. In fact, one might just as easily argue that Shakespeare's "original" text offers a decentered inscription of gender to the reader who "masters" the text by "reading against the grain." This decentering, which can only be produced through reading, might well be more "feminist" than the "natural" categories of the masculine/feminine binarism (an essentialist construction of gender that cannot be questioned) that is assumed by *Moonlighting*.

Yet to profit from this decentering as feminists rather than as intellectuals, that is to make use of it as feminists, we may have to forego the profits to which our intellectual capital as readers of Shakespeare entitles us, and refuse to use our readings to increase our status, our capital, as intellectuals. To do so, however, to read as feminists and not as intellectuals, we might have to abandon French's position by judging it impossible to have any sympathy for Petruchio, losing our privileges as nationally literate lovers of great works because we too in turn will lose the sympathy of those other "lovers" of culture for whom Petruchio "stands in." We might have to become shrews ourselves in our defense of Kate's right to speak her mind. To read *The Taming of the Shrew* as a feminist without compromising one's position as a feminist, to construct a feminist reading, might tell us that we have neglected the shrew. In our attempts to understand the marriage plot[15]—the romance as the founding narrative of femininity—we have overlooked the shrew in favor of Cinderella, who seemed so much worthier of our sympathies. And yet as feminists, we should immediately identify with a figure who rather than silently waiting for her prince to come fought fiercely for the right to speak.

Certainly, the notion of a feminine that might speak has long been a preoccupation of feminist theory, most formally in its attempts to define a woman's language, a language that could be defined as specifically feminine.[16] Yet if the romance constructs a language that is silent, that waits (Cinderella, Sleeping Beauty, Snow White), what does it mean to speak or write as a feminist who is certainly shrewish in the sense that she wishes to be heard? Perhaps the Ur-narrative of romance is not the Cinderella story at all, but a taming of the shrew, the shadow text that in our reclaiming of the romance we would rather forget.[17] We prefer to pass over this narrative, this story of femininity, because though we may argue for the relative activity, the recognition of feminine desire, that characterizes the Cinderella story from *Pamela* to *Pretty Woman*, the shrew story offers, at least at first glance, no such hooks upon which to hang our feminist fantasies. Yet the shrew as a figure of ridicule, a trope of the unfeminine, persists, not because the shrew narrative is a classic, a great work of the past, but because the narrative occupies a specific position within contemporary textuality as a productive cultural matrix (*les dessous des cartes*) that counters the romantic fantasy of a union that transcends language. Or perhaps more accurately, like the steel girders that support the baroque stucco castles of Disneyland, the shrew and her story is the occulted structure that upholds the romantic paradigm and its fantasy of a language that is not spoken.

The Romance and the Shrew

> I have now been married ten years. I know what it is to live entirely for
> and with what I love best on earth. I hold myself supremely blest—blest
> beyond what language can express.
>
> —Charlotte Brontë in *Jane Eyre*

The words above were written by Charlotte Brontë in the mid-eighteen
hundreds: they represent the goal of every romance heroine whether she
appears in a novel of Mrs. Gaskell, George Eliot, Victoria Holt, or even in
the pages of a contemporary format romance. The message of the romance
throughout its history is painfully clear: love of a man, and only the love of
a man, makes life worth living. It is the magic substance that, from the
shards of a self shattered by experience, will magically reconstitute the
whole in an Other. Lillian Robinson comments:

> It would appear that female readers do not seek out trashy novels in
> order to escape or to experience life vicariously, but rather to receive
> confirmation and, eventually affirmation, that love really is what moti-
> vates and justifies a woman's life. (222)

In the face of no-fault divorce and delinquent child support payments, it
would seem difficult and dangerous to confirm and affirm that only in the
heterosexual couple will a woman find justification for her existence.
Nonetheless, the romances of the late twentieth century, the Harlequin
romance, the Barbara Cartland novel, as well as the great works of the
nineteenth century, posit that a man's love supplies the transcendent signi-
fier that legitimates feminine experience as pleasure—that signifies her
value, her worth. Thus the crucial issue addressed and negotiated by the
romance is the relationship between value (in particular self-worth) and
femininity. That value must be understood differently (as outside the
bounds of language) within the romance is implicit in its narrative para-
digm, as is its privileged relationship to feminine identity. The question
becomes: how does the woman speak of a value that is beyond language, a
transcendent signifier beyond signification, a sign the meaning of which
cannot be expressed. Is this silence an(other) language? or has she simply
been gagged—or to quote Shakespeare "tamed"?

A careful reading of Shakespeare's *The Taming of the Shrew* might lead
us to believe that the classic model of the romantic paradigm that grounds
its representation of feminine pleasure through the figure of a silent

feminine is in fact the story of the silenced shrew. Through the figure of Kate, the play articulates and rejects a feminine position that is defined by the desire to construct a self that might speak her mind. The figure of Kate-as-Shrew underlines the dilemma of the feminist critic who wishes to avoid the stigmatized position of the shrew and yet be free to speak her mind. On the one hand, among Shakespeare's "bad" plays, this one is almost uniformly singled out as the most impolitic of his largely politically incorrect oeuvre. On the other hand, the late Joel Fineman, the poststructuralist Lacanian Shakespearean scholar, in a brilliant and insightful reading claims that the play clearly defines a notion of feminine language to which Petruchio must also surrender (138) and in so doing it reveals the construction of gender as such. Fineman argues that from Kate Petruchio learns an Other way of speaking: "Petruchio reestablishes the difference between the sexes by speaking the lunatic language of women" (138). The play appears to offer both possibilities—that of a "bad" work that should be censured, and that of a great work that should be discussed—precisely because of the privileged place Shakespeare's oeuvre occupies in the Eurocentric culture of the United States as its national literate culture. Shakespeare's work, unlike the "trashy" novels discussed by Robinson, is education, culture, and high art—"the best which has been thought and said in the world." Or to quote E. D. Hirsch's *Dictionary of Cultural Literacy,* he is "generally considered the greatest of writers in English" (132).

We might say that *The Taming of the Shrew,* as it is read in English departments as part of the literary canon of a late twentieth century high school and university education, represents the artifact of high culture—of literate national culture in Hirsch's terms. Lawrence Levine comments that in the mid-twentieth century, Shakespeare was:

> the possession of the educated portions of society who disseminated his plays for the enlightenment of the average folk who were to swallow him not for their entertainment but for their education, as a respite from— not as a normal part of—their usual cultural diet. (170)

Lawrence Levine and E. D. Hirsch make it easy to forget that literature has other pedagogical functions than to provide expensive conversational accessories—possessions—for the well-turned out daughter or son of the upper-middle class, the trappings of culture and insider membership (and certainly Hirsch's dictionary entry on Shakespeare does little to allay our

fears on this account). If this were indeed the case, the multiple choice test rather than the essay would be the most appropriate measure of literary knowledge, as many students insist. Because the text within the canon is an object of analysis, our reading of this text includes something that, by definition, is excluded from our reading of the text outside the canon. This text encourages a certain practice of rereading and analysis in the very definition of its category as part of the canon. The product of this process of rereading is not necessarily the creation of a list of approved lexical entries—but also of the essay, in which critique as a process of self-examination generates another text, this process of regeneration becoming the defining attribute of textuality. The apparent transparency of the mass culture text initially denies that there is a need (though this is perhaps where it is needed most) for this particular type of intervention, for analysis—hence the refrain, so familiar to those of us who study popular culture, What's the big deal, it's just entertainment. Here we might distinguish between *analysis* that intervenes, that transforms, that produces textuality, and *reiteration* that merely repeats, or refurbishes, that produces a series of discrete lexical entries.

Analysis offers the possibility of a position from which the woman reader might speak as a feminist, if not as the Feminine, because she speaks from outside the text. However as an academic reading, analysis also offers the woman-as-reader the possibility of identifying with her class (an educated elite) rather than her gender. If *The Taming of the Shrew* constitutes "in the western literary tradition . . . the master plot of the relation between language and desire" (Fineman, 139), its analysis perhaps demands a mistress who is even more shrewish than its heroine, who is willing to condemn the master of the English language for writing "bad" Shakespeare—who is willing to say that, on the contrary, the play clearly demonstrates that there is only one way of speaking and then . . . there is silence. Kate does not speak "the lunatic language of women," she simply speaks until silence is imposed upon her, until she is gagged, which is literally the case in *Moonlighting*'s rendition of the play. But if Shakespeare is a bad writer, or at least is capable of bad writing, do we have a "bad" literate national culture? For those who are "literate" the temptation to preserve the status that this literacy is designed to confer by conserving the works that constitute its canon is tempting because cultural privilege always has the possibility of being translated into material benefit, and is therefore not willingly relinquished by those who enjoy these benefits. As "outsider" feminists we may, like bell hooks, be "frustrated by the binary opposi-

tion . . . between the intellectual and the underclass," but we must also be aware that academic discourse too frequently (again in bell hooks' words) can produce "a mirroring of the very kind of hierarchies that terrorize and violate" (qtd. in Fiske, "Cultural Studies and the Culture of Everyday Life," 171). In *Moonlighting*, this hierarchy is represented by Petruchio/Kate, the hegemony of those who are authorized to speak over those who are not. For, what is it to be an academic, except to have been authorized to speak by the academy? Is there a way in which academic feminist criticism can position itself outside this hierarchy and yet "speak"?

We should be wary because the very methods of analysis that if used shrewishly might position the feminist on the outside, can also be used to maintain the status, the privilege, of the feminist who remains on the "inside." She remains inside the academy, her class, and dominant culture. She critiques but through this critique "inoculates" (to borrow from Roland Barthes) herself against the necessity of finding herself on the outside—outside her class, outside the academy, outside dominant culture, "infected" by the disease of a feminized mass culture that E. D. Hirsch and others have diagnosed as the cause of the disintegration and erosion of literate national culture. Through the double movement by which the intellectual both rejects the "bad" text, inoculating herself or himself, and thereby saves the "good" text, retaining Shakespeare and his oeuvre as "the best," the intellectual feminist preserves both her moral and cultural authority by challenging national literate culture while preserving intact the hierarchies of class and education that it represents. Her challenges are tolerated, and may even afford her a certain authority to the extent that she speaks the language of the national literate culture; at the same time she also runs the risk of losing the status that she may have enjoyed as feminine. (She will no longer be taken seriously as a saleswoman, she will never again be a "hot date.") She may lose her position as feminine and the negative authority she may have enjoyed as such. She is "de-feminized," and becomes the unwomanly woman, another less virulent version of the shrew. And thus, through this double movement of denial and acceptance in which the feminist as the unwomanly woman plays a conservative role, everyone "saves face," the canon and the hierarchies it represents are both negotiated and preserved.

The introduction to a popular paperback edition of *The Taming of the Shrew* (frequently used in high school English classes) is symptomatic of the double movement of denial and acceptance by which a reading of a "bad" text inoculates against the infection of cultural subversion. In

Barthes' words: "one immunizes the contents of the collective imagination by means of a small inoculation of acknowledged evil; one thus protects it against the risk of generalized subversion" (156). Though a more sophisticated reading would follow a more convoluted itinerary, the result would be similar to that achieved in this introduction in that the goal will again be to save the text, to reinscribe its legitimacy as a great work. (Thus no "reading" has as its goal to dismiss its text as insignificant, unworthy of our attention as scholars.) Let me recapitulate this process through a description of the introduction to the Folger General Library edition, written by Virginia A. Lamar and Louis B. Wright, entitled "The War of the Sexes." (It seems unlikely that this "coupling" of male and female authors is mere coincidence.) The introduction begins with a quotation from John Masefield, Victorian critic, whose position Lamar and Wright reject because he:

> called the language that Shakespeare puts into the mouth of the broken Katherina "melancholy claptrap" and sadly described Petruchio as "a boor who cares only for his own will, her flesh, and her money." (vii)

This description coincides with my own reaction to the play when I first saw it as a young girl. And happily for the little girl who hated Shakespeare, recent feminist criticism confirms that Masefield has a point:

> Even if teachers of literature offer an ingenious reading of the play, their students will probably not be seduced into a very happy view of it. They will know in their hearts that—at the least—there is something wrong with the way Kate is treated. And they will be right. (Garner, 105)

We might well ask with Shirley Nelson Garner, quoted above: where are we positioned, "inside or outside the joke"? In rejecting Masefield, Lamar and Wright claim to offer a modern enlightened reading. They thus safely place themselves and their acolytes as insiders, here inside the joke. This "modern" reading provides interpretive guidelines for the uninitiated, following a set itinerary. Readers are invited to reject the position represented by Masefield through an argument that identifies the reader as too sophisticated to interpret the play literally. Lamar and Wright claim that "audiences and readers—except those serious souls who must see a profound lesson in all literature—have enjoyed *The Taming of the Shrew* for what it is, an entertaining farce on a topic of eternal internal interest" (xi). We (readers) are requested to understand and sympathize with "sentimen-

tal critics of the Victorian period and socially minded critics of the twenti-
eth century" who "have been inclined to apologize for Shakespeare's
attitude toward women as received in *The Taming of the Shrew*" (vii). We
are, however, also encouraged to see ourselves as more sophisticated than
these critics because we can accept the play for what it is while recognizing
the play's misogynist bias ("a small inoculation of acknowledged evil" in
Roland Barthes' terms). But because we are more sophisticated, we should
not let trivial qualms inhibit our enjoyment, suggest Lamar and Wright,
and thus, this recognition need not deprive us of our pleasure in the play
as a whole.

The banner of sophistication, with which Lamar and Wright flag down
the reader pursuing the incorrect interpretive path, is misleading; in
another interpretive move, a "rope trick" in Shakespeare's rhetoric, they
claim that the play is not misogynistic at all, but rather recognized a
"problem" and thereby enabled the audience to work through and negoti-
ate the problem. The play is symptomatic not of man's domination of
woman, but of woman's desire for love and protection—this then is the
"problem" (a feminine problem) that the play must resolve.[18] The intro-
duction notes, in a language that recalls contemporary psycho-babble
about the "problem of abused wives," that Petruchio is guilty only of men-
tal cruelty, a cruelty that is really a sign of his love for Kate. Like the readers
of format romances, the readers of *The Taming of the Shrew* are encour-
aged to interpret the hero's hostility as love.[19] The introduction comments:

> Petruchio pretends to be concerned only for Katherina's welfare. He will
> not let her eat a morsel of burned meat, which might make her choleric;
> he will not permit her to wear a custard-coffin of a cap, which, he asserts
> is not good enough for her. Everything that he does to tame her, he does
> with excessive claims of his great love. In the end Katherina is really in
> love with her lord and master, and her speech to the "froward" wives on
> the duty of obedience has the ring of sincerity. (xi)

Or so Lamar and Wright would have us believe.

By laughing at the absurdity of Petruchio's regime of domination, and
evolving a more insightful understanding of his motive, the readers/view-
ers, in the words of Barthes, are conveniently "rid of a prejudice which
costs . . . dearly, too dearly, which costs . . . too much in scruples, in revolt,
in fights, and in solitude" (42). The reader/viewer's sense of injustice is dis-
sipated through a complacency bred of irony and intellectual virtuosity,
her position defined in terms of education and intellect, in terms of class

issues rather than gender issues. To a degree, then, the educated woman in the circumscribed area of literature is allowed to react as if she were a man. Virginia Lamar and Louis Wright appear to operate from a single homogeneous position as coauthors without gender or any other distinguishing features. The intellectual woman through education and class is privileged in her access to self-consciousness and accepts the evils of her situation (here, legitimating an obviously misogynistic play) in return for the benefit of these privileges, enjoyment of the play as a reward for the privilege of education, and the privileges of education signaled through enjoyment of the play. Virginia Lamar as a critic does not speak for herself as a woman, but in defense of a cultural agenda (which includes Shakespeare) that defines a specific class. To speak as a woman, within the canonical critical perspective, would be to violate the interest of this class in upholding a specific canonical tradition that guarantees that class as such.[20] (Is to speak as woman to speak as a shrew?)

Within the Shakespearean topos, enunciation, the permission to take up the position of the speaking subject, is even more explicitly the specified property of the man as the representative of the masculine, of a patriarchal rule—acquired through domination—here represented by Petruchio's appropriation of Kate as his wife and all that this entails within the comedy. In *The Taming of the Shrew*, the woman's development parallels that of a man; however, when the woman reaches the stage at which she is indeed "a speaking subject" in full possession of her faculties, an adult, she must be re-subjected, or "grow down" in Annis Pratt's terms, to take up her position as a wife, in which she may speak only to the extent that she enunciates her husband's desires, that he speaks through her. She must relinquish her mastery of the language as a site of production through which her desires can speak. Henceforth, her desire, her pleasure must be mediated through the desires or voice of her master, to whom she owes complete obedience. Or, at least, this is the distribution of power described in *The Taming of the Shrew*, in which for Kate the relationship between signifier and signified must change even as her husband changes his mind—for it is he and only he who may master language, serve as the master of language, the guarantor (for which there is no guarantee) of the stability of that system and its ability to ensure social order.

The Taming of the Shrew establishes language and speaking as a central thematic in its "master plot" through the Induction, a framing device that situates the play within another play revolving around a character called Christopher Sly. During the course of the Induction, Sly is found in a

drunken slumber by a lord who decides to play a trick on him. The lord dresses Sly as an aristocrat, organizes a play in his honor and convinces him that he is a lord suffering from amnesia and the delusion that he is an inebriated derelict. Sly himself emblemizes the human condition reduced to its lowest common denominator: "Grim death, how foul and loathsome is thine image" are the words with which the lord initially describes him (Induction, scene 1, line 35). Death is the ultimate goal of all human existence. Life exists insofar as it transforms death into an economy that defers death. Thus in rescuing Sly from death, the lord enfigures the moment of intersection that psychoanalyst Jacques Laplanche has termed the "strange chiasmus" of death and desire (124). In the framing device, the economy of deferral is achieved through the intercession of the lord as representative of the Law. By subjecting himself to the law, the individual defers chaos, animality, and thus finally the organicity of death—defers but, of course, does not escape. At a primal level, the law, enabling man to live as a social being, triumphs temporarily over nature, which will reclaim its own in death. The law is the necessary structure that constitutes the social as a coherent body for its own protection. The structure or law of narrative parallels this double movement: the flow of narrative (its resolution) is inhibited so that it can continue to function as narrative for a limited amount of time.

The law as a system that regulates the symbolic functions and narrative apparatus of the text (the rules of meaning and story) is both constitutive of and constituted by the text as a procedure. Here, this function is narrativized in the character of the lord, who takes on the directorial or authorial role of the play within the play. Though the lord will organize the play within the play (*The Taming of the Shrew*) ostensibly for Sly, ultimately the play revolves around the desire and power of the lord himself, as the final privileged viewer. The joke is on Sly; the lord thinks that it is funny. Strategic in the joke that the lord plays upon Sly is the introduction of a page who masquerades as Sly's lady. The lord's attention momentarily shifts, dwelling upon the image of the transvestite as a replication in terms of sexual identity of the transformation wrought upon Sly in terms of social class.

> I know the boy will well usurp the grace,
> Voice, gait, and action of a gentlewoman.
> I long to hear him call the drunkard "husband."
>
> (Induction, scene 1, lines 141–143)

The lord's pleasure in the play becomes two-fold, grounded in his ability to manipulate the play of difference in terms of both gender and class. If at first the lord's deception appears benign (he merely wants to amuse the old man), in fact, it is the lord's pleasure that is at stake and the joke that he plays on Sly is for his own amusement—deferring the image of death within a complicated trajectory that finally will come to define the play as narrative.

Both page and Sly are the dupes of this play of power that will ultimately benefit only the lord to the extent that the joke, the play, is for him as the privileged viewer, the one who is "in" on the joke; however we notice that even the lord is only in on the joke to the extent that he gives up his position as lord-in-name, occupying yet another position than the one that "names" him. The lord, placed on the inside, can be seen as the corollary of that place Lacan terms the Name-of-the-Father, that "names" the position of power, designates it as such, but in name only (so to speak). Thus, the lord may speak as the representative of the law, but he is never the law itself. In Lacan's terms, the position of the lord, that position that authorizes Sly as the false lord but that in fact the lord gives over to Sly, links:

> the appearance of the signifier of the Father, as the author of the Law, to death, even to the murder of the Father, thus showing that although this murder is the fruitful moment of the debt through which the subject binds himself for life to the Law, the symbolic Father, in so far as he signifies this Law, is certainly the dead Father. (*Écrits*, 199)

To use Lacan in this context is to use psychoanalysis against itself. The mechanism that Lacan announces with such authority as an essential moment in the production of the subject, functions in *The Taming of the Shrew* to unmask both the necessity of these processes of inscription and the arbitrary nature of this necessity. What we have here is no murdered king, but a drunkard, a monstrous beast who "lies like a swine" in the street and is in spite of himself tricked into masquerading as the lord that he knows he is not. By placing Lacan against Shakespeare, the myth of the all-knowing father is revealed as the fiction that it is, a fiction that "works" in the service of a specific social order.

Within Shakespeare's play, the "construction" of this position as a "play"—the mise-en-scène of a fiction necessary to the generation of the fiction and play of gender—is articulated within a specific culturally-coded class hierarchy that is very clearly not that of a biologically

generated "family" group. Though the general tendency within Lacan's work is towards a quasi-biological reading of human subjectivity as a product of a universal Oedipal narrative, there are also ways in which this Oedipal narrative seems to catch itself, recognizing itself as one play among many possibilities. To read Lacan productively, in some senses, against himself, is to seize upon these moments in which the Oedipal narrative is seemingly decentered, recognizing itself as necessarily contingent. In this context of a decentered Lacan, Lacan himself remarks: "Of course, there is no need of a signifier to be a father, any more than to be dead, but without a signifier, no one would ever know anything about either state of being" (*Écrits,* 199). In other words, it is the foregrounding of *a* signifier, in this case (though not inevitably in every case) the signifier that establishes the terms of a patriarchal order, that is crucial to the construction of social order. This "order" is a symbolic order, necessary to, in Lacan's terms, the "collective organizations, outside which human life does not appear capable of maintaining itself for long" (*Écrits,* 192).

The play, the specific play *The Taming of the Shrew,* defines the position (that is not-the-lord, not the name-of-the-father) that it offers the viewer/reader through the limits delineated by the characters of page and derelict, two underclasses, subjected through different mechanisms. The page as representative of the feminine (we recall that all female roles were filled by young boys in the Shakespearean theater) is complicit in the circumstances of his/her own domination. He/she cooperates with the lord in his elaborate hoax on Sly. Sly, on the other hand, is unconscious of the role he must play.[21] Though Sly obviously "occupies" the place from which the audience might view the play, the audience/reader, like the page, is not duped but aware of the deception that enables him or her to make the play's experience his or her own, to reappropriate the play as though it were the mise-en-scène of his or her own desire. In fact, the play only takes place in so far as it generates pleasure and profit for the lord as representative of the law, the social order, the hegemonic structure in its largest sense. Thus the lord in spite of the fact that he cannot be the name-of-the-father accrues certain privileges as the representative of that place, which are not accorded the page or Sly. This play of differences is, then, not a "free play," but a play that operates in terms of a specific ordering of interests, of regulated, hierarchized investments and returns. That the play appears to offer up the deconstruction of its own ruse as part of its generically coded regime of reading is a characteristic of its function as high art, which the reader/viewer is always encouraged to enjoy, self-consciously taking a

position of complicity in the process of his or her own deception. In this sense, this deconstruction is not an inherent property of the play, but of the reading formation, the regime of signification, that the viewer brings to bear upon it, through which the play becomes a text, in particular a text within the canon. Thus the canon is not simply a collection of great works, but also implies a specific method or "technology" of reading.

To return to *The Taming of the Shrew*, the Law (and thus its representative, the lord) speaks through the play because the law as the law of narrative provides an economy under which the individual is subsumed, but which is the individual's only hope of deferring death and retaining individuality. Here the law and its inequities may be recognized; however, the play is also recognized as a great work, a complicated text, embraced as a literal representation of the cultural hierarchy in which we docilely take our places, lords and pages. We refuse the position of "boor," that of the uncultured Sly, who would willingly exchange the play for cruder forms of entertainment. There is a payoff and the compromise is made worth our while; the reader/viewer is "inoculated" in Barthes' terms: "common sense makes its reckoning: what is this trifling dross of Order, compared to its advantages?" (42). The pleasures of the text, the mechanism through which we are interpellated into the cultural forum of the educated, the culturally literate, outweighs the dysphoria evoked by the inequities of the regime of power that this same spectacle represents.

Sly's relationship with the page as lady replicates the relationship between reader/viewer and the play, which defers, displaces, sexual desire (or the crude desires of mass culture) into a play of high culture. Sly's first reaction is to want to act out his desires and immediately couple with the page/lady. Such an action, however, would arrest the diegetic progression of the play. "(I)f it ever happens that Sly sleeps with his wife, he will soon enough discover that she is a he in drag disguise" (Fineman, 139). Sly would discover the mechanism of deception: the page is not a lady, and ultimately Sly himself is not a lord, putting an end to a situation that is pleasurable for both Sly, the lord, and perhaps even the page. Fortunately for the play, the sexual act is deferred—is never played out—and Sly is presented with another play, *The Taming of the Shrew* proper, in its stead. Though there may be pleasure and profit for all in this investment and deferral, the position of pleasure offered Sly and the lord are distinct. Sly's pleasure derives from his ignorance of the "real" situation, whereas the lord's pleasure depends on his knowledge of the fact of deception. Sly continues to anticipate the deferred moment of sexual pleasure or the deferral

of at least the nominal source of his pleasure, and in the middle of Act I, Sly interjects impatiently, "'Tis a very excellent piece of work, madam lady: would 'twere done" (Act 1, scene 1, lines 266–267). The page, on the other hand, as an employee, so to speak, has no choice but to gracefully acquiesce to the voice of power in the person of the lord and to act out his part, complicit in his/her own deception. We might ask: where is the page's pleasure—is there a feminine position from which his/her pleasure might be conceived? The page must "masquerade" as the feminine for the pleasure of her two men; her masquerade is necessary to maintain the fiction of sexual difference upon which the play is based. But, her profits can only be measured by the disfavor she would incur should she not prove "obedient to his honest will," in this case to her lord to whom she owes the same duties a woman owes her husband within the laws of this play.

At its origin, then, the stakes in the play are displayed as a concern with the necessity of maintaining sexual difference as the root of an economy of desire grounded in deferral, maintained by the subjection of the feminine to the masculine, in which this subjugation defines the feminine as such. Though gender has a biological significance that is not merely culturally inscribed, here the issue is not procreation but desire. The page's attire and status vis-à-vis the position of power held by the lord determines his/her definition as an object of desire. This formal mechanism by which the masculine can become the feminine must be occulted if, indeed, the play is to continue, since its production depends upon this very act of deception as the moment of the play's inception. Joel Fineman points out that "the play's apparent omission of a formal conclusion to the Sly story" suggests "that the audience for the entirety of the play is left at its conclusion with a desire for closure that the play calls forth in order to postpone" (139). Or in the terms of *Moonlighting,* the play is about a couple who argue all the time but who really want to sleep with each other, thus who argue, who speak, instead of coming "to bed," as Sly would prefer . . . and yet these arguments can hardly be dismissed as insignificant. The narrative (here the play) creates an underclass (here the repositioning of the page) solely for the purpose of perpetuating itself; as narrative it is the rhetorical equivalent of a love that can only express itself through abuse, through argument as speech. In a move that recalls the Wright/Lamar justification of the play's misogyny, Fineman interprets this *mise-en-abyme* of the play of (in)difference deferred as the production of a "desire that leaves something to be desired—a desire, therefore that will go on and on forever." Fineman claims that this desiring productivity explains "the abiding popularity of

The Taming of the Shrew," a popularity one might add that his reading both reestablishes and legitimates. Fineman's analysis, which assumes a universal Lacanian subject, relieves the reader of the task of asking: popular with whom? Certainly the play is not popular with Shirley Nelson Garner for whom Fineman's analysis would constitute yet another ingenious reading.

The framing narrative of the play offers a counter explanation of the terms of the play's popularity or at least of its significance for those (like Joel Fineman) who read/like Shakespeare and imagine themselves as insiders, the bearers of national literacy. Through this frame, which announces another more complicated law than "do your homework" (in *Moonlighting*'s frame), the lord's control of the entire mechanism of deception and difference, his power over the site of enunciation as the moment at which meaning is produced (the play), is inscribed as the originary and legitimating moment of textual/sexual production. The lord is the ultimate insider—as is the viewer who imagines himself or herself in his position as he invites us to do, for after all, we share the joke with him, the secret of the play as a play of deception. Yet, ultimately, in response to Shirley Nelson Garner's question about who is inside and outside the joke, the frame seems to suggest that, in spite of our complicity, it is only the lord who is in fact on the inside, a position that he occupies only to the extent that he is not in "position," his place taken by Sly. The rest of us are forever outside looking in, perhaps some of us, like Sly and the page from their different positions, still hoping that we are really on the inside.

If we push this analysis a bit, we might even say that there is no inside—the lord is only inside to the extent that he masquerades as a "regular guy," slumming on the outside. Thus we might say that to read Shakespeare gives us the tools by which we recognize our own contingency, where we stand outside a joke that has no center, no inside—a feminist reading that remains feminist only to the extent that it is strategically effective in dismantling a structure of gender difference that ironically Shakespeare as the keystone of the canon holds in its place. To borrow from Jacques Derrida, the feminist reading must function as an "inscription" which "is not a simple position: it is rather that by means of which every position is of itself confounded (*différence*)" (96).[22] In contrast, *Moonlighting*'s mother leaves us in a position of relative indifference in which the canon and its specular image, mass culture, are read as one and the same.

However, the temptation to stop our analysis with this notion of "confounding" must itself be resisted—to confound for the sake of confounding moves us dangerously close to the ingenious reading. The shrew must

occupy language strategically (and here I use the word "occupy" in its military sense), if at times only provisionally. To control language is not simply to defer difference but to recognize the difference between *Moonlighting* and *The Taming of the Shrew*. The feminist position as shrew must seek to understand and to speak the structural function of that difference and its inscription in the enunciation of power, to refuse the pleasure and profits the play might offer us in the form of "ingenious readings," and thus to give voice to our continued irritation, our shrewishness, as "serious souls who must see a profound lesson in all literature."

The relationship between Petruchio and Katherina underlines the issue of sexual difference as dependent upon the issue of enunciation, upon the problem of language and control. The issue that motivates the play centers around Katherina's suitability as a wife. She is unsuitable because she has a problem. Her problem is that she speaks. She will be heard. This is the essence of her shrewishness—she is an outsider (female) who wants the authority, an authority vested through control of language, to speak as an insider.

> Why, sir, I trust I may have leave to speak,
> And speak I will; I am no child.
> .
> My tongue will tell of the anger of my heart,
> Or else, my heart, concealing it will break,
> And rather than it shall, I will be free
> Even to the uttermost, as I please, in words.
> (Act 4, scene 3, lines 80–81, 84–87)

However, speak is precisely what she may not do. Yet it is difficult to judge her desire to speak as an adult "lunatic," the expression of the "lunatic language of woman" in Fineman's terms. Her claims seem quite rational: certainly as she points out, she is "no child" and to be "free . . . in words," is, in this day and age (if not during the Elizabethan era), the right of all adults. If her speech is lunatic, it is only because she speaks as a woman. The same words coming from a man or men, the right to a declaration of independence in response to the "course of human events," the right to speak, is the very foundation of rationalism—but only if spoken by a man. The battle between Petruchio and Kate is over the control of language; Petruchio deliberately sets out to bar her access to language—to deny her the privilege of speaking for herself as a subject—to "subject" her to a man as her lord and master. Speech is Petruchio's weapon because in it

lies the power to structure and thus to control Kate's position within the social order.

> He'll rail his rope tricks . . . she'll stand him but a little he will throw a figure in her face and so disfigure her with it that she shall have no more eyes to see withall than a cat. (Act 1, scene 2, lines 114–118)

In the play, one can disfigure with a figure (rope tricks as rhetorical devices), blind with speech ("she shall have no more eyes to see"). Petruchio's specific strategy is to always advocate the opposite of Kate's propositions, producing a situation of a-semiosis, in which language loses its ability to create difference, to differentiate between chaos and order, to signify. This regime of abuse reduces Kate to a state of a-cognition: language loses its specificity, it is not fixed in terms of an external system except insofar as it is arbitrated by her husband as sole speaking subject. And when finally Kate capitulates to Petruchio, claiming: "But the sun is not when you say it is not/And the moon changes even as your mind" (Act 4, scene 5, lines 24–25), she relinquishes the right to speak her mind, the right to subjecthood. If there is ever a moment in which she affects lunatic speech it is at this moment of her capitulation, the moment in which she gives over control of language as the sign of her gender.

But, in spite of the "ring of sincerity" that Lamar and Wright detect (perhaps she is humoring Petruchio—"whatever you say honey"), whether or not Kate believes what she says is not important to her position. Duplicity and complicity are crucial elements in the mechanism of subjugation. Certainly, for Fineman "Sly's metatheatrical desire for the pageboy defines the essence of femininity as masquerade" which underlines "the traditional duplicity of woman" (142). Thus the traditional duplicity of woman (in Fineman's terms) assumes that as a woman she must "play at" that which she is not. Fineman's analysis leaves us wondering whether she is ever herself, demanding that we ask that as-not-herself, what language does she speak. Are we then to believe that a woman may never speak as herself, as a woman? However, according to Fineman, the woman is always also complicit in the process of the deception that becomes her own domination, while giving the appearance of unselfconsciousness. In essence, Kate decides that it is to her benefit that she cooperate with Petruchio: appearance is all that is required of her, as was required of the page in the framing scene. Appearance without language to confirm or deny its status signifies only in terms of that which speaks for it. And thus though she

may speak, Kate has now taken up a feminine role—in which she must perform or "appear" for the male gaze.

Kate takes up, then, the position initially occupied by Bianca, who though she:

> does in fact speak quite often . . . the play describes this speech . . . with a set of images and motifs, figures of speech that give both to Bianca and to her speaking a specific phenomenality which is understood to be equivalent to silence. . . . Bianca and her language both are silent because the two of them are something to be seen. (Fineman, 130)

As something "to be seen," the problem of intentionality is irrelevant—it is only appearance that counts, that signifies when one can no longer speak for oneself. In the final analysis, Kate does submit to Petruchio's "awful rule and right supremacy" as the means of achieving "what not that's sweet and happy."

The fundamental issue, and this cannot be repeated too many times, is that Kate may no longer speak her mind, with her own voice, but must always borrow the voice of her husband, the ventriloquist who commands her speech in terms of his desires. This silencing is not a result of "nature," difference as biological, Shakespeare suggests, but a result of the imposition of patriarchal law, the husband as lord and master, as the organizing function of the social entity. Kate's final speech is not in favor of nature but of expediency. As "a foul and contending rebel," we can well imagine what her fate would be; far better to become the "subject" of a "prince," a lord, who occupies this position as her husband.

Kate's capitulation is not simply a matter of political expediency but also of economic necessity. Kate is a "commodity" which must be made profitable (Act 2, scene 1, line 330), or reinvested, as her father, the merchant, says while deploring her unmarried state. Her marriage with Petruchio signifies her compliance with this law of investment and return. She is the very means of reproduction of the means of production, and, as such represents the male subject. She cannot be that subject for she, then, would no longer re-produce him, be profitable for him. She would be he. What is revealed here is twofold: firstly, that within Shakespeare's play the woman as subject must be interpellated, known to herself and others, through her subjugation by the male subject. She must take his name, she must speak his desires if she speaks at all. Secondly, though this subjugation of women is not biologically ordained, it must be ideologically grounded as "nature."

This duplicity insures that the hierarchy of sexual difference be maintained, that the play as a play of difference and heterogeneity take place.

The core of the Shrew prototype as it is inscribed in the popular romance (in contrast to the play as described above) effaces the complications of re-enunciation, concentrating on the hero as narrative agent. Petruchio's statement: "For I am he am born to tame you, Kate" (Act 2, scene 1, line 278) reappears, not as part of Petruchio's word games, but as an unspoken principle of narrative inevitability. To be found by he who was born to tame her is the foreordained and seemingly enviable destiny of all Harlequin heroines, the sign of their intrinsic value. The second half of Petruchio's statement is conveniently elided from the explicit text of the romance paradigm: "And bring you from a wild Kate to a Kate/ Conformable as other household Kates" (Act 2, scene 1, lines 279–280). The romantic hero must signal the uniqueness of the heroine to her: his desire constitutes the mark of her individuality, her specialness, again her value, even when it is quite obvious that there is nothing special about her at all. Petruchio makes quite clear that the designs of the romantic hero are, in fact, quite different. His function is to eradicate the heroine's individuality, to render her non-specific, "a Kate conformable as other household Kates" whose identity derives only from her husband's name.[23]

In Shakespeare's play, the natural-as-pretense is signaled to us before the play begins in the frame. The artificiality of Kate's position is reinscribed by the homosexual repression in the frame. In this sense, the play exists only to defer and displace the possibility that all desire be grounded in culturally contingent categories in which the categories of gender function as mechanisms of sexual control. This is not to deny the reality of biological function but to signal the fact of desire and sexuality as dependent upon an arbitrary difference designated by the Law as Language. This culturally determined difference, not biology, creates desire, as opposed to instinct (Laplanche, 8–24). Kate is a speaking subject; however, insofar as a speaking subject is the male subject (by definition), she is a male masquerading as a female, the non-speaking subject, within the topos engendered by *The Taming of the Shrew*.

To seek out an essentialist definition of femininity within this structure, this topos, makes no sense since femininity is a creation of the masculine subject defined as the object of his desire. (The page can become the "feminine" according to the whim of the lord's desire, which desire confirms him/her in her position.) *The Taming of the Shrew* delineates but does not resolve the contradiction of woman; she speaks and she desires, but she

must appear not to speak, not to desire, except as the expression of an Other, male, desire. She must take the position relegated her by the male; and it is precisely the taking of this position that defines her as feminine. She must appear neither to have a position of her own nor to accede to the male position, but of course, she does, as will always be revealed through the procedures of analysis. The cynicism of the Shakespearean model, its recognition of misrecognition as the foundation of the male/female relationship, is read as such by the educated audience for whom culture is exemplified in the ability to read and interpret Shakespeare. The educated are "inoculated" against the greater evil of biological determinism through their ability to recognize misrecognition, yet this knowledge is not sufficient in and of itself to challenge the patriarchal order that perpetuates these structures of misrecognition. Self-consciousness is not sufficient to effect a "cure"—rather, it has the contradictory effect of enabling those who should protest to tolerate the status quo.

The educated woman is allowed to take her pleasure as though she were a man. She is further "inoculated" against the possibility of becoming a subversive agent, the one who might speak for her class, women, because she fears losing the limited privileges she enjoys as a member of the cultural elite (as did Kate). Her ability to analyze and interpret gives her an arena of power; however, her power is as illusory as Kate's because insofar as interpretation and analysis become the sole goal and practice within the canon, a goal sufficient unto itself, analysis and interpretation have a conservative function. Though analysis itself may open the possibility of an intervention, a rupture in the play of difference and deferral, to take up this possibility is to become shrewish, to run the risk of being accused of speaking the lunatic language of women. The intellectual woman fearful of finding herself discovered, unmasked (that she is really a shrew in disguise), holds her tongue, and becomes a victim of her own elitism, subjected by the institution of which she is a part and which in turn is part of a larger hegemonic structure that maintains gender and class differences in place.

The intellectual woman is thus "inoculated," in Roland Barthes terms; her intellectualizations appear to unmask the working of ideology only in fact to confirm its status as status quo, acceptable as such in spite of it all. However, it would be a mistake to dismiss the canonized text as without value, to reject women readers of the canon as "pages" fawning over the lords of high culture. Rather, the value of the canonized text lies in its rereadings, which offer the potential for an analysis in which the canonized text becomes a site of struggle, in which it is perpetually recolonized

by different readers within different contexts. To follow the threads of this conversation, perhaps shrewishly, certainly tenaciously, weaves another text that emerges intertextually in the transition from one medium to the next. It is in the reading of the process that produces this other text (as analysis that never ends, an open text) rather than in the text produced (the finished analysis, a closed text) that there lies the possibility of an inoculation that inoculates against Inoculation. This intertext reveals in the movement from one text to another the possibility of a feminist reading that situates itself within a postmodern context—that does not neglect the past nor linger nostalgically, but rereads the past as a site that must be continually revisited, reconceived, and revisioned. As Umberto Eco has said: "the past. . . . cannot really be destroyed, because its destruction leads to silence" (67). If a woman's work is never done, neither is that of the feminist. It is precisely when she thinks that her task is finished, the moment at which she feels that she may speak for woman, even as Petruchio speaks for Kate, it is at that moment that she speaks with her class against her gender and it is at that moment that she must begin her Penelopian task again.

The female professor, married, tenured, secure in her position, and in her authority, can smugly ask: what's wrong with essentialism? Those of us on the outside might respond: what's wrong with essentialism is that it enables a white upper-middle class heterosexual woman to ask that question—a question that was meant to silence, to inoculate against the necessity of asking the more difficult questions that her own presence at the podium raise, to stop the process of continued engagement that woman's work demands. The smugness of the professional woman finds its clearest expression in forms of parody that allow her to display her ironic mastery of the words of men. She may continue to read the canon, to disdain culture outside the canon, to refuse to recognize other canons; and thus, her feminism may work against the interests of women because it maintains current hegemonic institutions of education and culture. In simple terms, we can say pointing to this woman, we are not sexist, we have no need for curriculum reform, because women can read Shakespeare, Richardson, Hardy, Beckett, etc., as feminists: we are safely inoculated against the dangers of cultural subversion.

The professional woman's education enables her to insert herself into the discourse of parody from a position of mastery created by her ability to manipulate codes of cultural literacy at multiple levels. She may, even, congratulate herself on escaping the construction of gender; however, she also

runs the risk of sliding into shrewishness, one false move and her comedy will be revealed, that is to say that she is a woman who enjoys an unnatural mastery of language. Thus, the shrew as an icon represents the perpetual threat that hangs over the head of the educated woman. The temptation to reclaim that "threat" and transform it into a moment of empowerment produces the shrew as an ambiguous figure in feminine culture, both hated and envied within the annals of the popular, embodied by figures as diverse as Lady De Winter in *The Three Musketeers* to Abby on *Knots Landing,* or more recently the notorious Murphy Brown in the eponymous situation comedy. Thus, the shrew as a cultural icon is a site of struggle, in which her story is used to generate conflicting readings of the problem of feminine identity. This conflict is exemplified in the transformation of Kate's role from the woman-who-speaks into the woman-who-needs-someone-to-speak-for-her in *Moonlighting*'s version of the story. It is symptomatic of television's broadly based audience, of quality television's desire to attract male as well as female viewers, that *Moonlighting* fore-grounds the role of Petruchio, and in the process disempowers her because Petruchio will always have the first and last word.

Moonlighting's appropriation of the shrew as an icon is perhaps more explicit in its ambivalence than most rewritings to which Shakespeare's work is routinely subjected, but it is certainly not unusual. Tracking the shrew will take us far afield, even to the arcane realms of the self-help book and the women's magazine. Exemplary of this process of reappropriation (another turn of the shrew, borrowing from Joel Fineman, borrowing from Henry James), is the use of the shrew icon by therapist and free-lance writer Susan Price in her "self-help" book, *The Female Ego.*

2

THE "NEW WOMAN"
AND HER "SELF"

Self-esteem, Self-worth, and Ego-strength

In the move from television show to self-help book, one would expect to find that the position accorded the female voice would also be transformed, if only because the term self-help implies the empowering of a "self," of the autobiographical voice that speaks for and to a readership in which it is always implicated as a participant. Indeed, the book jacket promises those "kates" of the world seeking a voice that this book "tells how you can let go of guilt and pursue the roles in life you want most" including, perhaps most importantly for this argument, "(h)ow to claim power and success without losing love" (book jacket, back flap). The voice that promises these transformations is explicitly defined as emerging from within the very constituency that it addresses. Price is "a woman who speaks both as an authority and as a female who personally has experienced the process of self-discovery that she describes in this volume" (book jacket, back flap).

The book seems to promise a counter-narrative to *Moonlighting*'s rewriting of the shrew story in which authority is given over to the feminine voice. But, the voice with which Price speaks is the voice with which Kate speaks her own submission when she rejects her previous desire to be "free . . . in words" as befitting only a "graceless traitor to her loving Lord." The key word here for Price would be "graceless," should she ever think in these terms. Price threatens her reader with the loss of "grace," the fate of the unwomanly woman, the shrew, should she fail to learn this lesson on

35

her own, to give the "help" to her "self" that Petruchio so brutally imposed upon Kate. In this sense, *The Female Ego* is not so much a rewriting of the feminine "voice" as the legitimation of the position defined by Kate's final speech of capitulation. Price recommends that women voluntarily assume this position from which Kate as the ventriloquist's dummy speaks Petruchio's desires. According to Price, this position constitutes the most effective place from which a woman might seek "to embrace a joyous life full of love and accomplishment" (book jacket, back flap).

The importance of *The Female Ego* lies, then, in the way it documents a strategy common to feminine culture's attempts to negotiate feminine autonomy as the need for a "voice," and the "silencing" of that voice necessary to the feminine position as defined by the culture at large. That Price speaks both as an "authority" and as a "female" is representative of the contradiction that motivates her narrative, a contradiction which can only be resolved by transposing the role Shakespeare accords Petruchio onto the woman herself. Though *The Female Ego*'s version of the shrew story initially eliminates Petruchio's function as the pedagogue of correct feminine positioning, Price's re-elaboration of Shakespeare's lessons also reclaims him as the sign of an "internal" regulator of the feminine "self"— the "help" in "self-help."

Crucial to her authority is her position as representative of a new feminine voice that does not exclude the traditional roles of mother and wife. The book jacket situates her voice by offering the following description of her position:

> Susan Price, M.S., is a clinical social worker and psychotherapist practicing in New York City. She is a contributing writer and psychological consultant to *Glamour* magazine, and also lectures widely. She and her husband and two children live in Montclair, New Jersey. (book jacket, back flap)

Her "qualifications" fall into three categories—most obviously, professional: her degree and her practice place her as "knowledgeable" within a masculine and public hierarchy. Equally important however are: her involvement in the specifically feminine institution of the women's magazine (signified through her relationship to *Glamour* magazine), and finally her position within the home as both wife and mother. Perhaps even more significant within the hierarchy of feminine experience than her professional status and institutional accreditation (a necessary but insufficient

credential) is that she herself as a woman who combines career and family represents the audience to whom she speaks. As important to her legitimacy as her ability to quote Shakespeare is that fact that her own experience as professional, wife, and mother "authorizes" her to speak within an autobiographical mode, to say "my" husband, adopting the voice of private and personal experience as a specifically feminine criterion of validity. This intertwining of private and public standards of validity, of personal experience and canonical references, is peculiar to the self-help genre and its vocabulary.

Price's conceptualization of her task reproduces this dual standard of private and public, of intimacy and canonical knowledge. Her techniques of self-help revolve around the development of what she refers to as "self-esteem" and "ego-strength," both of which derive from a "healthy ego," an ego tailored to the specific needs of the contemporary female (according to Price). In the juxtaposition of terms such as "ego" (the professional vocabulary of the psychologist) and "self-esteem" (the personalized vocabulary of the friend and counselor), Price reiterates and strengthens her claim to move between two worlds. The use of the second person (invoking the intimacy of the feminine experience within the domain of the private) in conjunction with the professional vocabulary of the psychologist reinforces this same movement between two positions. The healthy ego is:

> your internal psychological system that meets your needs and solves your problems. When we say that a woman has a good ego, we mean that the inner system for meeting her needs is doing a good job. She is able to know what her needs are and to find satisfying ways to meet her needs in the environment. Because a woman is often more concerned with pleasing others than with pleasing herself, she can find herself in a trap in which she hardly uses her ego to meet her needs. (Price, 6)

Moonlighting's rewriting of *The Taming of the Shrew* would seem to suggest, at least at first glance, that within Price's paradigm, Kate has a "healthy ego" (she can express her needs), but the times, "when men were men, and women were property," denied her the circumstances whereby this "healthy ego" might function as such. In fact, Price takes quite a different direction—rather than setting up Kate as someone who deserves sympathy, she exploits the currency of the shrew icon and its narrative paradigm by drawing upon the shrew's negative associations, mining both the closeness between the shrew and the strong woman, and the accusations of

shrewishness with which this woman is frequently plagued. Price's strategies offer women strength while cautioning them against the dangers of shrewish behavior, lending value to her position as a successful representative of the feminine who is not a shrew. In her second chapter, "The Female Ego in Crisis," the figure of the shrew is invoked as a statement against woman, as a sign of her failure to fulfill her role as woman. The reader is urged to submit to an ideological technology of control that has no need of a Petruchio to metaphorically beat the outspoken or discontented female, because in her fear of seeing herself as that shrew, she becomes her own "Petruchio."[1]

The shrew as an icon represents a specific position accorded women that Price, as a therapist, defines as "dysfunctional." Her authority, already established through her professional position, is extended through the references to Shakespeare's play as another icon of high culture and education. By quoting directly from the play (Price, 34, 35), she gives weight and currency to her notion of the dysfunctional, inflecting it with a knowledge that is in excess of her professional capacities. Her "knowledge" of Shakespeare, psychology, and everyday life permits her to sum up her "cure" in the following terms:

> Only Shakespeare could invent a powerful man who would undertake the task of taming a shrew. In real life, self-respecting men won't do it. A shrew must tame herself. (Price, 33–34)

Ideally then, the shrew would find a man capable of taming her and thus "fulfilling" her; however, the shrew as a practical woman cannot expect this type of fulfillment and she must renounce the romantic paradigm as a solution to her problem. (Are we to assume that there are some women who are more easily and more happily "tamed"?) Price's description of the shrew is confusing because in many ways the shrew's frustration would appear to be legitimate:

> Basically a shrew is a high-spirited woman with a chronic case of sour grapes. Even as a healthy person, she would be a powerful force to deal with. Convention bores her; routine is a trap, and she has little respect for authority, unless it has earned her respect. She resents mistreatment with a passion and is a poor loser. (34)

Price dismisses the possible legitimacy of the shrew's complaints—her boredom with convention, her contestation of authority that has not

earned her respect, and her resentment of mistreatment are dismissed as irrelevant. Instead, Price focuses on the image of "sour grapes" as the emblem of the shrew, a woman who resents the success of others because she has no outlet for her "powerful force." Similarly, she describes as pathological Kate's accusation that men, her father, Petruchio "mean to make a puppet out of me" (qtd. 35), a goal that Petruchio not only desires but that the play's ending leads us to believe he accomplishes. Price claims that the shrew keeps "herself stuck by rebelling" [*sic*] (36). Price explicitly models her techniques on those employed by Petruchio in his successful transformation of Kate from shrew to puppet:

> If I had been discussing the male counterpart of a shrew, I might have described a high-spirited and rebellious troublemaker who hasn't got his act together yet. We might say that he needs to go into the army and get himself straightened out because he seems to need discipline. Shakespeare had the same notion about his shrew. Her tamer made her walk through mud and rain after her horse gave out. Whenever she complained she was presented with a tougher situation to deal with. He put her through her paces and ultimately "shaped her up." (36)

Given that the exceptional woman is unlikely to meet her match, her Petruchio, Price recommends that the woman internalize the Petruchio figure and the values that he represents. Petruchio as the representative of the Law becomes expendable and women are enjoined to internalize the regulatory function that he incarnates.[2] Thus the shrew story is feminized in that the masculine/feminine binarism is effectively dismantled; however-er, the traditions of feminine interiority and domesticity remain intact, as exemplified in the following case history. Price explains:

> I once worked with a woman who was married and occasionally wanted to go out with her women friends. Two or three times a year she would go bar hopping and stay out all night. This pattern, which she could not explain to herself, nearly destroyed her marriage. (35)

The solution to such behavior is to find a constructive outlet for these "destructive" urges. Price recounts the story of "Judith," who transforms her personality by developing her musical gifts. In addition to her musical talent, Judith "is magnificent to look at as well, with flaming red hair and flashing dark eyes" (37). Over a non-specified period of time, Judith faces "her trek through the mud" from "the humiliation of beginning as a

beginner" (37) to playing "advanced piano repertoire" (38). Eventually, not only does Judith enjoy a certain degree of professional success, but her disposition improves as well and she becomes a "Born-Again Woman" (38). Price comments:

> Through it all, an amazing change comes over her personality: she is easier to be with. She enjoys the comfort of others. She is less demanding; others don't have to be perfect. She draws on the emotional support that she needs and learns to give it as well. (39)

Price's discourse becomes increasingly convoluted: the rewards of professionalism are diverse, but are valued ultimately through reference to the woman's role as the sympathetic companion, who seemingly "saves" her marriage rather than her "self."[3] Judith's accomplishments are important not in and of themselves but because they enable her to better fulfill her role as wife and mother. She remains for all intents and purposes an amateur, important because as an amateur she must define herself primarily as wife and mother. Significantly, Price passes over in silence the economic imperative that motivates most women, married or unmarried, to develop a "career." "Career" is articulated as the graceful accomplishments of a woman who does not suffer from economic constraint. In other words, femininity and self-esteem are the prerogative and the luxury of the affluent woman. Price accords no voice to the woman whose "complaint" springs from her material conditions. She disregards the inequality of a socio-economic system in which a woman can still expect to earn significantly less than her male colleagues regardless of her qualifications, dismissing these discrepancies as the proverbial case of sour grapes. Price's "cure" suggests that women's complaints within the workplace should be understood in terms of "personal fulfillment" rather than "equitable return for services rendered." Is to "suffer" the material constraints of poverty a peculiarly masculine condition? In other words, do material constraints have no significance in understanding women's oppression? Certainly, Price's methodology discourages women from considering that their material conditions might define their position as feminine suffering from a "female complaint."

In conclusion then, Price's perspective has the virtue of giving the middle-class affluent woman permission to seek out her pleasure for herself, thus according to this woman a degree of autonomy and empowerment, a basis for generating a system of value, of measuring her own "self-worth"

herself without reference to an external (patriarchal) authority. At the same time, this permission is ultimately legitimated in terms of traditional feminine virtues that support a largely patriarchal structure of value and power, illustrating Ann Cvetkovich's point that: "the middle-class woman provides a central example of how power operates in covert ways by producing particular kinds of subjectivity" (9). From Price's perspective, the woman with extracurricular interests (as distinct from the woman who bears her share of the economic burden of "raising a family") values her self. As a result, she is better able to perform her fundamental tasks as helpmate and companion within the family than the frustrated shrew.

In this sense, Price assigns the woman an impossible task, impossible because it is contradictory. On the one hand, she gives the woman full agency over her own "value" but she confines her to existing social institutions such as marriage and motherhood as the woman's proper place, in which value is regulated by patriarchal structures. Because Price defines the etiology of the subject in a purely personal context, the shrew's "frustration" has no historical or social legitimacy, but is a function of her own failure to develop a "full" life for herself, a project that, according to Price, is always possible, regardless of the economic and social conditions in which the woman finds herself. As Cvetkovich notes: "It can be argued that the middle-class woman's oppression takes the form of psychic disturbance rather than material deprivations. . . . such diagnoses are often not 'real' but produced as a means of containing women and managing other social problems through the scapegoating of women's sexuality and affect" (9). This technology of "self" control offered by Price, then, is grounded in the denial of the importance of economic, social, and historical conditions. This denial directs the woman's attention away from these conditions towards a self that is constructed ultimately in the service of sustaining the institution of marriage and the larger social constructs marriage comes to represent, *pars pro toto*. Finally, then, the shrew is responsible for transforming her narrative into a story that even in the face of insurmountable odds can be read as having a "happy ending."

This ethos of autonomy and self-control differs from that usually associated with the masculine subject because, rather than emphasizing external accomplishment and public recognition, Price underlines private happiness as the source of satisfaction for women. The externalization of aggression and competition are not permitted, for this behavior though admired in men would be considered shrewish in a woman. Rather, the woman is enjoined to internalize these processes as the mark of her auton-

omy—in fact to hide and contain her desires and ambitions; her goal as "self-fulfilled" is to become a "pleasant" person. Thus Price's perspective can never offer a solution but only a displacement of the "problem" (problem from Price's perspective), ultimately positing a feminine subject who will always prove inadequate to the demands of her own construction because she will never be able to assume the burden of an entire set of historical and social conditions. Her "shrewishness" as a failure to contain her anger is always her fault, her problem, the result of her inadequacy.

The legitimation of this process of internalization and of the values that it represents is tied to Price's use of Shakespeare. Most obviously, the references to Shakespeare—the actual quotations from the play *The Taming of the Shrew* (as discussed above) taken out of context—lend authenticity to Price's position as a member of an educated elite, in spite of the banal, hackneyed terms of her own prose and analysis. Less obviously, Shakespeare's articulation and treatment of the "problem" (the "War Between the Sexes" in Lamar and Wright's terms) endow the narrative with a history into which Price inserts the contemporary woman. By rewriting the story of Kate as a case study that personalizes the situation, Price offers an individual solution to an historical problem within traditional patriarchal structures. In other words, the sense of dissatisfaction experienced by the shrew, according to Price, is purely the result of her personal situation and though this problem has a history its solution is not historical; never does Price suggest that to resent "mistreatment with a passion" might be an appropriate reaction to the historical conditions of women's subordination within a largely patriarchal order or that mistreatment might in fact demand social action rather than psychotherapy. Price fails to consider the possibility suggested by Ann Cvetkovich that: "It (psychic pain) may be a problem that cannot be alleviated by private or individual solutions such as the expression of feeling or the work of therapy" (9). Nor does Price open up a space in which a woman might legitimately question "authority" that "has not earned her respect." (Is it the woman's place to give respect where it is not due?)

In Price's analysis there is no room for statements such as those made by Rosalind Coward when Coward writes that:

> Men take up more space than women with their speech, filling the air
> with their way of talking, their jokes, their sense of priorities, and fre-
> quently belittling women who attempt to talk. I have been witness to a
> woman called a "harpy" for disagreeing with a male colleague, and to

women dismissed as "shrill" when they challenged the priorities set by men. . . . No wonder women's speech sometimes sounds dominated by discontent. Our attention is required but our speech is not heard. We must understand the messages of others, but cannot expect to be understood ourselves. (158)

Disregarding the shrewish outbursts of feminists such as Coward, Price creates a new position of privilege that she then offers to women willing to see themselves as subjects of her discourse, of her "cure"—who are not "harpies." In the case of *Moonlighting,* the implementation of the cultural codes signified through Shakespeare signals the privileged position accorded the quality viewer who chooses quality television. These reinscriptions imply that the positions that these texts create for their readers/viewers are positions of mastery, in this case metaphorized by the mastery of the culturally literate over the canon of texts that produced their literacy. The positions offered to the woman in the two examples cited above afford her varying degrees of autonomy and control—of mastery. The television episode shifts the responsibility from the woman to the man, affording him ultimate control over her pleasure and leaving her little option but to react to him. He remains the ultimate arbitrator of her value. Price's narrative initially chastises the shrewish woman but in so doing offers her the possibility of control over her self, without the intervention of a masculine voice. These two self-proclaimed "feminist" readings are at odds with each other in delineating a new reading of the canon: *Moonlighting*'s shrew does not need to be tamed, she needs to be loved; Price's shrew does not need to be tamed, she needs to be "self-fulfilled"—to develop "self-esteem" and "ego-strength." The obvious feminism of the television show intersects with the more convoluted discourse of the self-help book, marking the complexity and conflicted nature of the discursive networks that define specific moments of feminine culture and practice, and the ways in which a canonized figure can be reinvented in the service of different groups, with different interests.

The prevalence of the shrew model as a site of struggle, evidenced through contradictory reinscription, underlines the very real influence of canonized texts in the creation of a cultural literacy, as well as their equivocal status, in which codes of cultural literacy are invoked to create a position of privilege for the reader of a given text. The manner in which the shrew icon circulates is comparable to Chantal Mouffe's description of the democratic tradition:

> It is important to emphasize the composite, heterogeneous, open, and
> ultimately indeterminate character of the democratic tradition. Several
> possible strategies are always available, not only in the sense of different
> interpretations one can make of the same element, but also because of
> the way in which some parts or aspects of tradition can be played against
> others. This is what Gramsci, perhaps the only Marxist to have under-
> stood the role of tradition, saw as a process of disarticulation and
> rearticulation of elements characteristic of hegemonic practices. (41)

These struggles that we might be tempted to term personal, in their
movement across such diverse public spaces as the television show and
the self-help book point to the reconfiguration of the political that femi-
nism has demanded from its inception. Again in the words of Mouffe:
"Our societies are confronted with the proliferations of political spaces
which are radically new and different and which demand that we aban-
don the idea of a unique constitutive space of the constitution of the
political" (44).

The stakes of these new "political spaces" are played out in *Revolution
from Within: A Book of Self-Esteem,* written by the feminist activist Gloria
Steinem, in which activism (the "harpie" who is not afraid to speak up)
and self-help (the "born-again woman" sustained by her "inner self") are
placed against each other. The activist, shrewish Steinem replays the
feminist adage of personal and political in an attempt to reconcile
shrewishness and "self-help." In choosing the shrew as the prototype of her
neurotic unhappy patient, Price perhaps rendered too obvious that the
mechanism of the "cure" (implied in the self-help genre) guarantees a
woman's silence, gagging her as effectively as the brute force applied by
Petruchio. To speak her mind is to become shrewish, neurotic, and unde-
sirable. In this sense, *The Female Ego* inadvertently reveals the crucial
misogynist underpinning of the self-help genre that assumes neurosis as
the foundation for the feminine condition. In contrast, Steinem overtly
rejects *The Taming of the Shrew* as a romantic paradigm (in fact she sets up
the play as a cautionary tale, the counter-example to good heterosexuali-
ty). This rejection permits her a more subtle (yet at the same time more
disturbing precisely because it is less obvious) reinscription of the shrew.
Though her position, defined through the autobiographical voice that
Steinem takes up as author, and the narrative of the "cure" that she offers
initially seem diametrically opposed to that of Price, the "self-help"
methodologies formulated in both works return women to a private inte-
rior, ultimately silent and silenced space.

Steinem as an authorial voice that speaks the feminine is initially located outside the family (unlike Price): Steinem's book jacket describes her as "a writer and activist for almost thirty years." Steinem's association with *Ms.* and *New York Magazine,* described in the same paragraph, locates her voice as outside of the comfortable middle of feminine culture represented by *Glamour* (which situates Price). Further, Steinem is defined in terms of an exclusively public and professional arena, as "author," "editor," "lecturer," and "organizer." This definition transforms her home from the familial private arena that it constitutes in the description of Price into "'a stop on the underground railway' for international feminists" (book jacket, back flap). Price invites her readers to integrate the demands society places on woman "to value herself primarily as she is reflected in the eyes of others" (book jacket, front flap) with her "desire to desire" as Mary Ann Doane might say. Steinem, on the other hand, encourages her feminist readers to turn away from "a social revolution against sexual and racial barriers" towards "a necessary internal revolution of spirit and consciousness" (book jacket, front flap). Yet in each work, the moment of exchange, that which the author offers, that which the reader hopes to re-enact, is articulated through the concept of "self-esteem." Thus, though the authors' narratives are generated from two different positions, the positions that both offer the reader have uncanny similarities.

Hardly coincidentally, Steinem's emphasis on "internal" or "interior" life replicates the mechanism of "silencing" laid out by Price but more effectively masks the strategy as one that ultimately delegitimates women's anger. Like *Moonlighting,* Steinem rejects the shrew as a paradigm for romance, establishing feminist and literary credentials:

> The man who falls in love with a strong and independent woman and then tries to tame her, for instance, is not loving but conquering; a common romantic ploy ever since *The Taming of the Shrew.* (275)

By rejecting the obvious misogyny of *The Taming of the Shrew,* she "inoculates" her position against accusations that might categorize her theories of self-esteem as upholding traditional feminine values that privilege "interior life" over "external accomplishment." Steinem is thus able to offer another "romantic" paradigm that is defined as "not *The Taming of the Shrew*," but a different paradigm which she bases on the novel *Jane Eyre.*[4] The use of this novel serves to reconfirm Steinem's position as "culturally literate" (in Hirsch's terms) by adding another "classic" to her bibliography,

reassuring her culturally literate readers that her rejection of *The Taming of the Shrew* was not a blanket rejection of the canon of which this title is a member—that she nonetheless accepts the overall value of the canon, and the values of the class that this canon represents.

The question remains for those of us familiar with the debates that have raged around this novel in feminist literary criticism:[5] to what extent is *Jane Eyre* not a taming of a shrew? For certainly little Jane, whose "shrewishness" as a child brought down upon her the disapprobation of the adult world, is "tamed," transformed into a model of Victorian domesticity. Yet as a child, confronting the unjust accusations of her aunt, the orphaned Jane reflects, echoing Kate: "Speak I must: I had been trodden on severely and must turn: but how?" (Brontë, 68). Like Kate, Jane's fault is that she is passionate, and must speak the Passions of her heart—and so she does in a shrewish outburst. But afterwards she regrets her anger: "I would fain exercise some better faculty than that of fierce speaking—fain find nourishment of some less fiendish feeling than that of somber indignation" (Brontë, 70). Susan Price would approve of the education through which Jane evolves from a shrewish fiend into a paragon of feminine virtues. Jane finds "self-fulfillment," and once "self-fulfilled" she can then take up her role as wife. As Steinem explains, when Jane has "work, people she loves, and even—that great rarity for a woman—financial independence" she is then "ready" to "hear" love, "the sound of Edward Rochester's voice calling her name across the miles" (Steinem, 274). Thus Steinem's criteria (if we examine the list above) for self-esteem are very close to Price's definition of self-fulfillment. In Steinem's terms, echoing Price, we might say, "Kate never needed to be loved, she merely needed to develop self-esteem." Further, like Price, Steinem articulates "financial independence" in terms of "self-esteem" and "love" rather than economic necessity.

It is impossible to argue that women deserve neither self-esteem nor self-fulfillment—rather, the above descriptions should lead us to question whether either is possible in a world that neither esteems women, nor allows them the luxury of placing "self-fulfillment" at the top of their weekly shopping-lists. If Steinem commends Jane as a model heroine because as a child she refuses "to swallow angry words," Steinem herself, as a feminist activist and writer, and in her role as editor of *Ms.*, has devoted herself to giving voice to women's indignation. In turning inwards, in advocating the nourishing of the child within rather than a critique of the world without, Steinem is advocating a virtual silencing of women's anger, relegating her madwomen to the attic, her maniacs to the cellar. In holding

up Jane as her romantic heroine, Steinem forgets the tragic fate of Bertha
Mason, who, unable "to speak her mind," becomes the proverbial mad-
woman in the attic; she forgets that it is Bertha, Rochester's first wife,
whose death makes Jane's marriage and eventual happiness possible.

In Jane's journey from orphan to wife, she moves in Gayatri Chakravorty
Spivak's terms from "the counter-family set to the set of the family-in-law"
(267)—in other words, as an orphaned female, Jane has no status within
the law of patriarchy, but once married to Rochester she acquires his sta-
tus, his class standing. For Steinem this journey is a movement towards the
position of self-esteem—what Spivak aptly terms "the constitution and
'interpellation' of the subject not only as individual but as 'individualist'"
(263). Spivak continues: "If we read this account from an isolationist per-
spective in a 'metropolitan' context (*as does Steinem*), we see nothing there
but the psychobiography of the militant female subject" (264). However,
and this is Spivak's concern, "the 'native female' as such (*within* discourse,
as a signifier) is excluded from any share in this emerging norm" (264).
This exclusion is marked by, is signified through, the exclusion of Bertha
from Steinem's discussion, whom Steinem dismisses with a footnote send-
ing the reader to Jean Rhys' novel, *Wide Sargasso Sea,* a twentieth-century
novel in which Rhys rewrites *Jane Eyre* from Bertha's perspective. Yet if we
were to proceed in the direction suggested by this footnote, we would find
that Bertha cannot be so easily forgotten.[6] As Spivak comments: "*Jane Eyre*
can be read as the orchestration and staging of the self-immolation of
Bertha Mason as 'good wife'" (278). In the context of her own work,
Spivak speaks of this immolation in terms of "the history of the legal
manipulation of widow-sacrifice in the entitlement of British government
in India" (278). Extending Spivak's argument, we might say that to fail to
understand the story of Bertha's immolation as *intrinsic* to Jane's story is
to reproduce the "story" of feminine identity as though it had no histo-
ry—as though identity as a position existed independently of the
production of historically contingent categories such as nationality, eth-
nicity, race, class.

Not surprisingly, Jane too forgets Bertha. At an earlier moment in *Jane
Eyre,* when her journey towards "individualization" had only begun, she in
fact expressed a type of political consciousness as the oppressed member
of that class of women who find themselves without family or income in
the nineteenth century. At the age of eighteen, Jane comments: "(M)illions
are in silent revolt against their lot. Nobody knows how many rebellions
besides political rebellions ferment in the masses of life which people

earth" (Brontë, 141). We cannot but wonder if Bertha might have been included among these millions—for if not silent, she was certainly silenced, effectively hidden away in her husband's attic. We might also ask for whom does Bertha, a Creole whose wealth derived from the slave economy of the West Indies, whose money was in turn appropriated by Rochester as was his legal right as her husband, for whom does Bertha stand in except for those millions? Rochester's wealth, Jane's security and happiness devolve from the systematic reproduction of colonial exploitation which Bertha represents, leading us back metonymically to the dispossessed of the British Empire as Spivak explains above.[7]

At the novel's conclusion, having re-entered the middle class, secure in her newfound family, income, and capital, Jane is content to turn away from these silent millions, to lose herself in another kind of silence, that of a marriage "blessed beyond what language can express," words that Steinem conveniently drops when she quotes the passage that describes Jane's uxorious fulfillment (269). Rather, Steinem focuses on the next sentence in which Jane states: "To talk to each other is but a more animated and an audible thinking" (qtd. 269). But what sort of "talk" is this, a talk that is beyond language, that depends on the realization of the very fantasy of "romantic rescue" that Steinem rejects, the magical "other" who will become the lover's "life," who will create a bond that binds the lover and beloved "ever together," effacing the boundaries between self and other, the fundamental boundaries that make language, and speaking, necessary and possible? For Steinem the goal is still to be "my husband's life as fully as his is mine" (qtd. 269). Nonetheless, through the trope of self-esteem, she rewrites the romantic fantasy represented by *Jane Eyre* for a late twentieth century readership, reformulating the ideal of romantic fusion[8] in terms of a "self" that is somehow outside "my husband's life" even though the above quotation suggests that the couple shares only one life. This trope of self-esteem seemingly resolves the irresolvable conflict between the pursuit to individual happiness (to which Jane, dutifully aspiring to enter the middle class, gives herself over completely) and Steinem's need to speak for her class, that is, for women. Thus this trope aspires to efface the contradiction between a woman's status within her class and her status as a woman. Though Jane is a member of the middle class, enjoying the privileges thereof, her life is completely subjected to that of her husband. She has no "life" outside his. Jane's happiness is relegated to the private realms of domestic spaces, seemingly outside the political and public arena. As a twentieth century reader one must ask if in fact the price of her happiness

is her identity, or at the least her public identity, once she retreats into the home where the care of the crippled Rochester and his eventual offspring become her tasks. Even more importantly, it falls to Jane to sustain the "moral" center of this new if chastened family, through her newfound sense of a "privatized" self-esteem.

Ironically, in her recent emphasis on self-esteem, Steinem sends her reader back to a nineteenth century formulation of the feminine in which fulfillment and "value" are articulated exclusively within the private, personal arena. In her attempts to articulate a feminism that accommodates the "inner child," she assigns the woman the impossible task of both militating against an unjust public social order (speaking out), and preserving the traditional virtues of femininity defined in terms of a "moral guardianship" (Hansen, 52). This "moral guardianship" is formulated through a privatized "inner space" ("voyaging inward") associated with a nineteenth century conceptualization of the feminine as "passive nurturer" whose task was the cultivation of "affect" in "the sacred and personal realms" (Bloch, 247), represented through Jane in her final bourgeois haven at Ferndean, which she describes ironically as "a desolate spot" (454).

Neither Steinem nor Price articulates an economy of investment and return as part of their "cure." That is to say, neither emphasizes the price that women must pay in order to structure a system of value for themselves (a criterion of "self-worth") outside patriarchy and a patriarchal system of value. Sue Llewelyn and Kate Osborne, British "women-centered" therapists, in their book *Women's Lives* offer a less optimistic vision of the degree of autonomy that women can achieve. They comment that "women's individual, personal experiences are affected by the political position of women; and conversely, that social and political change can only come about through the actions of women re-establishing their personal power within their own lives" (Llewelyn and Osborne, 13). But they also caution that "a psychodynamic understanding alone is not sufficient to alter people's lives, since changes in individual consciousness cannot alone bring about the societal changes necessary for an improvement in women's social and economic position" (Llewelyn and Osborne, 13).

Their description of the case of a young girl, "Lucy," illustrates their more cautious approach, the way in which they both authorize individual experience but also "excorporate," appropriate for their own use, structures of knowing and evaluation that are grounded in larger more complex forms of social organization, conventionally categorized as "masculine."[9] Lucy, whose "wavy red hair" is not her only point in com-

mon with Price's "Judith," and whom Price would certainly classify as a shrew, felt that "her sense of self was on the verge of disintegration" (Llewelyn and Osborne, 21). Lucy's conflicts stem from her attempts to separate herself from an overbearing mother and family, but also from her attempts to carve out a life for herself in a culture that she finds "decadent," "corrupt," and "empty." She rejects the business world represented by her parents in which she can see nothing but "competition and greed" (22). Lucy reconstructs another future for herself through the help of her therapist and a relationship with another woman; however, this reconstruction is not a reconciliation. Rather, she must accept the necessary division between herself and her family, moving to another town, creating another set of friends, leaving behind even the woman whose affection initially helped her through the period of transition. This is not a story with a happy ending, but rather a story of survival in which there are costs as well as benefits.

In a certain sense, Steinem and Llewelyn and Osborne have many points in common in their emphasis on the interpenetration of private and public space; however, Llewelyn and Osborne create a discourse that works to produce a fragmented "story" of women's lives in which there is no redemptive moment, which might magically draw these fragments together in a fantasy reconciliation and union. Their methodology and position as therapists are grounded in the recognition of this fragmentation, unlike Steinem, who prefaces her book by saying: "We are so many selves. . . . What brings together these ever-shifting selves of infinite reactions and returning is this: There is always one true inner voice" (back jacket). In this inscription of the "one true inner voice," Steinem stabilizes the "ever-shifting" with a nostalgic reinvention of what Chantal Mouffe terms "the abstract Enlightenment universalist undifferentiated human nature" (38).

Llewelyn and Osborne refuse this redemptive moment of a "true inner voice" just as they refuse the romantic heterosexual paradigm that Price advocates directly and that Steinem reinstates through her discussion of *Jane Eyre.* Again Steinem apparently valorizes the homosexual couple, just as she legitimated the initial moment of "speaking out"; however, in a slight of hand she moves from the "correct" heterosexual couple of Jane and Rochester to an idealization of the "lesbian and gay" couple:

> But characteristics of love hold as true for lesbian and gay couples, who may be love's pioneers in our own time, as for Charlotte Brontë's

daring nineteenth-century lovers. As described by those who experience them, they are remarkably similar to the marks of high self-esteem. (Steinem, 275)

Heterosexual romance then becomes not only the model of all relationships between partners but the model of the relationship of the self to its "self" in the sense of a "self" that reflexively "esteems" itself.[10] Steinem's reduction of "many selves" to a single underlying "true" voice is paralleled by this movement from heterosexuality to homosexuality, from heterosexuality to a form of narcissism (self-esteem as self-love). All three positions—heterosexuality, homosexuality, narcissism—can be subsumed under the rubric of "love," as a unified category "Love" (as the final goal of the "inner voice," the indexical manifestation of "undifferentiated human nature") binds the Enlightenment ideal of universalism to a universal "sexuality" grounded in heterosexuality.

In stark opposition to this "fixing" of the heterosexual romance at the center of feminine experience, Llewelyn and Osborne advocate a practice that is not grounded through a hierarchy of affective "value" that might determine the feminine "self." Sexuality itself is "unfixed"; Llewelyn and Osborne refuse the contemporary dictum that "sexuality" is the defining movement of identity and subjectivity, negating, in Stephen Heath's terms, "Sexuality as imperative, the sexual fix" (*The Sexual Fix*, 51). From this perspective, Llewelyn and Osborne conceive of celibacy as an alternative that receives equal attention with heterosexuality and homosexuality. This displacement further fragments notions of feminine subjectivity as a place from which women might speak as "feminine" by decentering sexual identity as the defining moment of femininity. This category of celibacy arises, not out of a theoretical model, but through their encounters with women who chose deliberately to live in a way not accommodated by the binary heterosexual/homosexual opposition.

Llewelyn and Osborne recognize the fragmented nature of experience, and the inadequacy of theory (in its function as a unified narrative) to accommodate this experience. This recognition permits Llewelyn and Osborne to address the contradictory demands that construct the feminine position as the "female complaint" rather than effacing the contradictions that this fragmentation produces. They only provisionally occupy a position from which they speak as therapists without offering a narrative (a single itinerary as the "cure") that might arrest the proliferation of feminine identities that they encounter. The "provisional" nature

of their "cure" permits their "clients" to speak to them, and through them—the cure is not imposed upon the client as a kind of *de facto* silencing. Rather, the mutability and fragmentation of this voice, which is not silenced, produces not a cure, but a new position in a series of positions in which movement itself becomes the "sign" of subjectivity, of "voice." As Chantal Mouffe comments: "we are in fact always multiple and contradictory subjects, inhabitants of a diversity of communities . . . constructed by a variety of discourses and precariously and temporarily sutured at the intersection of these subject-positions" (44).

The Covergirl's Cover Story

If we return to *Moonlighting* we will see that this same fragmentation of the feminine position is recreated through the doubled demands of narrative and of spectacle. Within the narrative, Cybill Shepherd functions at least nominally as a speaking subject, but she also constitutes the spectacle of spectacles held in the gaze of the viewer. Shepherd, through her culturally produced position as a beautiful woman, and as a "star," offers an image of desirability, with which the woman viewer may identify but which she can never replicate. Through her function in the other discourse of a specifically feminine practice exemplified in her role as a covergirl, Shepherd "genders" the story for the feminine viewer. The feminine viewer, through her knowledge of and participation in feminine culture in which Shepherd (as opposed to Maddie) signifies as a lexical entry, is encouraged to read the show as a "feminine" rather than an "ungendered" subject identified by class alone. Thus the position of an apparent subject-beyond-gender that the program offers the feminine viewer has always already been recuperated as feminine. She is situated as feminine through the way in which Shepherd evokes a specifically feminine literacy. In this sense, the superficial parity of masculine/feminine relations generated by the overthrow of Petruchio's nominal position of superiority in the play's conclusion has already, before the episode even began, been recuperated by the star system of the show.

Stardom is translated through narrative and stylistic strategies (lighting, camera angles, etc.) that privilege Shepherd as the object of the camera gaze. Though Kate rages against Petruchio when he rails against women with cellulite during Act II of the "Atomic Shakespeare" episode, the standards that Cybill Shepherd represents contradict her denial. "What value

be a woman with cellulite on her thighs," states Petruchio. "When men be displeased with fat legs and fat hips, most of them would look better if be given fat lips," retorts Kate. Yet, in an era in which lipectomy or liposuction (an operation that uses a form of suction to remove fat from women's thighs and hips) is the most commonly performed cosmetic surgery (Kaufman, 70), on *Moonlighting,* on television in general, women with fat thighs and fat hips have no value.[11]

Mary Ann Doane comments that "(t)he cinematic image for the woman is both shop window and mirror, the one simply a means of access to the other" (33). This remark certainly holds true for the televisual image, which actually penetrates the home, which constitutes part of the trappings of bedroom culture, nail files, creams, lotions, and women's magazines—a fact that cable television attempts to exploit with home-shopping channels and late-night "info-mercials." In turn, Shepherd's image as a commodity in and of itself is replicated and circulated through different media. If tabloids tended to use the image as a narrative element (either in the Shepherd/Willis relationship, or the Shepherd success story), the women's magazine used her as an exemplary model, from whom readers can learn an appropriate technology of the image. A feature in the September 1986 *Harper's Bazaar* in which Shepherd is included as one of "America's 10 most beautiful women from 18 to 63" illustrates this tack. Cybill Shepherd functions as the covergirl, a position she enjoyed that season on a variety of magazines, from *Bazaar* to *Rolling Stone.*

The covergirl represents a coverlook that distinguishes itself from the "look" of previous seasons through the introduction of new products, often represented through the trope of "this season's colors." This look, which is constructed as difference, is not "new" in the sense of innovative; its "newness" as such is determined only by the shelf-life of the products that define it. In fact, in the attempt to encourage women to replace their baby pink lipstick with a new purchase, whether it be deep crimson or pale mauve, the fashion industry frequently engages in a process of recycling "looks" in which everything old becomes new again. Thus with the beginning of each season the consumer replaces one product with another in an endless cycle in which she may end up with a variation of the platform shoes that she donated to the Salvation Army a few years before. This look, its specificity as the minimal yet necessary difference, is achieved through product usage, detailed within the magazine. The products that have created this look are meticulously listed, usually on the same page as the table of contents, as the defining enunciative instance of that issue:

> On the cover: Cybill Shepherd, an all-American beauty, in fall's warm makeup colors. On lips, vivid red: Lumina Lipstick in Scarlatto. On eyes, Creme Kohl Eye Liner in Notte; Eye Pen Automatico in Grigio. On cheeks, Lumina Powder Blush in Smoke Rosa. From Princess Marcella Borghese's Imperiale collection.

> The Fashion: Playing a major role in this season's color palette: Camel in myriad textures and tones. Cybill wears it with flair, in a suede jacket, about $400, over a silk charmeuse blouse, about $125. Both by Calvin Klein Classification. For store information, see page 390. Pink cashmere scarf, Calvin Klein. Gold vermeil hoop earrings, about $300, Patricia Von Musulin. See Fashion guide for details and stores, next to last page. Hair, Suga of Suga Salon; makeup, Way Bandy. Photo by Francesco Scavullo. (10)

In a photograph that is only a large headshot, Shepherd is wearing eight hundred dollars worth of consumer items (the prices of which are all listed within the magazine). This does not include the price of makeup, or of anything not visible in the photograph (including underclothes, stockings, watch, shoes).

Bazaar devotes four more pages of photographs to Shepherd in the interior of the magazine—three head shots, and one cut off at the knees (388–391). All describe product and fashion usage in ways identical to the coverlook, while adding to the list of new products, new clothing items. The photographs that *Bazaar* offers the reader are, thus, always accompanied by a text that explains Shepherd's look in terms of product usage. In another text accompanying the photographs, Shepherd comments on her philosophy:

> "I'm convinced that my ability to hang in—to make things work for me—has as much to do with sheer physical endurance as with good old-fashioned stubbornness," says Cybill Shepherd. "And, as with everything else, you start with the body." (390)

Shepherd emphasizes discipline as a means of achieving a position of empowerment and it is her body that constitutes the mise-en-scène of this discipline.[12] *Bazaar* confirms the importance of the body, attributing the success of *Moonlighting* to Shepherd's ability to control her body as both the scene and the instrument of discipline, rewriting this control (in the passage below) as "control of her life and career." Ultimately however, emphasis is returned to Shepherd's function as image, a spectacle pro-

duced through a given set of media in the tradition of the Hollywood star
of the studio era:

> The show's millions of fans have no doubt that her character, Maddie
> Hayes, incorporates some of Cybill's own hard-won wisdom, her
> spunk and resilience, as well as hints of an appealing vulnerability.
> Cybill's *taken control of her life and career,* charting her own course
> back to the top. But she's maintained a perspective—a slightly cynical
> and ironic stance—that imbues her classic good looks with a surpris-
> ingly elusive quality reminiscent of the screen sirens of the '30s and
> '40s. (10, italics mine)

In spite of the fact that *Bazaar* emphasizes Cybill's "control," as though
her success were the result of an act of will on her part, the supreme test
of agency, the magazine inevitably returns to the issue of Shepherd's looks
as an "elusive" quality that is in excess of the body produced through dis-
cipline and control. The magazine article articulates a contradiction
between "looks" and product usage that can never be fully resolved—
Shepherd's image depends upon a moment of aporia that the rhetoric of
the magazine attempts to cover up through a regime of product usage—
as a cover narrative, a cover story. For example, in the descriptions of the
cover shot (cited above), we are told that camel will play a major role in
this season's palette, but that in addition "Cybill wears it with flair" (10).
It is this "flair" that represents the undefinable excess of the image that
cannot be recuperated through product usage, the gap between a tech-
nology of beauty and the trajectory of desire. Again, after perusing
another section of the same issue that describes Shepherd's beauty
regime, the reader receives a number of helpful instructions but must
also conclude that Shepherd is blessed with an athletic body, flawless skin,
and good hair, an excess that inscribes her image as different from that of
the reader (32). This discontinuity is the mark of a properly feminine
lack, the failure of the woman to fully identify with an image that can
never be entirely her own, her "self." This moment of lack is effaced by an
agenda that promises to transform looks into accomplishment through
product usage and discipline. Shepherd's looks would come to nothing,
could not function as capital, without a discipline, a technology, of mar-
keting and display.

The importance of the women's magazine lies in its formulation and
circulation of a strategy that promises to transform looks into accomplish-
ments through consumerism. Women's magazines suggest that to assume

the appearance of the executive woman (rather than occupying her position) is the sign of success—they attempt to offer an agenda that resolves the contradiction between appearance and action, between gender and class, that does not compromise the woman's position as feminine, as an object-to-be-looked-at, the object of the masculine gaze. Consumerism in the women's magazine suggests a narcissistic economy of investment that is not, at least in the first instance, oedipalized—thus a narcissistic position of feminine enunciation that is not initially heterosexualized. In other words, within the women's magazine, feminine narcissism is not in the first instance inscribed through the masculine gaze. Rather the relationship with the image as such is primary. Psychoanalyst Eugénie Lemoine-Luccioni indicates the possibility of such a relationship evolving from the primary relationship with the mother.[13] The infant at a stage in which she has no control over her own body identifies with the image of the Other, the complete body of the mother, as though it were her own. Because within French (and United States) culture the position of the Other is almost inevitably occupied by a woman as the mother, the female child, unlike the male child, does not rearticulate this overidentification with the image of the Other through the recognition of sexual difference. Rather than abandoning her overidentification with the image, she reinvests in it as though it were her "self." She misrecognizes it as herself. Eugénie Lemoine-Luccioni suggests that the little girl:

> substitutes for the person of the mother crucial in the *fort/da* game her own person figured by her body in the specular image;[14] an image that the mother's look brings out, "causes."[15]

The "fort-da" refers to a game that Freud observed as part of a child's routine in which he throws a spool and then brings it back towards himself, drawing on a string to which the spool is attached. As he repeats this motion he articulates the words *fort/da,* here/there. Freud theorizes that through this repetition the child attempts to assert some sort of control over the seemingly inexplicable absences of his mother. Lacan sees this moment as exemplifying the fundamentals of language in which the recognition of loss, the absence of the object, is necessary to the recognition and naming of the object as such. That is to say, only an absent object can produce the sign, which signifies both the object's absence and its potential return. In this sense, language can only be generated through the recognition of loss, which within patriarchal society is rewritten as "castration"

sur l'après coup, after the fact, through Oedipalization and the process whereby the phallus becomes the privileged signifier.

Here Lemoine-Luccioni would seem to suggest that there are alternative modes of reinscribing this initial moment of loss, in which the phallus is not necessarily the privileged signifier. The "inverted" *fort/da* to which Lemoine-Luccioni refers above has as its symbolic stakes the entire body, a body subject to hysterical fragmentation and paralysis precisely because in its origins it is grounded in a fiction based on the subject's lack, its inadequacy to the image that it (mis)takes as its own (48–85). The look of the mother transfixes the subject as object, but if that look is interrupted, if the mother does not guarantee the daughter as her image, the girl, out of frustration, so to speak, turns to the father (87).[16] Lemoine-Luccioni describes this process as a "rocking in the image" (85).[17] Thus, though the gaze of the father is the guarantor of entry into the symbolic in the last instance, implied in the notion of rocking, of the seesaw effect, of the fort/da itself, is the possibility of another entry into the symbolic in which it is the relationship to the mother that is primary.

Lemoine-Luccioni's description of feminine narcissism is suggestive within this analysis because (as a culturally contingent rather than a universally inevitable topology) her account rehearses the way in which patriarchy reinscribes the possibility of other libidinal economies within its domain. In *Moonlighting,* the *va et vient* (the coming and going) between representation and narrative that defines the figure of Shepherd recalls the topology of mother/father/child offered by Lemoine-Luccioni. The psycho-sexual configuration that defines Shepherd within the narrative of the *Moonlighting* series permits feminine narcissism as a regression to a pre-oedipal libidinal relationship with the image by containing it through narrative structure, as the representative of language and the fully oedipalized subject.

The central narrative conflict confirms the dominance of the couple as the sign of heterosexuality and, ultimately (especially within the "Atomic Shakespeare" episode), of patriarchy. Thus, *Moonlighting* underlines the persistence of the romantic paradigm, in spite of a deep suspicion of its cultural stakes, represented by Maddie's reluctance to accept her role in the David/Maddie couple, or in any couple, for that matter. Nonetheless, Maddie, after several years of acrimony, at the end of the show's second full season, "gives in" to David, just as the Harlequin heroine succumbs to her hero. (This episode, which concluded the 1986–87 season, garnered the series' highest rating, 33.4, and audience share, 48 percent [Williams 99,

note 18].) In both cases this acquiescence takes the form of a sexual seduction in which the woman submits to the man's advances. This seduction, however, has already taken place through the camera as the representation of the masculine gaze, which fixed Shepherd as its object in her role both as television star and covergirl.[18]

Some viewers recognize the "fake" feminism of the show and often react with hostility. J. P. Williams remarks that viewers "who dislike Maddie's character tend to focus on two points: their dislike for Shepherd and/or their disapproval of Maddie Hayes's appearance" (Williams, 93). As part of a larger audience study, Williams quotes a viewer who rejects Shepherd's image:

> "I believe that the program perpetuates an unrealistic image of professional women—that they wear open blouses to show cleavage, have beautiful long hair and a wardrobe that is extravagant. It also reinforces the idea that woman must be charming, manipulative and always rescued by a male." (93)

Shepherd's image, which she offers the feminine viewer as television star, and as covergirl, indicates (implicitly through the televisual image, explicitly through the directives of the women's magazine) that the feminine woman must constitute herself as an image in a way that permits the reinscription of the masculine gaze as voyeur. This mechanism explains how men are able to read women's magazines through a voyeurism that reinscribes feminine display (offered initially for feminine consumption) for their own pleasure.

It would be a mistake to see the masculine gaze as the defining instance of feminine narcissism. The fact that he can see her as a reflection of his pleasure does not deny the validity of the first term as a possible site of power and pleasure for her, but rather underlines the effect of oscillation described by Lemoine-Luccioni above. An identity formulated through feminine narcissism does offer women a program of empowerment within a consumer society, as is demonstrated by Shepherd's program of self-discipline. This is not the only process of empowerment available to the woman but it is one that preserves her identity within the heterosexual couple. This is not to say that, within Lemoine-Luccioni's account of feminine subject construction, other positions are not possible, but rather that an initial position of narcissistic libidinal investment is easily reinscribed within a patriarchal structure. The importance of narcissism as a libidinal

strategy is that it defines the feminine through identification with the Other as mother, permitting (but not obliging) the woman to function within the established norms of heterosexual behavior, and foregrounding sexual difference.

The importance of staking out an arena of properly feminine narcissism[19] can only be understood through a recapitulation of Sigmund Freud's own analysis of narcissism, which rehearses the process whereby feminine pleasure is fixed by the masculine gaze. Initially, Freud offered a general definition of the term that still corresponds to popular usage today:

> The term narcissism is derived from clinical description and was chosen by Paul Nacke in 1899 to denote the attitude of a person who treats his own body in the same way in which the body of a sexual object is ordinarily treated—who looks at it, that is to say, strokes it and fondles it until he obtains complete satisfaction through these activities. (14:73)

To make this analogy for the feminine subject within popular culture, let me quote a 1987–1988 high saturation ad campaign (print and media) featuring Cybill Shepherd for hair dye.

> See the Preference difference. Look at the rich, translucent hair color, the subtle shading only L'Oréal's exclusive colorants can give you. Feel healthy-looking hair. That really is a difference. Now say I'm worth it.

This text exemplifies the treatment of feminine auto-eroticism, which can be spoken to the degree that the woman is addressed, interpellated, as a narcissistic subject that is contained through the masculine gaze and consumership. Feminine narcissism as a polymorphous auto-eroticism (the pleasure in feeling "healthy-looking hair"—or some other, any other, part of her body marked out as such by some consumer item) affords the woman the opportunity of constructing (or perhaps more accurately buying) a position of autonomy in which she takes control of her imageness as a source of pleasure for herself.[20] The fact that she must construct herself as an image ("see" the difference, or be "healthy-looking" rather than simply healthy) leaves open the possibility that this image will be appropriated by the masculine gaze. Masculine appropriation is not the only outcome for the work of grooming—capturing the masculine gaze is not the exclusive nor even the dominant purpose of grooming. The L'Oréal ad emphasizes the pleasure the woman can have (as a form of auto-eroticism) in the

process of grooming as an activity in and of itself, independently of her relationship to the masculine gaze.

The grounding of the pleasurable image in product usage ("Only L'Oréal's exclusive colorants can give you") positions feminine narcissism within a consumer economy. The possibility of the woman taking pleasure in herself, for herself, is circumscribed by the necessary contingency of the masculine gaze and the demand that she function as consumer. The ad illustrates what Mary Ann Doane has described in the classical Hollywood cinema as "the overwhelming intensity of the injunction of the feminine spectator-consumer to concern herself with her own appearance and position—an appearance which can only be fortified and assured through the purchase of a multiplicity of products" (30). Here, then, feminine narcissism upholds a consumer economy in which the feminine subject must reproduce herself as image on a daily basis through a myriad of interconnected products (Shepherd's look in the ad is produced through the use of makeup, etc., in addition to hair color, if in fact she uses it). Thus, the use of a feminine pronoun in the passage by Freud cited above ("a person who treats her own body as a sexual object") is somehow unexpected, even jarring; however, within the context of the ad, feminine auto-eroticism becomes permissible, desirable, and finally a moment completely within the range of the "normal."

"Now say" in the L'Oréal text gives the woman permission, in fact commands her, to speak, to enunciate value at the price of purchasing a product, or of re-producing herself as image. The woman is accorded access to language to the extent that she also offers herself as an image. Consequently, to say "I'm worth it" implies the reverse as well, that the worth of "me" is measured by "it," the consumer-constructed body. This moment of enunciation recalls Lemoine-Luccioni's description of the construction of the feminine subject (see above) as dependent upon the female's overidentification with the image of an Other (initially the mother, here Shepherd) as though it were her own, in which her value is guaranteed by that overidentification with the image.

This question of value cannot be resolved without a more evolved conceptualization of narcissism. Though it is difficult to imagine an account of feminine auto-eroticism similar to the description Freud gives above, it is not impossible. Freud's theories on the development of narcissism, however, apply only to the masculine position. For Freud, narcissism, more accurately secondary narcissism, is predicated on the recognition of anatomical difference between the male child and the mother, and an

overidentification with the father, who becomes the object that is intro-jected as the ideal ego. In other words the daughter cannot identify with the father, because that defining anatomical difference is absent. Thus her desire for the father becomes her destiny rather than a narcissistic moment in which she imagines herself as her father.[21]

As we have seen above, the itinerary of the female child must be con-ceived differently as an overidentification with the image of the mother as not-the-mother, but as her "self." Further we have seen that there is always a gap, a lack, that is inscribed within the consumer image as an excess that prevents full identification between the feminine subject and image (the gap between Shepherd's "blessings" and the beauty techniques the maga-zine extolls). Thus, I would suggest that it is not her body that is the object of narcissistic investment but the rewritten body of the mother, to which the feminine subject is never fully adequate.[22]

This is not to say that Lemoine-Luccioni's account of feminine identifi-cation should be taken up as a new "master" narrative—rather it offers a viewpoint, a perspective, another way of understanding the profound ambivalence, the fascination, and the terror with which the female con-sumer embraces feminine culture. We may be witnessing within feminine culture the intensification of this ambivalence, in which feminine culture is both embraced and rejected, in the "post-feminist" era, or more accu-rately, in the era of "third wave" feminists, in Naomi Wolf's terms. It cannot be mere coincidence that the importance of this new narrative is associated with a historical moment, characterized by several generations of women desperately seeking "something else besides *my* mother," in which this something else may be "imaged" through the reconstruction of identity through product usage.[23]

Within the above context, the most accurate analogy to feminine nar-cissism, or rather its rearticulation within the women's magazine, is suggested by Freud's analysis of melancholia—not his analysis of mascu-line narcissism. In melancholia the ego protects itself against the loss of the love object through introjection of the lost object as the ego ideal. Object-libido is withdrawn from the object and re-cathected within the ego as the ego ideal (Freud, 14:237–258). In simple terms, we might roughly say that the subject's investment in the lost object detaches from the object itself, investing instead in an idealized internalized construct that replaces the object as such. Here, it might be useful to think of feminine narcissism as predicated not on ego-libido but on re-cathected object-libido—that the lost body of childhood (the object of the "inverted" fort/da) is introjected

as the ego ideal. Feminine narcissism grounded in product usage would offer the possibility of renarrativizing the ego's original relationship with the image of the other as the fiction in which the subject misrecognized the complete body of the mother as its own. From this perspective, product usage might be considered a fetish activity, the momentary retelling of the narrative of the lost body as a body completely adequate to itself. As Mary Ann Doane notes, "(w)hat we tend to define, since Marx, as commodity fetishism is in fact more accurately situated as a form of narcissism" (32).[24]

The formulation of an auto-erotic discourse, reinscribed as an erotic discourse through the masculine gaze, would then constitute a moment of secondary elaboration. That is to say, the auto-erotic discourse produces a "cover story" that makes this particular libidinal economy compatible with the demands of a patriarchal structure that constructs desire as by definition masculine desire. The subject's ambivalent relationship to the consumer-constructed body is a tale retold in which the lost body is mourned as well as cherished. The introjection of the lost body as ego ideal enables the ego to treat itself as an object, to direct against itself the hostility it feels towards the object that through its loss has demonstrated its inadequacy. Implicit in the process of mourning is the anger that the mother's abandonment, if we return to our original fort/da discussion, inspires in the child who must come to terms with this loss if he or she is to speak, to be constructed as a subject within language. The metaphors of battle and attack that the media mobilize against the female body would then be explained as the articulation of an ambivalence towards the introjected body. "I don't intend to grow old gracefully . . . I intend to fight it every step of the way" comment models in another high saturation media campaign of the late 1980s for facial products by Oil of Olay. Here product usage becomes a weapon—a point of attack against the "it" of the body that has overwhelmed the "I" of the ego.[25] The significance, then, of a feminine narcissistic structure patterned on the structure of melancholia hinges on its ability to explain the regime of loss implied in the image of the body offered the feminine consumer.

This structure also suggests the conservative or reactionary function of this libidinal trajectory. As discussed above, this narcissistic structure complements rather than negates oedipalized libidinal structures in which feminine pleasure is articulated through the masculine gaze. Freud points out in "Mourning and Melancholia" that "people never willingly abandon a libidinal position" (14:244). Narcissistic introjection enables the feminine

subject to retain the masculine gaze as a point of legitimation, preserving beauty as the guarantor of femininity and difference. Lemoine-Luccioni remarks that:

> A woman is beautiful by definition, because if she knows herself or declares herself to be ugly, she is no longer a woman. This is in any case what one hears in analysis, where these statements do not generally appear one without the other. (151)[26]

For the masculine subject, the oedipalized structure with the gaze as the point of adhesion remains intact, a position that Freud himself recapitulated in his own work.

Freud recognized feminine narcissism only to the extent that it operated as the reflection of a masculine ego-ideal, rehearsing the process whereby feminine pleasure is rewritten through the masculine gaze:[27]

> Women, especially if they grow up with good looks, develop a certain self-contentment which compensates them for the social restrictions that are imposed upon them in their choice of object. . . . The importance of this type of woman for the erotic life of mankind is to be rated very high. Such women have the greatest fascination for men, not only for aesthetic reasons, since as a rule they are the most beautiful, but also because of a combination of interesting psychological factors. For it seems very evident that another person's narcissism has a great attraction for those who have renounced part of their own narcissism and are in search of object-love. (14:88–89)

French critical theorist Sarah Kofman concludes that Freud pursued a "path reassuring for man's narcissism" in which the woman is treated as though "she cannot get along without a man, if she is to be 'cured'" (66). Within a Freudian topology, there is then no articulation of feminine narcissism except as the projection of a fantasy of masculine narcissism.[28] The New Femininity grounded in narcissism as product usage mimics this process, appearing to construct a femininity that exists solely to confirm the projection of the masculine gaze but that in fact also offers women a libidinal return on their investment that is in excess of the pleasure they may or may not receive as the object of the male gaze.

Within this new paradigm, represented by such women's magazines as *Self* or *Working Woman*, shopping is retained as a prototypical feminine activity, but it is represented differently. Shopping is no longer the recre-

ational activity of the bored housewife who must incarnate her husband's wealth and success. It becomes the means through which a woman externalizes her "self-worth" as properly her own. Similarly, the magazine reader is encouraged to reinterpret the fit body as a sign of feminine self-esteem, a mark of self-control and autonomy rather than submission to the gaze of a masculine subject. This new position of privilege is one of contradiction; it depends not on the generation of new models of femininity but on a rereading of old models. The old model, the pre-feminist model, is retained, in fact reinvented, replacing the feminist model of a woman-centered culture that rejected a femininity grounded in patriarchy and consumerism. "Post-feminism" in the terms of the culture at large, including the fashion industry, becomes a way of integrating certain demands by women for economic autonomy without rocking the boat. As the quotation that I discuss in my opening chapter states, for the contemporary woman, "self-worth" does indeed "reside" in the body. The body becomes in this sense a contested terrain, attacked from within and without, the cite at which both victory and defeat are negotiated.

Lemoine-Luccioni's work also indicates why the search for "ego-sense" and "ego-strength" as defined by women such as Price and Steinem is doomed to failure.[29] Lacan in his discussion of language explains that the "ego, whose strength our theorists now define by its capacity to bear frustration, is frustration in its essence" (*Écrits*, 42). This is because the ego is a construct, in which the subject engages "le monument de son narcissisme."[30] To build up this monument, this fiction, does not "strengthen" the subject, who is perfectly aware of these fictions which, in Lacan's words, the subject "ends up by recognizing that (this) being has never been anything more than (a) construct in the imaginary and that this construct disappoints all (his) certainties" (*Écrits*, 42).[31] Rather, it frustrates the subject. Lacan elaborates in a footnote: "This is the crux of a deviation as much practical as theoretical. For to identify the ego with the discipline of the subject is to confuse imaginary isolation with the mastery of the instincts. This lays one open to errors of judgement in the conduct of the treatment: such as trying to reinforce the ego in many neuroses caused by its overforceful structure—and that is a dead end" (107, note 10). In the context of Price's and Steinem's theories, Lacan's statement seems to suggest that to strengthen the "female ego" is to increase rather than to lessen the gap between the "worth," the monument that the woman constructs for herself, and her position within the fabric and texture of contemporary society: this could only lead to psychosis (in which the woman persists in

denying this "gap") or to neurosis, in which the woman is governed by the anxiety that at any moment her fiction of "worth" will be revealed for what it is, a fiction. The following chapters offer a discussion of the ways in which contemporary feminine culture generates "fictions of worth" that women borrow and reconfigure, with varying degrees of success, attempting to speak for themselves, to construct structures of value that might authorize a feminine voice that is neither psychotic nor neurotic.

3

"A Dream of Thee"

The Erotic Gag: Reading the Category Romance

Crucial to understanding the problem of speaking the feminine is rec-
ognizing the centrality that the romance occupies within feminine and
feminist culture.[1] Anne Cranny-Francis explains that "it is romantic fiction
which foregrounds the central problematic of many feminist generic texts,
the nature of female/male relationships in a patriarchal society and the
constitution of the gendered subject" (178). At the same time, she ascer-
tains that "feminist rewritings of the romance are not easy to find" (178).
This paradoxically silent centrality comes as no surprise: if, as the previous
chapters suggest, *The Taming of the Shrew* operates as a shadow text within
the genre of the romance, feminists who wish to "speak out" might well be
forced to abandon a genre grounded in the silenced feminine.

Like Gilbert's and Gubar's "madwoman in the attic," the shrew is a dis-
turbing figure who serves to remind us, should we care to listen, that the
romance as a genre is built upon a silencing of the feminine voice—a trans-
formation of the feminine into a voice that speaks not for itself but for its
"master" as a subjected voice. "Silence" as a defining trope within feminine
culture could only produce the paradox to which Cranny-Francis alludes
above: if the purpose of the romance is to legitimate feminine experience as
Lillian Robinson claims, it must also operate as the legitimation of the
silence that the woman accepts as her lot. The principal object of the
romance might be best summarized as the transformation of this loss of
"voice" into a dream of love and happiness. The primacy accorded the
romance as the articulation of this "dream" within feminine culture is per-
haps one of the most striking symptoms of the "subjection" of the feminine

as a silencing of her voice; the romantic tale itself, as a feminine genre, almost inevitably seeks to define the feminine and feminine pleasure in terms of silence.[2]

Because the romance is indeed so crucial to feminine identity, it rapidly became a central area of research within feminist scholarship.[3] Though initially rejected by feminists as a hegemonic form of social regulation (see Ann Douglas, Lillian Robinson), as "a representation . . . of bourgeois, patriarchal ideology" (Cranny-Francis, 183), feminist scholars of the 1980s, in a laudable and necessary move to recognize the "value" of feminine experience, sought to delineate the means by which the romance and the category romance in particular might offer moments of resistance to its readers.[4] Thus, among others, Tania Modleski argues that the repetition inherent in the formula of the series romance produces a fantasy of control and revenge (*Loving with a Vengeance*). Janice Radway posits that the romance hinges on the fantasy of a nurturing feminine man, and that the act of reading itself becomes an appropriation through which the reader stakes out a space for her "ideal self" (*Reading the Romance*). Leslie Rabine sees the series category romance as articulating a moment of reconciliation between the domestic feminine and a new corporate feminine. According to Rabine, the novels create a mise-en-scène in which a system of domestic "values" is imposed on the corporate world represented through the male hero (see *Reading the Romantic Heroine*). Carol Thurston associates these novels (category romances in the most general sense) with the development of a new feminine eroticism that has encouraged women to express their sexual desires more freely, thus to construct themselves as agents as well as objects of desire (*The Romance Revolution*). Indeed there are always points in any popular text in which the hegemonic narrative "catches," creating micro-tears in its fabric, opening up space for the generation of other narratives that unravel the weave of the dominant text. However, in focusing on these openings, these authors have ignored the figure of the silenced shrew, a figure that haunts both the romance and the critical literature that it has inspired.[5]

The story of the silenced shrew is the occulted narrative of the romance, in which the shrew operates as a "constituent lack" or "structuring absence,": "the unsaid included in the said and necessary to its constitution. In short, to use Althusser's expression "'the internal shadows of exclusion'" (the Editors of *Cahiers du Cinéma*, 496). The romance hides its lapses by announcing the inevitability of the heroine's fate, inherent in the very definition of heroine: she will be singled out as exceptional by an

exceptional man. The seeming inevitability of this happy destiny masks the fact that to be singled out as heroine, she must be positioned as silent, a silenced shrew. The figure of the silenced shrew ties the romance to a masochistic scenario that has in turn become the structuring absence of feminist scholarship. I propose that the reinscription of the shrew as an "internal shadow of exclusion" within both feminine and feminist discourse surrounding the romance can serve to reposition existing readings of this genre, as a process of revision rather than rewriting.

Thus it is not my purpose here to duplicate the excellent scholarship that already exists on the romance. Rather, in the following discussion, I wish to emphasize a number of issues to which my discussion of the shrew figure has led me, in particular the way in which the fantasy of a nurturing male, which so many scholars associate with the romance, functions in terms of a masochistic scenario at the heart of the romance. In order to discern the operation within the romance that produces this seemingly contradictory scenario, it is first necessary to understand the role that silence and silencing plays in the articulation of the romantic narrative. It is this silencing of the feminine voice that upholds the repetition of the regime of reading that characterizes the romance, a regime that in turn is based on a systematic misreading of the figure of the masculine hero.

It cannot be mere coincidence that the feminist critic Tania Modleski sees the issue of misreading as critical to the narrative regime of the Harlequin romance. She argues convincingly that the reader, in her identification with the heroine, is led to misread the hero's abuse as a sign of love (*Loving with a Vengeance*, 40–44). The romance reader, then, borrows Petruchio's argument that he abuses Kate because he loves her, in order to "read" the hero's behavior as "love" within the context of the romance genre. Janice Radway offers a similar argument in *Reading the Romance:* "The romance narrative demonstrates that a woman must learn to trust her man and to believe that he loves her deeply even in the face of massive evidence to the contrary" (149). Learning to "trust," continues Radway, is somehow analogous to learning "how to read male behavior successfully"—or, to borrow again from Radway, "correctly" (149). However, from a strictly literary and perhaps even legal perspective, it would seem that learning to trust a man is learning how to read *incorrectly,* that is to say disregarding "massive evidence"—accepting the oxymoronic proposition that abuse signifies love.

Though Modleski and Radway argue that the romance prototype encourages the reader to misread, or rather to "read" (within the genre's

conventions) the hero's verbal and physical abuse as the sign of his love, they do not explain how the specificity of language as a signifying process is transformed. The reader invests in "reading" as an identificatory process in which to read is to be positioned within a scene of fantasy. The reader does not resolve the enigma, the riddle, of the narrative, since its resolution is always a given. This "given" is nonetheless a "mistake" in that this resolution depends on a misreading of the abusive male as heterosexual hero within the genre. A hermeneutic engagement in narrative is subsumed by the reading process as identification with a specific fantasy, or more accurately with the scene of fantasy itself. This process of reading denies the logic of cause and effect (in which abuse, effect, would be caused by hatred, disdain, self-interest, but certainly not "love") that governs the narrative generated by an unresolved enigma. Because, within the category romance, the scene of desire is signalled as the site of misreading (in which a logic of cause and effect is inoperative), the referential function of language within the context of the category romance is de-emphasized.[6] Rather, language functions primarily as the means of designating the space of fantasy, the material "stage" on which fantasy as a hallucinatory moment of identification will play itself out. The reading process is significant as activity, as experience, rather than as signification, or communication, in the technical sense. Its narrative form is emptied of meaning, becoming experience. This experience itself might be most accurately thought of as analogous to a concept of performance, with actor and audience conflated within the single position of reader, in which reading constitutes the displaced performance of the fantasy itself.

Cranny-Francis points out that "in these contemporary romances the romantic plot itself is the focus of the text" (178). She contrasts the contemporary romances with novels such as *Jane Eyre* and *Wuthering Heights,* because unlike the above, "modern romances. . . . do not deconstruct the patriarchal marriage or the erotic relationship which is its initial phase. Instead they fetishize it; the relationship itself is the focus of the narrative" (183). Here what I am suggesting is that the phenomenon characterized by Cranny-Francis as "fetishism" might be more usefully conceived in terms of identification from a psychoanalytic perspective—in which the reader identifies with the act of reading itself as the scene of desire, of fantasy in the psychoanalytic sense.

To borrow Constance Penley's formulation, fantasy might be most productively understood here in terms of a "subject (*who*) participates in and restages a scenario in which crucial questions about desire, knowledge,

and identity can be posed and in which the subject can hold a number of identificatory positions" (480).[7] Penley uses the definition of fantasy as a staging of desire to counter the arguments of Radway and others who see femininity as defined in terms of a pre-Oedipal regression. Here I pursue a different avenue of inquiry in which I will use this conceptualization of fantasy to underline the contradiction inherent in an account of subjectivity that privileges the prelinguistic as the founding moment of feminine identity. In this argument I substitute the term prelinguistic for pre-Oedipal since the term Oedipal assumes a masculine subject as the norm. The usefulness of Penley's formulation of fantasy is that it neither limits description of feminine subjectivity to the prelinguistic nor precludes the restaging of prelinguistic fantasies. (For a fuller discussion of the prelinguistic and feminine subjectivity, see below.)

Of particular importance to my argument are two characteristics of fantasy among the six isolated by Penley. "Fantasy is not the object of desire but its setting" (Penley, 493, note 2). "Although the subject is always present in the fantasy, she or he may be there in a number of positions or in a de-subjectivized form, that is, 'in the very syntax' of the fantasy sequence" (Penley, 493, note 2). Here I am suggesting that the romance reader is engaged at a primary level by the process of reading itself as repetition, thus in precisely a "de-subjectivized form" manifested as "the very syntax" of the fantasy sequence in which the setting of the scene of repetition is as crucial as the content of the story. In terms of the romance (it is hardly possible to generalize using this formulation of fantasy) it is precisely this moment of de-subjectivization that is suggested by the reenactment, and its repetition, of misreading. The inscription then of the reader (as mis(s)-reader within the text) is a reinscription of the scene of desire within the formal narrative of the heterosexual couple—in which the joining of hero and heroine itself is a product of misreading and rereading, a process that is reenacted again and again each time the reader opens a novel and discovers the same scene.

The defining feature of the genre is this method (generated by the repetitive nature of the formula) by which the category romance is read.[8] Through the repetition of a basic plot paradigm, the meaning of the story is precisely the creation of a fantasmatic mise-en-scène which enables the playing out of the fantasy, the repetition of "the unchanging pattern of the dream,"[9] in Harlequin tip sheet terms.[10] The reader knows the story; she does not read to resolve an enigma, but rather to experience "reading" (and "misreading") itself. The story no longer says, or speaks, but merely

repeats. A feminine regime of enunciation as repetition figures the speech-lessness to which woman must be reduced in order that the man take on his role as the master of the semiotic process, of language as the produc-tion of meaning through difference. The woman as reader is silenced in much the same way as is the shrew or the heroine of romance, through her pleasure in a fantasy of misreading. Here, however, fantasy might be best conceived in terms of a layering and proliferation of scenarios, a palimpsest rather than the reenactment of a single closed scenario that reins in and defines the narrative moment.

Thus, this fantasy grounded in misreading is also a fantasy of repetition in which the pleasure of reading lies in the reader's ability to repeat the fantasy as much as in the fantasy itself. In this sense the reading of category romances is linked to the formal repetition that Freud identified in the "fort-da" game.[11] Repetition becomes a paradigm that permits precisely a fantasy of "control" that negates meaning as the tyranny of absence/pres-ence, while precisely confirming its reign of terror.[12] This repetition as a fantasy that is outside difference and that confirms difference as such is expressed in terms of the category romance "plot" through the articulation of a narrative climax that represents a moment of *undifferentiated erotic fusion* between hero and heroine. I use this term to suggest how the moment of heterosexual coitus is rewritten as a metaphor for a state beyond language as "differentiation."[13] This is not to say that the reader stops reading in a literal sense (i.e. loses the ability to differentiate linguis-tically); rather it is the fantasy of such a transformation that is invoked by the category romance. Thus the narrative economy of the category romance is regulated by an economy of reading pleasure that demands a slow mounting tension culminating in the moment of undifferentiated erotic fusion—a nonspecific sexuality of total identification between hero and heroine that is never explicitly described as such.

Even in the recent more explicitly erotic versions of the romance for-mat, the actual physical details of heterosexual coitus are obscured, even rendered unidentifiable, through the conventions of the formula that dic-tate that the act be described in a global nonspecific vocabulary. Thurston distinguishes between the "sweet contemporary series romances" in which sexual activity is not explicit but implicit, in which for example the hero-ine is inevitably a virgin, and the "sensuous or erotic series romances" in which sexuality is more explicitly described and the heroine is more aggressive in the pursuit of her own pleasure. Harlequin, notorious as the first publishing house to mass market "sweet romances," introduced a

number of erotic lines in the 1980s such as Harlequin American Romance (1983) and Harlequin Temptation (1984).[14] For the purposes of this analysis, I would like to stress that the paradigm of nonspecific erotic fusion is one that is transferred without difficulty from the sweet romances to the erotic romances. In neither format does the sexual act constitute a series of specific physical gestures and physiological reactions; rather, it is always articulated as a transcendent moment. The comparison to other forms of traditional pornography renders striking the lack of any factual discussion or display of sexual technique in both sweet romances and erotic romances.

Barbara Delinsky's treatment of sexuality in *Bronze Mystique*[15] is characteristic of the more erotic category romances. The heroine Sasha, herself a romance writer, meditates on this "moment"—which she has "written," but which also appears to "write" her own future with the hero:

> Sitting back in her easy chair in the corner to the left of her desk, Sasha reflected on the cataclysmic scene she'd written. From page one it had been inevitable. The hero and heroine had been fascinated with each other, intrigued, aroused. Neither of them had ever experienced such instant and overwhelming attraction before, and it had been only the force of it all that had, ironically, held them off so long. But it had to be. The craving of their bodies went hand in hand with a mental craving that cried out for fulfillment—a oneness that, when it came, was devastatingly joyous and incredibly electrifying. It was a true merging of bodies and souls, a mind-altering experience, taking man and woman and producing far more than simply the sum of their parts. It was, quite breathlessly, magnificent.
>
> Sasha closed her eyes and took a long breath. Her body tingled. It was Doug's face she saw. Her hero? She wondered. (154)

The "book" that Sasha writes becomes of course the story of her relationship with Doug—and thus something that must be reincorporated into the private arena, hence never published. Rather it becomes the "bible" of their erotic union, the behavioral guide that regulates their relationship:

> *Bronze Mystique* never made it to press. On the day of their wedding Sasha gave it to Doug, who promptly bound it in leather and set it on the nightstand by their bed to be read only on special occasions when they were alone, together and naked. It became quickly dog-eared, for he found himself rereading various portions on the sly from time to time,

> just as she did. It was a diary, a treatise on trust and understanding and patience, as well as on jealousy and suspicion and fear. (Delinsky, 249–250)

However, as readers who have also read the book "on the sly" so to speak (because for any number of reasons, whether we be academics, house-wives, working mothers, it is something that we ought not to read, a guilty pleasure), we know that *Bronze Mystique* is not a diary or a treatise. Rather, one of the fantasies endemic to the category romance is that such a book might constitute simultaneously the more legitimate forms of diary and treatise within a single genre. Imagining that to read a romance is some-how the equivalent of reading a diary or a treatise offers a cover story that legitimates the reader's investment in reading, not as knowledge, but as an evolved and elaborated scenario the expression of which is most fully real-ized in metaphoric terms by the moment of nonspecific erotic union.

This moment is the final goal of the sexualized union of man and woman who become "of one flesh," and the movement towards this state governs the narrative economy of the category romance. However, this purely utopian state of total identification between the heroine and an Other is tempered because the hero and heroine must marry or be already married. The couple's happiness must always be situated within a domestic arena that is the locus of an economic system with its own demands and exigencies. This association is emphasized by the wealth and prestige that surround the hero, frequently an upper-class Western European who, in turn, confers this wealth and prestige upon his spouse. It is worth noting that the "sensuous romances" such as *Bronze Mystique* frequently feature a heroine who is not only more experienced sexually but also financially independent, though never to such a degree that the hero might become dependent on her; however, it remains the task of the hero to re-educate the heroine in terms of proper transcendent heterosexuality in which he thus remains her master. This erotic mastery is not coincidentally signaled through the heroine's consent to marriage, a state that she usually initially rejects on principal. In this sense, Thurston and Rabine are correct in emphasizing that the romance evolves in response to the changing position of the woman within the public arena; however, its erotic fantasy remains the constant, exemplified through the hero's imposition of the kiss.

This relationship between "silence" and "desire" is figured and placed within the narrative primarily through the description of this first kiss, as in the following example from another Harlequin romance, from the now

classic era of the 1970s, *Bamboo Wedding* (1977).[16] The moment at which Carey (the heroine) realizes that she actively wants Brad (the hero), she must also repress the desire to speak:

> She didn't want to go calmly to her room like any other night when every part of her was aching for Brad's touch. But she was too shy and reserved to give a hint. . . . His lips brushing her cheek were enough to ignite the flames of longing in her. In an agony of expectation she felt them travel caressingly along her throat. Breathless, her lips parted as with head bent he made silent love to her. It was all she could do to stifle the pleas for fulfillment. Must she always be tortured like this? And then in one swift movement Brad's mouth was on hers. (Lane, 69)

Carey's desire is introduced and named as such through the hero's imposition of his desire upon the woman as though it were her own, as the passage above illustrates. In the world of the category romance, the only way a woman can have a man is to be had by him in the way that she desires. The woman must always take a position of passivity in relation to the man. This position must appear to be involuntary and unselfconscious. This is one of the fundamental contradictions of feminine sexuality: it is based on a passivity that is the result, not of nature, but of certain ideological choices that must appear natural and inevitable. As if to reward her for her silence, Brad fulfills Carey's unspoken desire because (it would seem) she does not speak it. He must speak her desire for her by acting for her. Here, again, fulfillment for the woman depends upon her willingness to relinquish her control of language: her sexual desires must align themselves with a desire to regress to a prelinguistic state in which there appears to be no distinction between object and self.

This direct association of the kiss and silence, though not formally part of a "tip" sheet, reappears again and again in the Harlequin Romance. For example, Barbara Delinsky in *Bronze Mystique* describes the hero and heroine's first kiss in similar terms. The hero demands:

> "No, no, Sasha, don't look away. Kiss me. And tell me what you feel."
> She doubted she'd ever be able to speak again, but she needed his kiss desperately and met it with an ardor more eloquent than any words. (74)

The emphasis on the kiss as the sign of the hero's and heroine's erotic engagement underlines (as another act would not) the silencing of the heroine's speech in which the kiss acts as a de facto erotic gag. In the category

romance this ideal state of speechlessness is further elaborated through the moment of undifferentiated erotic union (a place outside of language that echoes the prelinguistic state of the *infans*[17]) to which the kiss must inevitably lead within the narrative logic of the format.

This desire to return to a prelinguistic state might be best understood as a reinscription of a primal regressive tendency in the subject, who wishes to efface the trauma of absence and division by returning to a stage that precedes symbolization as language. With the advent of symbolization as recognition of difference and identity, the individual is subjected to the trauma of division. With the knowledge of distinct objects inevitably comes the knowledge of the potential loss of that object through its division from its subject. As Colin MacCabe comments: "To accede to the world of absence—to the world of the sign where one thing can stand for another—we must wound perpetually, if not destroy, a narcissism which would render the world dependent on our presence" (194). In fact one might say that it is the fantasy of a narcissism still intact, without "wound" that is one of the animating scenarios of the romance. In the opposition subject/object (seeing/seen) lies the initial split of the subject from itself, which MacCabe describes as the "wound"; however, it is the recognition of this opposition that gives the subject access to language, symbolization, presence as well as absence. It must be noted that this desire can only be activated (acquire its charge) retrospectively from a position fully within language. The pleasure of a narcissism intact has no meaning except from the perspective of one who has already suffered the "wound"; a state outside of language or beyond language can only be produced as fantasy within language. The pain of separation, of absence, is necessary to the pleasure of presence.[18]

Here, it might be useful to recall Jacques Lacan's explanations of the two stages that define language acquisition. Jacqueline Rose summarizes his theory in the introduction to her translation of Lacan's *Feminine Sexuality:*

> He gives as his reference Freud's early account of the child's hallucinatory cathexis of the object for which it cries . . . and his later description of the child's symbolization of the absent mother in play. In the first example, the child hallucinates the object it desires; in the second it throws a cotton reel out of its cot in order to symbolize the absence and the presence of the mother. Symbolization starts, therefore, when the child gets its first sense that something could be missing; words stand for objects, because they only have to be spoken at the moment when the first object is lost. (Rose in "Introduction to Lacan," *Feminine Sexuality*, 31)

The fantasy of nonspecific erotic union rewrites a desire to return to a prelinguistic moment, in which the object of desire reoccurs as a hallucination of plenitude, within a heterosexual scenario. Plenitude might be described, in this context, as a state of nondivision between self and other, between word and thing, between absence and presence—a return to a primary narcissistic state without "wounds," which is nonetheless heterosexualized within the romance. This regression is impossible in the absolute sense; there is no return to a primal scene of desire except for the psychotic, and then only as the sign of psychosis. It can be, however, represented, in a literary form, as the metaphor of its original content—a staging of the event rather than the event itself.

In the category romance as a rule, and even more explicitly within the brand-line romance with its higher degree of repetition, we have seen that the metaphor operates on two levels: at the level of plot itself, in which mature heterosexual relations are represented as nonspecific erotic fusion (through the exclusion of all description of anatomically specific acts); and through the process of repetition inherent in the formula, which erodes the status of the story as "sign," as referring to something other than itself. This effacement of specificity parallels a phenomenon in romance fiction that Tania Modleski aptly describes as "the disappearing act" (35–38). The woman must be perceived and perceive herself as unselfconscious: she must perceive herself as totally passive without design in order to achieve her designs—to have a man by being had by him. The object of her desire is to be the object of his desire. But if she is the object, can she simultaneously be her own subject? Modleski correlates this "split" with John Berger's concept, articulated in *Ways of Seeing,* that "a woman's self" is "split in two." Berger continues: "A woman must continually watch herself. She is almost continually accompanied by her own image of herself" (qtd. by Modleski, 37). In this sense, the reader's identification with the heroine and her fate mimics the contradiction of reading the romance itself. The woman-heroine must appear to be passive yet at the same time actively want the hero. She must appear to get her man without trying to do so and at the same time fuel the plot whose sole function is to unite her with the hero. Similarly, the reader must believe in the story, lose herself in it, while at the same time she is actually constructing the story for herself. Thus the reader herself disappears—or at least the romance enables her to articulate and embody the moment of disappearance as a form of paradoxical passivity that the reader herself controls.

It is so important that the heroine's desire manifest itself as passivity that Carey, the heroine of *Bamboo Wedding*, is convinced that no communication should take place between hero and heroine, at least in the ordinary sense. She must appear inert, without past or future—an object:

> Carey showed no curiosity concerning Brad's past, nor did she discuss her own. She was haunted by the conviction that any personal probing would destroy the magic surrounding their relationship, a magic which, in its precariousness made her senses soar with silent rapture and sealed her lips from all but surface talk. (Lane, 47)

The reward Carey receives will be a life of idleness in which her husband will clothe, feed, and pamper her. She will find fulfillment in a life of utter passivity surrounded by a profusion of objects. Janice Radway elaborates:

> Passivity, it seems, is at the heart of the romance-reading experience, in the sense that the final goal of the most valued romances is the creation of perfect union in which the ideal male, who is masculine and strong, yet nurturant, finally admits his recognition of the intrinsic worth of the heroine. Thereafter, she is required to do nothing more but exist as the center of this paragon's attention. ("Women Read the Romance," 66)

Underlying this consumer utopia of "frilly underwear," "simple linen shifts," "strands of delicately carved jade,"[19, 20] etc., is the moment of erotic fusion that all romance readers recognize as the product of love. In the words of George Eliot, nineteenth century woman novelist:

> Our caresses, our tender words, our still rapture under the influence of autumn sunsets, or pillared vistas, or calm majestic statues or Beethoven symphonies, all bring with them the consciousness that they are mere waves and ripples in an unfathomable ocean of love and beauty; our emotion in its keenest moment passes from expression into silence, our love at its highest flood rushes beyond its object and loses itself in the sense of divine mystery. (*Adam Bede*, 33)

As the above quotation indicates, a vision of romantic fusion permeates our notion of the literary and the artistic. Why does the quotation "its precariousness made her senses soar with silent rapture" elicit disdain in the educated reader when compared with the weight of authority implicit in George Eliot's effusions? Both discourses privilege this romantic union that is culturally recognized as a prerequisite to the experience of the beautiful within the norms of high culture.

Janice Radway posits that the distinction between the high art text and the popular text depends not on content or concept but on the form or language that expresses this content. She explains that the popular text denies the "now dominant aesthetic norm" that defines the high art or "literary" text (in her terms) as a text having "a double semiotic nature." By this she means that the literary text "signifies at two levels simultaneously: at the level of language itself and at the level of the text as a whole, that is, as a complex and autonomous sign" ("The Aesthetic in Mass Culture," 403). The implication is that the literary text demands self-consciousness from its reader, a consciousness of the mechanism of language itself as structure. The pleasure peculiar to the literary text is this pleasure (at least in part) in the play of language as language. The regime of reading as analysis and rereading (as opposed to a regime of reading as identification with the text) corresponds to this aesthetic norm that privileges complex language and demands self-consciousness and analysis in the act of reading.

The popular text is governed by another regime of reading than that mobilized by the reader who consciously chooses to read a literary text:

> because popular texts employ only the most familiar language and strict-
> ly adhere to "yield" their meaning in the face of the simplest kind of
> interpretation. On the linguistic level, such texts work hard to deny the
> fact that meaning is the end result of a process of production. (Radway,
> "The Aesthetic in Mass Culture," 403)[21]

We have noted already the rigidity of the category romance format at the narrative level. Here, Radway suggests that this "codification" is replicated at the linguistic level. Because the reader need never confront anything new, she can "go on automatic" so to speak. She, of course, creates the text herself, but here the action can become habitual because she has done it so many times before, and thus, it "appears" natural and effortless. The reader can put herself in a position in which the text seems to happen to her. She loses herself in a moment of fusion—of identification with the text that parallels the sexual experiences of her heroines.

There is an obvious fallacy in this argument. It implies that it is the text that determines meaning for its readers—that there is something innate in the novels of George Eliot that requires that we recognize the double semiotic nature of the novel. Anyone who has spent his or her childhood devouring nineteenth century novels, effectively "lost" in a state of "suspended" disbelief, knows that this is not the case. It is true that one must

attain a degree of literacy regarding the language conventions of the nineteenth century novel (which are quite different from those of the television sitcom, for example). But for those who habitually took refuge in the novels of Charles Dickens or Charlotte Brontë as children, this process seemed effortless. On the other hand, the process of becoming self-conscious, part of the process glibly dismissed as "professionalization," was very painful indeed. Those who are unable to take pleasure in the process of analysis, who crave an economy of pleasure based on identification, are weeded out by the academic institution. Those who are not weeded out are those who can take their pleasure through analysis as a process by which the text can be mastered and rearticulated. The reader no longer gives himself or herself over to the text but bends and breaks the textual experience into component parts that can be remolded into a new text in which the reader speaks as reader. This process of reading has bred its own genres: the anti-novel, the new novel, the new new novel, all predicated upon a regime of reading based in analysis and introspection. If popular texts "work hard to deny the fact that meaning is the end result of a process of production," then high art texts work hard to deny the fact that meaning is socially produced.

The high art text denies that its reading is a class-specific activity based on institutional aesthetic criteria. Not only is it confined to a certain social class, as an activity it also defines that class as a class. In other words, being literate within a given idiom, be it that of James Joyce, Janet Dailey, or Jean Auel, marks an individual as a member of a certain social class and becomes the means by which members of a given class recognize each other. It is no accident that the category romance as a genre overtly encourages a regime of textual pleasure based in apparent passivity. This regime of apparent passivity reflects the category romance's position as a genre that, by its nature and its readership, will always be condemned by the aesthetic norms of a ruling class that values activity and aggression and devalues empathy and intuitive response. Thus, in a now well-known argument, Andreas Huyssens claims that "mass culture is somehow associated with woman while real, authentic culture remains the prerogative of men" (191). In the context of the brand-line romance, it is not simply that "mass culture" is "associated with woman," but rather that the criteria of evaluation offered by *men* are turned on their head, devalued by the reader who marks out passivity as the position of ultimate value, which is a specifically "feminine" value.

This apparent passivity, privileged as a regime of reading, corresponds to the way in which woman's pleasure in the category romance itself is

emblemized through the erotic passivity that the heroine claims as her reward at the end of the novel. Unfortunately, whereas the passivity of the heroine is rewarded within the patriarchal structure of the novel, the passivity of the reader offers nothing but a temporary satisfaction predicated on its own repetition. Janice Radway comments:

> The reader of the ideal romance closes her book, finally purged of her discontent and reassured that man can indeed learn how to satisfy a woman's basic need for emotional intensity and nurturant care within traditional marriage. The reassurance is never wholly successful, however. That reader almost inevitably picks up another romance as soon as she puts her last one down. ("The Aesthetic in Mass Culture," 406)

Following Radway's line of argument, we might conclude that the successes of the category romance, and the brand-line romance at its most extreme form, result from the exploitation of a promise of fulfillment which is always only a promise. The genius of the brand-line paradigm as a mode of production and reproduction is that it reproduces a desire that can never be fulfilled. The "unchanging pattern of the dream"[22] is reproducible as a narrative economy that supports and is supported by a material economy of mass production that is itself based on repetition. This repetition of the formula works because these novels are consumed in an economy of pleasure that is, in turn, based on repetition as a sign of unarticulated pleasure.

My point here is not to condemn this reading regime as a regime of pleasure that "produces" feminine passivity nor to validate it in the name of the pleasure that it affords women. Rather, the category romance's importance lies in the way that it illuminates the complicated network that fixes the romance as a peculiarly feminine pleasure within a particular set of social relations. To take up one of the propositions with which I began this chapter, the implications of this "passivity . . . at the heart of the romance-reading experience" (Radway, "Women Read the Romance," 66) can only be fully understood if we reintroduce the concept of masochism, effectively relegated to the margins of any discussion of the romance for the last ten years. It is not generally considered politically correct for women to seek out masochistic pleasures, whereas the pleasures of being nurtured and cared for are offered as the politically correct alternative. But to see feminine masochism and the desire to be nurtured as mutually exclusive is to misunderstand fundamentally the teleological nature of the masochistic scenario and its origins in the primary relationship between

mother and child. As Gaylyn Studlar points out (borrowing from Gilles Deleuze's theories of a masochism grounded in pre-Oedipal relations) in an oft-quoted article about masochism and film theory:

> Both oral object and controlling agent for the helpless child, the mother is viewed as an ambivalent figure during the oral period. Whether due to the child's experience of real trauma, as Bernhard Berliner asserts, or due to the narcissistic infant's own insatiability of demand, the pleasure associated with the oral mother is joined in masochism with the need for pain. ("Masochism and the Perverse Pleasures of the Cinema," 777)

Studlar remarks that Deleuze "notes that the female child can take the same position in relation to the oral mother," though he evolved his theory of masochism in the context of the masculine subject (778). This is a point that Studlar does not pursue at length in this article but which is of particular importance to a discussion of the romance in so far as the formula defines the reader as feminine, that is to say occupying the position designated as feminine within contemporary social relations. Given the nurturing maternal nature of the romance hero, it is difficult not to pursue at least the suggestion that the nurturing hero functions as an avatar of the "oral mother" (in Studlar's terms) for the feminine subject. It should come as no surprise that category romances do not render explicit the connection between these two figures, often giving the heroine who begins as an orphan another mother, thus underlining the fact that the hero is not a mother, or emphasizing the couple's desire to have children, thus signaling the hero's reproductive capacities as male).[23, 24] The category romance must work hard to maintain a definition of femininity grounded in a heterosexuality that does not offend the current standards of feminine behavior generated by contemporary feminisms while facilitating the reenactment of a regressive fantasy that corresponds to the scenario of the "oral mother" laid out by Studlar above.

Within the historical context of the category romance, Studlar's and Deleuze's theories raise an interesting question: why does this particular configuration, generated by a matrix we might term the oral mother, this particular "fantasy" in Penley's terms, regulate the articulation of pleasure and heterosexuality within this genre, and at this particular time? Through the introduction of another shadow text, I hope to make clear the logic of this fantasy as a narrative within history, suggesting that not only are these scenarios (of nurturing and masochism) linked within the romantic paradigm, but in fact they are frequently coterminous in the novels discussed

above. I am not arguing for the universality of this particular figure that Studlar terms the oral mother, but rather for its importance to this particular genre at this particular time. This connection between the romance and the figure of the oral mother is examined most clearly not by feminist critics of the romance novel, but by a pornographic novel, *9 1/2 Weeks* (Elizabeth McNeill, 1978). The pornographic novel lays out the stakes of the romance, in particular the centrality of a fantasy grounded in a hallucinatory moment of fusion, of indivisibility. As the expression of forbidden, interdicted, and often unspoken desires, the novel transfigures the romance in the process, to borrow the words of Gaylyn Studlar in a subsequent article, "deconstructing the masquerade of normalcy that motivates the romantic scenario ("Masochistic Performance," 40). To reverse the process of transfiguration performed by *9 1/2 Weeks* on the romantic paradigm through analysis is to reveal the means by which "the unchanging pattern of the dream," the formula that underlines the category romance, is produced. This double rereading makes obvious that the formula depends upon a "typical masochistic logic with its romantic 'cover-ups' to sustain the perverse subjectivity that omnipotently reconstructs the world according to its own unconscious contradictory dream" (Studlar, "Masochistic Performance," 41).

Considering the romance in terms of a masochistic scenario is useful in a number of ways. It serves to explain the manner in which the scenario negotiates the apparent contradiction between a reader who "controls" her reading and a hero who "controls" the heroine; however, it also speaks to the way in which format romances very specifically and category romances in a more general sense depend so heavily upon a rigid formula that must be religiously repeated. Gaylyn Studlar's comments on the heroine of the film *Letter to an Unknown Woman* (Max Ophuls, 1948) seem to directly address the above issues: "Her apparent submissive capitulation to 'romantic love' demands to be read as a masquerade for a perverse sexual scenario that 'freezes' love into a single, compulsively repeated pattern" ("Masochistic Performance," 40). Thus the format romance invites the feminine reader, as the heroine of her own reading, to insert herself into a scene of "romantic love" that does not challenge socially accepted norms—of heterosexuality, of sexual preference, of gender stereotypes—while at the same time offering her the means of surreptitiously seeking pleasures elsewhere, "perversely" in Studlar's terms. Studlar emphasizes (drawing upon the work of psychoanalyst Louise Kaplan) "the deceptive nature of perverse strategies that use gender stereotypes" as a means of

producing a fantasmatic scene that is easily situated within existing social constraints and that does not "arouse the subject's own anxiety" ("Masochistic Performance," 44). In this context, the romantic scenario, with its trite, banal, and seemingly benign conventions, constitutes an ideal locus in which to play out certain more troubling desires—troubling not only to women at large but to feminists as well. The degree to which feminist critics are willing to ignore the more perverse dimensions of feminine pleasure within the romance testifies to the power of the social norms that hold the romantic paradigm in place. It is then not surprising that the most powerful challenges to this paradigm must come from outside the arena of publicly sanctioned feminine culture—in the form of a pornographic text as the unspoken desires of a silenced heroine.

Alibis and Cover Stories: Pornography, History, Race, and the Category Romance

If *The Taming of the Shrew* as the representative of the literary canon casts a long shadow over the romance, asking us to question these seemingly simple pleasures, the pleasures of being recognized, named, held, nurtured, and sustained, *9 1/2 Weeks* as an abject text, the pornographic text, haunts the romance genre by offering an ironic reply to the high culture text—telling us the story of a "Kate" who only too willingly gives herself over to the pleasures of "being tamed." As an abject text, it does not reassure but admonishes: *caveat emptor.*

Like *The Taming of the Shrew, 9 1/2 Weeks* offers another shadow text that silhouettes the problem of the romance and the feminine position situated through its narrative, a problem highlighted by the predicament of the anonymous heroine who begins "with a casual encounter" that ends "in a terrifying climax of bondage, humiliation, and ecstasy" (frontispiece, paperback edition). These elements of "bondage" and "humiliation" are precisely those tropes of the romance that the earnest feminist in her attempt to save the romance for feminism must efface, and thus she fails to account for the persistence and ubiquity of these figures. For example, Radway assures us "that the fairy tale union of the hero and heroine is in reality the symbolic fulfillment of a women's desire to realize her most basic female self *in relation* with another" (*Reading the Romance,* 155). She sets up this position in opposition to that of those "many students of the genre" who have assumed that "the romance originates in female

masochism, in the desire to obliterate the self, or in the wish to be taken brutally by a man" (155). However, *9 1/2 Weeks* reveals that if the "original blissful symbiotic union between mother and child" is "the goal of all romances despite their apparent preoccupation with heterosexual love and marriage" (*Reading the Romance,* 156) as Radway claims, this "goal" does not necessarily impede but may in fact enable the "desire to obliterate the self, or the wish to be taken brutally by a man."

A close reading of *9 1/2 Weeks* suggests that it is precisely the maternal melodrama of identification and division that produces the masochistic scenario, which troubles more idyllic accounts of the romantic paradigm. The general resistance to examining the connection between the primacy of the mother/child relationship and a masochistic scenario[25] (of which Radway's statements above are only one of many examples) results in large part from the emphasis placed on the theories of Nancy Chodorow, which seemingly offer "a more optimistic account of subjectivity" (Penley, 479) than those formulated through traditional Freudian perspectives. This account is "optimistic" in that it situates subject formation within the social realm, which is therefore "transformable," but also because it privileges femininity as generating an ethically superior subjectivity grounded in a notion of the self in its relation to others (rather than as an autonomous contained unit).[26] Certainly, the Chodorovian model of feminine subjectivity dominates scholarship on the category romance.

Thus, Leslie Rabine identifies her work with scholars such as Snitow and Radway, who also "relied on Nancy Chodorow" to define feminine character-structure in terms of "fluid ego boundaries" (175)—these fluid ego boundaries the result of the fact that the female child is never completely disentangled from the mother. Rabine further claims that the Harlequin heroine's destiny represents the reader's desire that the conflict between "the domestic world of love and sentiment and the public world of work and business" (166) have as its solution that the hero "must recognize and adopt the relational, feminine form of the self " (175) as morally superior to the masculine form of the self which is characterized by "more strongly defined and closed-off ego boundaries" (175). This assessment does in fact parallel that presented by Janice Radway, whose work *Reading the Romance* has arguably had a more significant impact on romance scholarship than any other in the field; her analysis depends on a definition of the romance hero as incarnating maternal and nurturing virtues associated with the maternal rather than the paternal. These characterizations are not inaccurate as such; they simply do not carry the analysis to its

logical conclusion. It is the author of *9 1/2 Weeks* who extends the romantic scenario to its logical conclusion, pornography taking up, so to speak, where feminist theorists leave off: the novel constructs a tentative examination of the relationship between the desire to be the object of the "nurturant, essentially 'effeminate' attention" of a "spectacularly masculine hero" (Radway, *Reading the Romance,* 155) and "the desire to obliterate the self" (Radway, 155).

"Elizabeth McNeill" (a pseudonym, the book cover informs the reader) lists the activities the sadistic[27] hero performed for the masochistic heroine:[28] "He fed me . . . He dressed me . . . He read to me . . . Every three days he washed my hair . . . He bought tampons for me and inserted and extricated them . . . He ran my bath every night . . . Every night he took my make-up off" (41–43). She also lists what the heroine did for him: "Nothing" (44). The dependency to which the novel's heroine is reduced rewrites the erotic fantasy of the romance as a masochistic scenario in which the "moment of nonspecific fusion" is clearly articulated as the "gagging of the heroine." Even when she is not literally gagged (47), she has relinquished agency and subjecthood, taking up the position of the *infans* whose every action, even the most intimate, is regulated by the phallic mother (the mother that embodies the monstrous, within the terms of contemporary heterosexuality, conflation of the paternal and the maternal, the masculine and the feminine).

This fantasy generated within *9 1/2 Weeks* rewrites a more primal fantasy, which would return the subject to a position in which the boundaries between self and other are dismantled.[29] Thus the heroine comments on her condition: "There is a sound, far away and surely not having to do with me, no responsibility. My body giving up, giving in. No bounds" (148). Superimposed on the erotic scenario is a scenario of regression, a return to the mother's body as the body without boundaries creating a palimpsest of scenarios, in which heterosexuality is added as another layer functioning simultaneously with and through the more archaic relationship of mother and child. At another moment in the novel, after the nameless hero has nursed her during a severe attack of the flu, she comments: "I had not been nursed like that since having chicken pox at the age of eight" (111). The heroine uses similar terms to comment on her seduction: "For weeks on end I was flooded by an overwhelming sense of relief at being unburdened of adulthood" (105).

This erotic scenario is set up in contrast to the heroine's professional life. The book blurb characterizes her as "a high paid young executive in a

Manhattan office." "Elizabeth McNeill" is described as "the pseudo-nym . . . of the New York career woman who experienced and wrote about the incredible nine and a half weeks" (paperback edition, inside page). The heroine herself alerts the reader to this division between public autonomy and private dependency as an essential regulating structure of the fantasy: "Through that entire period the daytime rules of my life continued as before: I was independent, I supported myself . . . , came to my own decisions, made my choices. The nighttime rules decreed that I was helpless, dependent, totally taken care of" (105). This division produces, in the heroine's words, again echoing the rhetoric of the series romance: "a segment of my life as unreal as a dream" (23). The essence of this dream is the breaking down of difference enacted upon her body as the initial site of symbolization: "the difference between pain and pleasure became obscured in a way that turned them into two sides of a single coin" (81). This breaking down of boundaries is overdetermined: it literalizes the series romance heroine's "confusion" as she learns to read "abuse" from her hero as "signs" of love, but it is also a rewriting, in terms of the dichotomy pain/pleasure, of the boundaries of the mother's body and the child's body.

The masochistic mise-en-scène reproduces the romantic scenario in two other crucial ways—in its relationship to the dynamic of recognition and to consumer culture. The phenomenon of recognition revolves around the heroine's conviction of her "exceptional" position, confirmed by the reproduction of a narcissistic scene in which the heroine's body is the central signifying text of heterosexual exchange. "Every night now I revelled in my beauty. Years ago . . . I had sized up my body and decided that it was all right. . . . But under his eyes and hands . . . there it was, unrecognizable, transformed: supple, graceful, polished, adored" (McNeill, 58, 59). The move from "all right" to "adored" is replicated when the heroine later places herself among "faceless girls out of Queens or wherever, just like me, I'm one of them" (129) only to ultimately rewrite her "self" as the heroine of her romance:

> But ME he loves, ME he allows to bury a face in his armpits, for ME he lights a cigarette with carefully squinted eyes, puts it between my lips, mouth slightly open, waiting for what he'll put into it next. (129)

In her articulation of her position, her jubilation as the chosen, McNeill's heroine describes the masochistic scene as one in which the sadist confers

upon the masochist her significance, "naming" her as heroine, in which finally it is she who occupies the central position, starring in her own story.

Rabine's description of the Harlequin heroine's desire, "what she wants from the hero is recognition of herself as a unique, exceptional individual" (166), is both played out within the masochistic scenario and deconstructed, in that it is clearly not the heroine (her "self") who is "exceptional," but rather the position that she occupies. Even if in fact the heroine is "exceptional"—has a special talent, for example, that distinguishes her from other women—this aspect of her identity is trivial in comparison to the exceptional position (and its benefits) that only the hero can confer upon her. Understanding the importance of position as a function of a masochistic scenario, in which it is not the heroine that is confirmed as exceptional by the hero but the position that she occupies, also demands a redefinition of the nature of "power" within the romantic paradigm. Rabine contends that: "Only from someone representing the power of the hero could such recognition serve its purpose" (166). Rabine does not pursue the masochistic implications of this exchange between hero and heroine that her statement seems to imply: that within the masochistic scenario the function of the sadist then is to represent precisely "the power of the hero" to confer "recognition." This moment of recognition refers back to a more primal moment at which the maternal and paternal functions both coincide and divide, the moment at which the Law as language is inaugurated, permitting the child to recognize the mother as such, while simultaneously finalizing the division between the body of the mother and that of the child through the presentation of a third body, that of the father. Here within the fantasy, the distinct positions of maternal and paternal are conflated in the single figure of a "spectacularly masculine hero," who yet confers "nurturant, essentially 'feminine' attention." It is precisely the logic of fantasy, the logic—not of yes or no—but of yes and yes again, that permits the representation of this impossible figure, a figure that marks itself as fantasy, exemplifying, to quote Studlar, "the status of the pre-Oedipal mother as a fantastic and transformative mental representation" ("Masochistic Performance," 39). The maternal male is not only the expression of a regressive desire but also of a heterosexual desire that might accommodate the more primal goals of the prelinguistic subject. He embodies the doubled narrative of the romance, as a palimpsest of scenes, that strives "to reconcile the irreconcilable" (Novik and Novik, qtd. in Studlar, "Masochistic Performance," 39) as one of the goals of the masochistic scenario.

This more primal dynamic of "recognition" is transformed through yet another inflection of the heroine's status, in this case as a consumer. This position as consumer ties her even more closely to her fellow heroines of romance while yet again pointing to masochistic underpinnings of the category formula, its "unchanging dream." Hardly coincidentally, the masochistic scenario of *9 1/2 Weeks*[30] is firmly embedded within the consumer practice of "shopping." The world of "frilly underwear" is one that is not unfamiliar to the sadistic hero of both the Harlequin romance and *9 1/2 Weeks*. In *9 1/2 Weeks,* the nameless hero offers as a prelude to a "Command Performance" (85), his term for the enactment of a masochistic scenario, the presentation of a shopping bag from Henri Bendel, the prestigious Manhattan luxury department store. The intensity of the heroine's erotic desire is initially expressed in terms of the desire to know what is in the shopping bag. The heroine writes: "I scream: 'WHAT'S IN THE BENDEL'S BAG?'" (84). Her desire appears to actively express itself in terms of a consumer object; however, this apparent desire is merely her assent to the "command performance" that her lover then will demand of her.

Later the hero rewards her desire, giving her two gifts, moving the narrative towards the constitution of the masochistic scene. The heroine describes: "I open the Bendel's bag first. It contains swathed in the throwaway luxury of six layers of tissue paper, a black lace garter belt and a pair of pale grey stockings" (85). Subsequently, she opens a second "gift": "The bag contains a shoe box from Charles Jourdan, a store I've only looked at from the outside" (89). The garter belt and the shoes become the crucial elements in constituting the mise-en-scène of the heroine's abjection, her passivity, even as these objects appear to function as the externalization of her subjectivity, the expression of her desire. The dilemma of subjectivity and desire within a scenario that posits femininity as the passive position is reenacted in terms of the traditional fetish objects of male perversion, transformed into objects of feminine consumer pleasure, only to be repositioned within a heterosexualized masochistic scenario.

Unlike the category romance heroine, the anonymous heroine of *9 1/2 Weeks* is conscious of her dilemma—the fact that she moves between two irreconcilable worlds.

> "We're an anachronism," I whisper, reading from the dictionary into the phone in a raspy voice; nearly every one of the definitions incorporates the word "error"....

"Anachronism," he repeats after me and there is a pause, and then he says lightly, "So maybe we are and so who cares. We're fine." (126, 127)

Yet, unable to dismiss her uneasiness, the heroine concludes the chapter: "ANYTHING FOREIGN TO OR OUT OF KEEPING WITH A SPECIFIED EPOCH. The epoch's a midsummer in the seventies. The out-of-keeping is me" (130).

Significantly between these two moments, her conversation with her lover and the conclusion of the chapter, the act of writing and its role in the production of fantasy becomes an element within the narrative. Inexplicably, as the heroine begins to type in the moments following her phone call, she recalls another story, the "shadow text" of her own story:

> The story a woman told me, how she lived with a man for the year it took her to write her first book, how at 11 p.m. every night he'd turn the TV up and say, "When will you be done with your typing?" She became adept at recognizing the split second when she had to stop—somewhere between 2 and 3 a.m.—just preceding the moment when he'd start hurling chairs, books, bottles.
>
> Typing. Recalling in print, pressing wobbly black buttons. A more or less faithful machine recording a process: what he makes happen. The sleepy slave who, at dawn, sits at her master's feet and recounts in a lullaby voice, a soothing singsong, what has happened to her that night, as the sky lightens and before they go to sleep, endlessly weary, limbs afloat. (McNeill, 128)

In the allusion to a first novel, and to the mythic pornography of *One Thousand and One Nights*, the author both undermines the status of the narrative as autobiography (a "true" story) and establishes an historical alibi for the masochistic scenario. The "true" abusive hero is the "husband" of realist fiction who throws his chair at his "wife" to stop her from continuing to type the novel in which she inscribes her fantasy of masochism. In the movement from the abusive man to the sadistic hero, the author rejects the social reality of male domination and affirms the status of fantasy as governed by another logic. Through the process of "writing," the writer/reader defines the goal of "the masochistic search" as the production of "a specific position from which the subject can control desire in relation to the object" (Studlar, "Masochistic Performance," 40). The insertion of this other moment, that of the author who is not the first-person narrator, troubles the transparency of the masochistic fantasy as

the expression of feminine desire. In what constitutes almost an "in joke," the author winks at the reader, letting her know that she should not be concerned, that this is indeed fantasy, and that the "real" Elizabeth is a woman who nobly tries to write herself out of a bad relationship rather than someone "silly" or "immoral" enough to give herself over to "9 1/2 weeks." This moment assures the self-conscious reader that this is after all only fantasy—and that reality is a man who habitually turns up the TV when a woman works (perhaps not so reassuring after all).

This story within a story suggests that only in writing/reading—in the space of fiction—can the irreconcilable be reconciled. The husband who throws the chair is not the hero of fantasy, of the masochistic scenario. Lest this reality disturb the pleasures of submitting to the fantasy, the heroine must refuse this story, the story of realist fiction, in order to reproduce the fantasy that will engender pleasure, even if a forbidden, incorrect (anachronistic) and possibly fatal pleasure. Thus the heroine must construct an alibi for herself (as her own reader) by reformulating her story in terms of history—as an anachronism. Within the narrative of 9 1/2 Weeks, the heroine must "historicize" the split in her own life between her adult life (reality) and her desire (sexual fantasy). Yet the history that she posits (in which her desires function as anachronistic) more properly refers to her own psychic development than to another historical period. Here, the novel narrativizes women's oppression, not as a product of social and economic institutions and their evolution, but rather as the result of a psychic evolution that presupposes an erotic core. It is this erotic scenario that has become the forbidden terrain, the repressed of the "liberated" feminist as "career woman," who is no longer constrained by an economy in which women were exchanged between men, in which the guarantee of a woman's value was her chastity.[31] The career woman of 9 1/2 Weeks constructs an imaginary past in which women's oppression is understood in terms of a masochistic scenario that returns as an erotic fantasy in the present.

This slippage between women's history and erotic fantasy (a "case history") works against an elucidation of the social and economic terms of gender. To read history and the feminine role through the single narrative of oppression is to ignore the significance of other categories such as race, class, ethnicity, sexual identity, in the construction of subjectivity and relations of power. Significantly this eroticization of feminine oppression is common to romance and pornography, in particular the "new" pornography represented by 9 1/2 Weeks in which a specifically feminine subject of desire is posited by the text—a genre that developed simultaneously with

the increase in the number of women working outside the home, thus of women who are economically independent. For example, this nostalgic recreation of "history" as a masochistic scenario is replicated in Anne Rice's series of pornographic novels, which she wrote under the name of A. N. Roquelaure, *The Claiming of Sleeping Beauty* (1983), *Beauty's Punishment* (1984), *Beauty's Release* (1985). Rice uses the fairy tale format to recreate a fairy tale past (a past that is itself the fictional product of the fairy tale genre). She gives the reader a historical alibi for her enjoyment of the masochistic fantasy by marking this fantasy as not "present." Rice demarcates the status of this fantasy in three ways: in terms of the past in the sense of the temporal setting of the narrative, which is not of the contemporary world; in terms of the past in the sense of literary history in which the fairy tale as a genre refers back to literature's origins; and finally in terms of the past in the sense of the fairy tale itself as a genre of childhood, associated with early stages in the development of the psyche. The anachronism of the masochistic scenario both distances the feminine subject from her desire and provides her with an alibi, because this scenario is after all from the past, which she revisits as a childhood "playground," and as the terrain of her oppression in history.

Rice's mise-en-scène produces a logic that parallels that articulated by the heroine of *9 1/2 Weeks,* who determines that her malaise can be attributed to the "anachronistic" position that she occupies, as though somehow the history of women up to the present might be subsumed under the scenario of eroticized oppression. However, Rice's work also undermines this logic by creating an obviously fantasmatic past for this masochistic scenario—a past that never was, and never could have been. It would be a mistake, however, to see the masochistic scenarios within these novels as a symbolic or displaced re-enactment of women's oppression in the past.[32] These scenarios seem to function much more clearly as the articulation of contradictions inherent in the definitions of femininities in the present, in which narratives of oppression return as erotic scenarios.[33]

The notion that the coincidence of an eroticized fantasmatic "past" and the articulation of a "masochistic" scenario is characteristic of the romance in contemporary feminine culture is supported by the popularity of the so-called "bodice-ripper" romances, also referred to as "erotic historicals." The popularity of these romances is also a phenomenon of the 1970s, beginning in 1972 with the publication of Kathleen Woodiwiss's *The Flame and the Flower,* the success of which produced, in Carol Thurston's words, "a conflagration of passion, possession, piracy, and

rape, portraying high-spirited women who ultimately won not only love but more respect and independence than the times in which they lived commonly allowed their sex" (19). This "conflagration" generated, according to Thurston, "the most avidly consumed form of entertainment for millions of women" (20) during the 1970s.[34] According to Thurston, the heated exchanges between hero and heroine in these novels (which inevitably lead to the recognition of the hero as hero by the heroine) articulate the proto-feminist feelings of women readers. These readers were struggling with the contradictions of a period during which, although 44 percent of all women sixteen years of age or older were in the work force, "they earned on the average fifty-eight cents for every dollar men were paid" (20). In spite of the fact that *The Flame and the Flower* begins with an abduction and an undisguised rape, Janice Radway also emphasized the proto-feminist leanings of these romances in her ethnographic study of romance readers. Furthermore it is again these romances, beginning with *The Flame and the Flower,* that provided the prototype of the nurturing male described by Radway (see above).[35]

However, it is arguably novels such as *The Flame and the Flower* that most clearly provide an avenue through which the eroticization of "oppression" (in the form of kidnapping, rape, etc.) can be explored in terms of the anxieties but also the pleasures that such scenarios suggest.[36] The historical settings of the novels provide the "alibi" for these occurrences. Rosemary Rogers (an early rival of Woodiwiss), whose 1972 novel *Sweet Savage Love* "gave rise to 'sweet savagery' as a generic label" (Thurston, 51), lost her readership and the "affection" and "respect" of those same readers when she "translated these characteristics into contemporary settings" (Thurston, 51). Woodiwiss, who continued to exploit historical settings, maintained her status as a "favorite author."

It is not my purpose to deny either the masochistic scenarios of these romances, signalled as such by earlier critics of women's romances such as Ann Douglas, nor to deny the proto-feminist tendencies of women's fiction in general and romances in particular. Rather what I would like to point out here is that, far from contradicting an analysis that foregrounds the masochistic scenario, the maternal prototype (isolated by such scholars as Radway and Rabine, among others) is intimately connected to the articulation of such a scenario. Indeed, because these romances revolve around the generation of a maternal masculine, they permit the expression of the interdicted wish but also provide a means of containing that wish, and thus of upholding the initial interdiction.[37] The contemporary

romance enables the reader to experience the masochistic scene within the protected arena of fantasy, without ever naming that fantasy as masochistic. In as much as the formula romance conflates history and the erotic fantasy, the genre perpetuates the fantasy that the "dream" or fantasy can be coterminous with "real life," that life can become a phantasmatic whole.[38] In this sense, *9 1/2 Weeks,* which marks itself as pornography, as the articulation of interdicted desires, is less pernicious than the so-called "sweet romance," which fails to call attention to the contradictions inherent in its fantasy.

The use of history within the context of the romance formula, no matter how carefully researched the novel might be, far from providing the "education" that readers would like to see in these books, is another form of the historical alibi, a function of the "censorship" mechanism that permits the expression of socially interdicted desires. Though the historical setting in terms of location, dates, food, and especially clothing, may reproduce a museum-vision of a given period, the heroes and heroines (as Thurston remarks) always have more in common with the reader than the period in which the novel situates them (76, 77).

Finally, the historical settings of these romances also enable the rewriting of the shrew figure within an erotic rather than a socio-economic context, returning the "shrew" to a central position within the romance formula. The emphasis on the "feistiness" of the heroine, her tendency to "talk back," invokes the shrew, here again a shrew who will be tamed, but who is also all the more desirable because she must be tamed. The desirability of "shrewish" women is remarkable within this context because it underlines the connection between the masochistic paradigm and the shrew story. Thus in the bodice ripper, shrewishness is a desirable characteristic (which is not the case in Shakespeare's play, for example) because, it would seem, this figure enables the use of the masochistic scenario as a process of engagement and denial on the part of an idealized reader. In *So Worthy My Love,* a 1989 Woodiwiss novel, the heroine, Elise, is described repeatedly as a "challenge," a woman with a "shrewish bend" (251). The following meditation on her by one of her suitors is notable because it renders explicit the connection between her erotic potential and her shrewishness:

> "I find the lady . . ."—he toyed with his glass—". . . most delec . . . ah . . . I mean . . . most comely. She has a strong spirit assuredly . . . as vell as a certain grace. She vould be a challenge to a man vith skill and patience."[39] (187)

Similarly, her cousin Arabella, who plays Bianca to Elise's Kate, is ultimately compared unfavorably with her more headstrong opinionated rival.[40] Maxim, the Marquess, retorts in one of his "spirited" exchanges with Elise: "No ordinary maid, this, but one well worthy of any game. Truly, I doubt that even Arabella could have created such stimulating diversions" (334). Thus, if Elise wins Maxim it is because she is shrewish, not in spite of it, heightening the masochistic theatricality implicit in the description of their "love-making":

> Though recently sated, he could feel again an awakening deep within his loins.
> "Is your curiosity appeased, madam?"
> Feeling the returning heat, Elise wiggled under him deliberately arousing him as she slid her arms around his neck and breathed dreamily, "You've more to teach me, my lord?"
> "You're not bruised overmuch?" he whispered with a brow raised questioningly.
> Elise smiled up at him with sweet seduction as she teasingly decried, "My lord, I am completely at your mercy." (Woodiwiss, 458)

This masochistic scenario is foregrounded early in the novel, when the hero and heroine first meet—and it is the full articulation of this scenario that is the focus of the first half of the novel.[41] Maxim recollects:

> "Never did I imagine when you dumped that pail of icy water on me that I would come to be thankful you were taken instead of Arabella. An overwhelming desire to lay my hand boldly to your bare backside was not born of lust that morn, my love, but rather another kind of passion the sort that yearns for vengeance." (388)

As readers we are left to ponder the possible connections of these kinds of "passion," and the extent to which Maxim and Elise continue to play out these ambivalences. However, this masochistic scenario can only be enacted within a certain décor, a décor that fulfills the generic requirement of "careful attention to the style, color, and detail of women's fashions" (Radway, *Reading the Romance,* 193). Radway elaborates: "Extended descriptions of apparel figure repeatedly in all variations of the form [the category romance], but they are especially prominent in gothics and long historicals" (193).

Radway hypothesizes that these descriptions contribute to what she terms "the romance's mimetic effect" (*Reading the Romance,* 193). She

continues: "The final effect of endless attention to 'pink-striped shirt waists,' 'sandy-tweed jackets,' 'long-sleeved dresses,' 'emerald-green wrappers,' may be the celebration of the reader's world of housewifery." More explicitly these descriptions recall the meticulous enumeration of the apparel of models in fashion editorials, but also the descriptions that fill clothing catalogues such as *Spiegel's, C.W., Tweeds,* etc., that bring the fantasy of shopping, of mobility and unrestrained expenditure, into the home. If there is indeed a referent that corresponds to these descriptions, it is the consumer utopia evoked by women's magazines and home-shopping catalogues. Like the category romance, then, the bodice ripper ultimately provides a consumer utopia for its heroine, here emblemized by the arduous and detailed attention with which the text, and the hero within the text, treats the heroine's apparel and various physical luxuries, such as baths, perfume, jewelry, food, bed linens, etc. Though the heroine may experience all kinds of deprivations, her happiness is always eventually guaranteed by the proliferation of objects that will ultimately surround her. The narrative must also efface the historical specificity of these same objects as part of contemporary consumer culture in order to preserve its alibi. (Who took baths in the sixteenth century on a regular basis?) The novels create a setting that has more in common with Hollywood's or Madison Avenue's vision of other centuries as a nostalgic mise-en-scène for new consumer non-durables than with the history of everyday life, thus serving the "anachronistic" demands of the formula.

Like the heroine of contemporary romances, Elise enjoys the pleasures of shopping, an activity included within the narrative not without a certain awkwardness, an awkwardness that underlines its importance (at the time Elise is being held prisoner at Falder Castle, a remote and dilapidated "keep"). After a trip to town, Maxim comments that Elise had left a good impression on the shopkeepers:

> A fine and comely young lady with excellent taste, they declared. She has chosen only the best . . . every last piece of the best!" (Woodiwiss, 251)

Elise's defense of her spree sounds more suitable to a twentieth century living room than to a sixteenth century "keep": "I could not have been *that* extravagant" (251). Elise's "extravagance" reproduces a similar refiguration of the objects of masculine fetishism that we observed in *9 1/2 Weeks,* as the very term "bodice ripper"[42] itself suggests. The objects of masculine fetishism are rewritten as consumer objects, objects of feminine desire—a

displacement that is facilitated again by the historical anachronism that characterizes the bodice ripper as a genre. Thus, *So Worthy My Love* can freely evoke the stereotypical vision of a woman lying naked on a fur, justifying this image as the product of a historical past (rather than an erotic present) in which people used furs rather than blankets.[43] A contemporary heroine would not be permitted this indulgence for a number of reasons, the consumer item of the fur having now become a sign of conflict rather than luxury; however, the historical alibi permits a nostalgic return to this scene of atavistic desire.

The heroine of *9 1/2 Weeks* does in fact retrace her history, effecting a literal return to the position of *infans*. She eventually ends up in a hospital, abandoned by her lover, reduced to the position of the infant, who can control neither her own body, nor her speech, who has lost language, whose form of expression is the undifferentiated "cry."

> All I knew was I couldn't stop crying. When I was still crying at six o'clock he took me to a hospital: I was given sedation and after a while the crying stopped. The next day I began a period of treatment that lasted some months.
> I never saw him again. (McNeill, 151)[44]

The heroine's "cry" or "crying"—a continuous state that does not recognize difference—exists as the trace of a subjectivity that finally she cannot relinquish. In the cry is always the promise of silence, of difference, of language. Crying as the persistent voice that cannot be silenced is the sign of the heroine's shrewishness, of her inability to live the fantasy of obliterated object except as fantasy, of her resistance to the mise-en-scène of this fantasy within the real. The passive voice, which she uses to describe her condition, suggests the status as object that she finally occupies but cannot continue to occupy. Rather she must be "cured" of what she terms a "pathological" condition (McNeill, 23), and return to her position as adult, rehearsing the process of moving from infant to adult that characterizes the production of subjectivity. "I'm responsible and an adult again, full time now" (152). Yet like the category romance reader, she regrets the pleasure that only the masochistic scenario seemed capable of giving to her. "What remains is that my sensation thermostat has been thrown out of whack: It's been years and sometimes I wonder whether my body will ever again register above luke-warm" (152). Her story reveals the complex trajectory of the romance reader who paradoxically controls a scenario

that has as its goal "a self repetitively shattered by an ecstatic excess of affect" (Shaviro, 56). The significance of repetitions at all levels of the romance reading experience suggests the importance of the masochistic scenario within this genre. The formula of the romance permits the production of a fictional moment in which the irreconcilable is reconciled. Pornography disrupts the equilibrium, deconstructs the masquerade, so that the voice of the masochist can be understood as such. When film theorist Steven Shaviro takes up the voice of the masochist, this voice could be that of the nameless heroine of *9 1/2 Weeks*—and also that of the confirmed romance reader:

> And I do not merely try to defend myself against slipping into this delicious passivity, this uncontainable agitation; I compulsively, passionately seek it out. (Shaviro, 55)

This fantasy, the fantasy of *9 1/2 Weeks*, must announce itself as always of the present—the conclusion, the end of the story, must safely place the fantasy in the past, as a history.

Interestingly enough, the "mid-seventies," the historical moment of Elizabeth's nine and a half weeks, is also the period that saw the category romance evolve as a specific mass-marketed formula into a multi-million dollar international concern (see Thurston, Rabine). Since "between 40 and 60 percent of the mass-market romance readership works outside the home" (Rabine, 169), Rabine quite correctly challenges the assumption that "these romances contain housewifely fantasies." Rabine also notes: "As Harlequin Romances have become more popular, more and more of their heroines have jobs" (166).[45] These historical coincidences direct us towards a conception of the category romance and its pornographic shadow text as a response to a feminine bid for autonomy rather than the expression of hegemonic control that puts woman in her place. Ironically, here the pornographic novel, while producing a mise-en-scène that stages a frankly masochistic fantasy, also functions as a cautionary tale, urging the woman to accept the fantasy as fantasy, to be wary of the heterosexual romance as a behavioral paradigm, and rendering obvious the stakes of its fantasy. The heroine of *9 1/2 Weeks* does not look forward to a future in which she will be cherished and nurtured by the hero—rather, once he has rendered her completely helpless, he abandons her.[46] The category romance, on the other hand, is far less explicit in laying out the stakes of the "heterosexual dream." Nonetheless, the distinct parallel between the fantasies that fuel both *9 1/2*

Weeks and the category romance points to the possibility that it is a masochistic fantasy that is the goal of the "dream," a fantasy that culminates not with the evolution of a caring male but with the obliteration of feminine subjectivity. The connection between this scenario and women's increasing presence within the public arena reproduces the conflicting terms that might define a properly feminine agency within contemporary culture. In *9 1/2 Weeks*, the heroine's autonomy within a public sphere is foregrounded by her desire for an erasure of self within the private sphere of erotic exchange.

This erasure of self corresponds to an overvaluation of the woman's own objectification, especially in its relationship to the othered other—the woman on the margins of femininity. In the novel *9 1/2 Weeks*, this other woman is almost indistinguishable from the woman as "chosen"—she is represented by the secretary the heroine might have been (129) and the prostitute that she becomes by equipping herself with the necessary accoutrements:

> I walk slowly to the bathroom door and its mirror, a narrow diagonal crack marking a right triangle off the top left corner.
>
> It is a sight from which one averts one's eyes if in the company of a man, which one looks up and down quickly and surreptitiously, if unobserved and by oneself: an Eighth Avenue prostitute; not a charming Lady of the Night in a Parisian café out of *Irma La Douce*, but a gawky, atrociously painted New York street whore of the seventies, in her cheap wig and come-on sixties gear. (139–140)

The pleasure and horror that the heroine experiences in recognizing her "self" as not herself, producing the breakdown of boundaries between the beloved object, which she imagines herself to be (fixed in the gaze of a fascinated lover), and the abject object, which she sees herself to be in the mirror ("a sight from which one averts one's eyes"), speak of the way in which the pornographic novel problematizes the categorizations of desire. This inflection of an othered other and its significance can only be fully comprehended through the invocation of another series of shadow texts. In the case of *9 1/2 Weeks*, the translation of the narrative to film, its visualization within the cinematic apparatus, pushes the visualization of this "other" into a social and political realm in which she is deliberately "ethnicized," reinforcing rather than problematizing these same categories of adored other and abject other.

The film opens as Kim Basinger, in the role of Elizabeth (named as such within the film), works her way through crowded New York streets on her

way to work. In the film, Basinger is visually engulfed by the influx of "workers" ("the faceless girls out of Queens"), among whom in the novel the unnamed heroine had felt herself singled out as desirable by the attentions of the hero. This crowd is no longer a crowd of women but a mass of "workers" whose diversity is underlined (written in italics) by the film's placement of Basinger against an African-American woman in curlers, waiting impatiently for her dog. The woman is left behind in the frame as Basinger continues her model's stride on her way to her glamourous job with a Soho gallery.[47] This anonymous woman marks out the division between woman and heroine—the woman as "not chosen" versus the heroine as the already specularized object of the cinematic gaze.

This "ethnicization" of the scene of desire and the concomitant glamorization of the heroine is intensified through the introduction of the prostitute. The prostitute is identified, signaled as such not through her accoutrements (her wig, her lipstick, her miniskirt) as she is in the novel but through her language and her race. The "whore" played by Cintia Cruz chatters in Spanish, her "dark" ethnically and racially ambiguous looks in stark contrast to Basinger's Breck Girl personification of blond feminine sexuality. Cruz laughs demonically at the couple, who abandon her in the hotel room once she has served her purpose—to push Elizabeth to a point at which she could no longer respond to "John's" commands because he has finally, with Cruz's cooperation, overstepped the limits of enlightened correct heterosexuality. That these limits are represented by his apparent pleasure in an other woman, a woman who is doubly "othered" because racially "other," who has also aroused Elizabeth's desires (another overstepping of correct heterosexuality), signals the profound ethnocentrism and heterocentrism of the romance. This again italicized emphatic representation of "otherness" serves to preserve the white woman's desirability as well as the white man as the agent of desire. Cruz represents another sexuality that both threatens and defines the limits of feminine sexuality for the female protagonist, the limits that her class status both permits and forbids her. Cruz's character figures a sexuality beyond gender that Elizabeth refuses to adopt, unlike her novelistic counterpart who "becomes" the "whore" that the "other" represents. What both novel and film have in common is the manner in which this other serves no purpose except to provide the mise-en-scène of the heroine's fantasy, a supporting role (literally in the novel) in the reproduction of her desirability. The film, in attempting to rewrite the novel as romance,[48] essentializes the difference between "Elizabeth" and "the whore"; that which was signified through

position in the novel, most significantly economic position and class position, is signified through race within the film, in particular through skin color and language (Spanish as opposed to English).

This same movement is reproduced in the category romance, both in sweet romances and in its more evolved form as the erotic or hot romance, and in erotic historicals. The woman of color is rarely if ever the heroine; rather, she appears exclusively in supporting roles, frequently reproducing an atavistic social structure more feudal than democratic in organization.[49] Not unusual is LaVyrle Spencer's *The Hellion,*[50] in which a number of women of color reproduce the stereotyped "mammy" as the desexualized maternal figure whose function is to care for and highlight the heroine's own sexuality. Set in Alabama, the novel narrates the rebirth of the love and eventual marriage of Tommy Lee Gentry and Rachel Talmadge, star-crossed lovers separated as teenagers who find each other again in their forties. They are assisted by a number of "mammies" who stand in for the inadequate or dead mothers of Tommy and Rachel. Callie Mae, the Talmadge faithful "serviteur," is the mother who has always known that Rachel belongs with Tommy: "'You don't have to explain nothin' to Callie Mae. I see how it is with you two. I always seen'" (Spencer, 145). Callie Mae represents a more essential pure femininity, its purity insured through the writing of her body as without erotic interest.

The novel, however, is unable to contain the contradiction inherent in its attempts to segregate maternity and sexuality. The sexuality of the woman of color, her possible position as an erotic threat to the heroine, and the effacing of that threat are re-enacted within the narrative. This ambiguity endemic to the position accorded the woman of color is represented and reread through the "eyes" of Rachel, the heroine, during her first encounter with another woman of color who plays a supporting role in the novel. If Callie Mae as the heroine's "mammy" figures the female line in which the African-American woman's role is to care for the white women, Daisy embodies the conflicted relationship between the African-American woman and the Caucasian man. Initially represented as an icon of sexual excess, especially in contrast with the heroine who is always described as too thin and childlike, Daisy was "a buxom woman . . . , her breasts the size of cantaloupes, earrings the size of handcuffs" (Spencer, 111). As fruit defended by handcuffs, Daisy represents a maternal fantasy of masochistic exchange that is expressly forbidden within the narrative, in which it is race rather than maternity that writes the cover story of the interdiction. In other words, the issue of race is always dis-

placed, constituting another "alibi" that preserves the heroine's absolute desirability.

Rachel's reaction to her first encounter with Daisy expresses the difficulty of maintaining this state of absolute desirability, its narrative instability. Tommy as the "hellion" enthusiastically kisses and is kissed by Daisy. Rachel's reaction echoes that of Joseph Conrad's Kurtz, only here the "horror" is represented as a response to the threat of miscegenation. "Rachel was horrified. Never in her life had she seen a white man kiss a black woman" (Spencer, 112). Rachel's "horror" parallels that of Elizabeth, for whom the sight of the white man and the "othered" woman embracing constitutes the limits of the masochistic scenario leading her to defy her "lover/master." Rachel's horror, however, is contained, mitigated, when she realizes that in fact it is a maternal function that Daisy fulfills for Tom: "She studied him silently for a while. Then it all became clear" (115). Daisy and her husband were Tom's "surrogate family" (115). Daisy as the improper feminine is de-eroticized and repositioned as the maternal. This maternal is never completely reassuring. The figure of Daisy, her sheer physical status, implies the possibility of a power and self-sufficiency never accorded the fragile frequently child-like persona of the heroine. In this novel, Rachel, like most of the heroines of most category romances and their offshoots, is small-boned, small-breasted, with a narrow pelvis—a child who must be nurtured and cared for by the hero who himself takes on a distinctly maternal role.[51]

The setting of the romance, especially when it involves the exotic locales favored by romance readers, evolves around the creation and perpetuation of privilege that defines the heroine as such, privilege that is made tangible in the guise of the attentions the hero lavishes upon her. *Bamboo Wedding*'s locale (the story takes place in Taiwan) produces a deformation of culture and ethnicity that works towards the isolation of the heroine, who then must be defined exclusively in terms of her relationship to the hero. This locale, at first glance, appears "innocent," designed to fulfill the readers' desire to see educational value in romance reading.[52] This initial impression of the educational value of romances is deceptive; the treatment of Taiwan in *Bamboo Wedding* is characteristic of the formula, which values geographical accuracy while propagating the myths of the white woman's universal desirability and the superiority of Western European civilization.

If at times the novel appears to reverse readers' expectations, demystifying the "orientalism" that the very title of the novel implies, it is only to

assert more strongly in subsequent passages the "exceptional" position of the heroine, and to inoculate the "story" against charges of parochialism. For example, Carey, the heroine of *Bamboo Wedding,* confesses to herself:

> Like so many people in the West, she had always imagined Taiwan as an embattled island fortress where the inhabitants lived in shelters and crept about fearful of attack from the mainland. In fact, the city abounded with temples, bars, and Chinese restaurants. (Lane, 33)

This statement lends credibility to Carey's earlier acquiescence to Brad's request that she marry him, because in the above statement she proves her "open-mindedness." Her earlier sense that she was "stranded and alone in a world of yellow unfathomable faces and weird customs" (16) was not a product of "racism" but of naiveté. The reader is encouraged to assume that the hero of *Bamboo Wedding* persuades Carey to marry him by deliberately playing on her naiveté, telling her that: "This is Taiwan, close to the doors of China and teeming with all kinds of foreign elements. The only real way I can protect you is to make you my wife" (17). Carey's coming to knowledge about the "real" Taiwan permits the reader to deny the uncomfortable possibility of her ethnocentrism. The reader can deny that she "reads" or perhaps "misreads" in terms of an ideology that embraces the explicitly anachronistic (in the sense of ethnocentric) terms demanded by the narrative, enabling the narrative to proceed on the basis of this misreading.

Even after Carey revises her opinion of Taiwan, the narrative continues to mobilize the setting in terms of an ethnocentric vision of desire. Thus, later in the novel a Chinese man says to Carey: "there is something in the crystal coldness of the women of your land which makes a man like me want to break through to the fires below" (Lane, 159). Carey's position as desirable is universalized and essentialized (all men want her), and this desirability is underlined through reference to her race and nationality. Setting (while appearing to offer something else—for example, a chance to learn about another culture) is manipulated exclusively in terms of providing an itinerary by which the heroine will come to realize that her true desire and source of fulfillment is the hero.

The ethnocentricity of this topology problematizes the claims that feminists might make for the romance as a form of resistance to the dominant social order, statements such as that of Thurston when she says that erotic historical romances "project a powerful sense of shared experience and unity among women, one that transcends both time and place" (88). The category romance's treatment of race and ethnicity can only reproduce the

inequities of the reigning social order, in terms of gender, but also in terms of race and nationality. Cranny-Francis's comments on the romance are hardly sufficient: "Its racist ideology is a matter of omission, of silencing, of marginalization" (188). As we have seen above, this process of marginalization is not passive but active. The romance actively supports the notion that, again in the words of Cranny-Francis, "under patriarchy, women are defined solely on the basis of gender" (188). To define subject position "solely on the basis of gender" is to eradicate the complexities of cultural positionings that in fact always define subjectivity and agency as such.[53]

Though the romance may not originate "in the desire to obliterate the self," its fantasy can only be represented as precisely such an obliteration— an obliteration more properly of "selves" rather than "self." The romance invites all readers to imagine themselves as the "white heroine," a position that is also always inscribed as an impossible position as I suggest in my analysis of *9 1/2 Weeks* above (or rather possible only as fantasy). For the woman of color this becomes a double obliteration, both in terms of gender but also in terms of race. The category romance demands that the reader continuously imagine herself as of an other race, that is to say without race or ethnicity, neither African-American, Jewish-American, Arab-American, Asian-American, Chicana, Mexican-American . . . without specificity, naturally "white."[54] The romance would seem to invariably function in terms of an economy of desire in which position and desirability are "naturalized" and fixed through the figure of the heterosexual couple as the white couple. The woman of color has no position, certainly no voice of her own; within the category romance she can only serve to enfigure the desires of others, to operate as a sign that always refers to something other than herself. Thus her subjectivity as a specific position is effaced in a narrative in which "masochistic desire masquerades its perverse quest behind the romantic guise of mythical or fateful inevitability" (Studlar, "Masochistic Performance," 51). All romance readers must take up the position of the "white" heroine who plays the role of the "obliterated self" in the prelinguistic fantasy "staged" by the category romance . . . or she may turn to another genre.

4

PRIVATE ENTERTAINMENTS

"Out of Category": The Middlebrow Novel

The Mind-Body Problem

Caught between two conversations, one private, the other public, women intellectuals occupy a paradoxical position in our culture. They participate in a public conversation to the extent that they define themselves in terms of their professional role and their educational status; they stand excluded because their identity as feminine is circumscribed by their role in the home, in relation to children, lovers, friends, and family. The middlebrow woman's novel reproduces the position of the intellectual woman who has no place, but must shift from one place to another, who is forever "out of category." The woman's novel represents this intersection of public and private in exemplary form. This type of novel stubbornly rejects the status of high art. It is adamantly not "against interpretation" and demands to be understood in terms of its content. The woman's novel says, by and large, what it means to say, refusing to reveal its secrets under the scrutiny of the analyst by displaying these last for all to see, literati and non-literati alike. On the other hand, the richness of its language, the subtlety of its arguments, its undeniable intelligence and self-consciousness defy the classification of popular culture. The woman's novel may be read as either popular culture or as literature and reflects the ambiguous social position of its preferred reader—the educated woman.

Methodologically, the woman's novel forces the reader to confront the limitations of a perspective that privileges either the formal characteristics of a text (reading as a literary activity) or its status as a symptom of larger

social issues (reading as a popular activity). Middlebrow novels are read and written by intellectuals, in particular intellectual women such as Anita Brookner, Margaret Drabble, A. S. Byatt—producing a genre that is by definition "out of category," that is not marked by a narrative formula but by the readership that it addresses, from which its authors are frequently drawn.[1] It provides the extracurricular reading of an educated class that can be defined in terms of a specific economic and professional status for whom middlebrow literature is "fun," the unprofessional "read." We might say that the middlebrow novel, particulariy in the form of the woman's novel, has been ignored, or exiled, so to speak, from the academic forum, because academia has failed to generate an adequate methodology that would represent this genre in its fullest sense as a cultural moment that is neither high art nor popular culture. Similarly, one might say that this exile represents the exile from this same arena of a specific subject, a subject that announces itself as feminine yet refuses both mastery and submission as defining instances. The woman's novel represents, in the words of Angela Ingram, "an intersection point" that marks a specifically feminine subject who wanders "between two worlds, exiled from both"— the public world of the professional and the private world of the feminine.[2] Indeed this is the position that has been carefully documented by such writers as Margaret Atwood, Margaret Drabble, Marilyn French, Joyce Carol Oates, Susan Fromberg Schaeffer, among others—that position of estrangement accorded the woman who chooses to define herself in terms of her intellect, while maintaining her position as feminine.

As a genre, the woman's novel represents the characteristic discourse of a certain class of women who have acquired a position of mitigated respect within the larger institution of masculinity. The privileged position held by these women depends upon their ability to assume a discourse of mastery, to operate within a regime of pleasure (or reward) modeled on obsessional structures rather than hysteric structures. The intelligence and acuity of social and psychological perception, the grounding of the novel in political and historical reality, the elaborate systems of citation, are all aspects of these novels that reflect a discourse of mastery. On the other hand, the efficacy of the form in terms of an identificatory mode in which the reader gives herself over to the novel as a process controlled by the other of the text, the experiential properties of the genre, reflect identificatory structures of pleasure that recall the romance.

The dual function of the woman's novel is perhaps most clearly illustrated by a sub-genre of the woman's novel that could be called the

dissertation novel. *The Début* by Anita Brookner, *Falling* by Susan Fromberg Schaeffer, *The Odd Woman* by Gail Godwin, and *The Mind-Body Problem* by Rebecca Goldstein, among others, are examples of this sub-genre—novels about women writing dissertations, written by women who have written dissertations. As is often the case for many writers, the novel represents only one aspect of the author's professional life. The writers of the dissertation novel supplemented their more culturally legitimate project, the dissertation, with another type of discourse, the novel, that, while rewarding economically, is considered secondary within the institution of academia. The cultural value of the dissertation within the paradigm of legitimate discourse was inadequate in terms of the occulted discourse of private experience, in our society closely associated with a feminine identity. For one reason or another it was not enough that these women acquire professional status. They turned to novelistic discourse despite the fact that this type of production was either ignored or actively discouraged by the academic institution. Both a product of the education that formed the professional lives of these women and a form of resistance against the values promulgated by this education, the dissertation novel publicly negotiates the public and private discourse of the intellectual woman. These novels constitute a response to the inadequacy of a purely professional and academic discourse.

The genre as such marks the creation of a community in exile within the community of academia. The dissertation novel offers the academic woman a sense of community—at a price; it signals the estrangement of the intellectual woman from the community of the feminine as a homogeneous ideological category. The academic woman as subject is created through a double movement of exile, exile from the community of male intellectuals and exile from the community of the feminine. Her position as "alien and critical" is precisely the position that defines her status as intellectual and as woman, as a member of a community that is exiled within the very institution that has articulated her as an instance of estrangement.

The dissertation novel as a symptom of this estrangement makes obvious the inadequacies of traditional theories of cultural production. This genre necessitates that we as scholars rethink critical methodology to find a position as a scholarly reader that is neither outside the text, nor within it. The dissertation novel as a genre (perhaps to a greater degree than the woman's novel in general) demands of its reader, its scholarly subject, a redefinition of the critical project in terms of a cultural studies perspective,

in which scholarly pursuit recognizes and questions its own position, its own historical and political agenda. In a certain sense, the dissertation novel itself, because of its historical specificity (written in response to certain issues characteristic of a specific period), constitutes a cultural studies *sauvage, sauvage* in the sense of a spontaneous and untutored body of work that selfconsciously criticizes its own premises. The genre contests the hegemony of a modernist perspective that privileges the minimalist text uncontaminated by the concerns of history and everyday experience because, as a a dirty genre, the dissertation novel produces an imperfect discourse that actively engages in the messiness, the "out of category" nature of the quotidian experiences of its readers. By turning to a single dissertation novel, *The Mind-Body Problem,* we can perhaps better understand the specificity of the estranged position accorded both this type of novel and its reader.

Rebecca Goldstein, now a professor of philosophy at Barnard, wrote *The Mind-Body Problem: A Novel* as a narrative reply to the impossibility of a philosophical epistemology that would resolve the ontological paradox of the mind-body problem—the topic apparently of both Goldstein's own dissertation and that of the novel's heroine. Though Goldstein, we assume, has finished her dissertation, the heroine of the novel does not, at least not within the novel. In a sense the novel explores an alternative path, that of a woman who relinquishes her academic ambitions in favor of marriage. The urgency of the mind-body problem, for Goldstein's heroine, derives in large part from her position as a woman attempting to establish herself in a field regulated by a system of "meaningfulness" produced by a masculine-dominated discourse. Renee, Goldstein's heroine, feels that she must choose between mind (professional, "public" identity) and body (feminine, in particular erotic, identity). "A woman is who she marries" (Goldstein, 67), according to Renee's mother; Renee finds her professional accomplishment meaningless unless she can find "the powerful affirmation of mutual mattering" (214) through heterosexual romance, and ultimately marriage. Through the concept of "the mattering map," the heroine tries to analyze the various and conflicting relationships of value that regiment both her mind and her body. With this concept, Renee "maps" out values as a hierarchy that operates horizontally as well as vertically, and that shifts according to the subject that conceives that "map"—and according to where that subject places herself or himself on the map. Ultimately the novel documents her failure to generate "a mattering map" that might fix her own value independently of an erotic

relationship with a man. Renee is unable to give up the project of a relationship of "mutual mattering" in favor of the public mattering map of masculine discourse, as does her friend Ava; however, she is also unable to fix her value through marriage alone. For Renee, both the frameworks of an academic or professional life and of marriage cannot contain her experience as "feminine." *The Mind-Body Problem* attempts to reconstitute within an analytic framework this "out of category" experience that is in excess of the terrains of public and private demarcated by the discourses that Renee has at her disposal. This experience is specifically the experience of the dissertation as a feminine experience distinct from the "work" itself, but also experience in more general terms, in particular feminine experience—that *cannot* be understood as meaningful within academic discourse. The novel attempts to write an alternate mattering map, but this mattering map can somehow never write itself because it is both within and without academic discourse.

As a genre, the dissertation novel renders meaningful precisely that aspect of experience that has been designated meaningless by the dominant discourse of academia. As such the genre constitutes a hinge moment between dominant or masculine discursive practice and occulted or feminine discursive practice, between legitimate textuality and institutionally illegitimate textuality, between the dissertation and the classical novel, between the production of writerly texts and the production of readerly texts. This novel actively produces a feminine position that is defined as both a site of struggle and collusion, in which feminine agency is not so much effaced (as in the romance) but caught in the contradictory desires of its subject. In *The Mind-Body Problem*, neither the heroine nor the author seem able to resolve the heroine's ontological dilemma; yet neither is willing to give up the position of privilege their education accords them. As a textual experience, the novel calls into play the complex social context overdetermined by class, gender, and education—the mattering map—that circumscribes the intellectual woman. The cover itself exemplifies the processes whereby the novel attempts to reproduce a reader. The cover is lavender, the design minimalist and subdued—tasteful, according to the standards of the professional and intellectual middle class, feminine yet not frivolous. The quotation on the cover from *Harper's* magazine—part of a tradition of literary respectability—states that the novel "anatomizes the dilemma of the intellectual woman in an anti-intellectual society." The quotation reconfirms the novel's "seriousness" while evoking a feminine subjectivity. Consider how differently the quotation would have operated

with the omission of the single word "woman": "Anatomizes the dilemma of the intellectual . . . in an anti-intellectual society."

This femininity is reiterated through the reproduction of a painting, "Figure in front of a mantel," by Balthus, Balthazar Klossowski de Rola, in which a naked young girl in the first stages of womanhood contemplates herself in what appears to be a mirror. Her breasts are small, her hips and legs heavy. She neither hides nor displays herself, but is positioned in sharp profile, turned towards the mirror, rearranging her hair. Oblivious to the spectator, she is fascinated by her own image: she seems to be meditating on her own condition, her nascent maturity. Consider again how different the effect would have been if the rubric placed carefully below had read "anatomizes the dilemma of the intellectual . . . in an anti-intellectual society." Without the single word "woman," reflection and contemplation are transformed into a discourse of voyeurism and obsession originating in a masculine rather than a feminine subject. The omission of the word "woman" and of the first name of the author "Rebecca" would return the depiction of a nude girl to its original context as a Balthus image—to its trajectory of masculine possession, desire, and perversion, signaled by the signature of the male artist as a specific recognizable style.

The use of the Balthus reproduction illustrates two crucial axes of textual practice characteristic of the woman's novel. The first is generated by the evocation of a culturally legitimate discourse. The cover exudes culture, taste, and education. Though the image of a nude woman looking in a mirror evokes the lurid sensationalism of romance or pornography, the colors, the unconventional pear-shaped body (unconventional to the degree that it does not conform to a current feminine ideal) of the woman featured in the painting, the reproduction of a work by a very recognizable "blue chip" artist, the quotation from a literary magazine, all ground the invitation to read within a discourse of education and high culture. The second axis of textual practice is more complex. It involves the systematic reinscription of masculine discourse within a specifically feminine topology. The use of the Balthus painting is a clear example. The author's name, a woman's name, emphatically inscribed in black as opposed to the blue used for the title, and the quotation from *Harper's,* also in black, frame the Balthus image from above and below. The initial masculine obsession of the painting, its very perversity, is rewritten in such a way that it says something—not about a male subject—but about a feminine subject who, if constituted for and by the male gaze, is nonetheless looking at herself for herself. The reappropriation of the body of the woman evokes a process of

reterritorialization generated by the novel as a specific topos discovered by men (or rather produced through a conjunction of a patriarchal order and private capital) and yet colonized by women.

The novel is a woman's genre—charting a lost continent of experience that is not legitimated by the dominant masculine discursive class, that nonetheless permeates the very fabric—the text—of cultural practice. The dissertation novel is, in a way, typical of the woman's novel as a whole, for it shifts our attention from one process of structuration to another— which is not hidden, but, like a picture (a gestalt experiment) that can be "read" two ways, simply not perceived. It would be a mistake to consider that all novels function in this manner—even all middlebrow novels. The masculine academic novel, for example, is almost always parodic, repro- ducing the dominant structure of meaningfulness in the unflattering mirror of social satire. Unlike the woman's novel, the academic parody doesn't speak in an Other voice of Other things. It speaks of the same things in a louder voice, exaggerating the features of the dominant struc- ture. This is not to say that parody cannot have a subversive function, but rather that it is a product of the very discourse against which it situates itself. In *Small World: An Academic Romance* by David Lodge, our atten- tion as reader is focused on the same figures, topics, theories, and issues that loom large in academic bibliographies. The dissertation novel returns our attention to another stratum of academic experience, to meaningless details, to the housework of academic life. In *Marya: A Life,* another dis- sertation novel, Joyce Carol Oates devotes a chapter to the conflict between the first-person narrator and, in her words, a "black custodian" (233–250). The conflict is minor in terms of the young woman's career; however, it provides the author and the protagonist the opportunity to dwell on that aspect of academic hierarchy that does not appear on a vita or in a profes- sional dossier—the occulted hierarchy of race, gender, and class. This hierarchy provides the core of a discursive practice, a crucial mechanism of academic life, that regulates the quotidian functions of the institution but is never named as such by the dominant discourse of academia.

A novel such as *The Mind-Body Problem* is permeated by these two dis- courses—the dominant masculine discourse designated as meaningful because of its dominant position and the occulted feminine discourse des- ignated as meaningless because of its occulted position. Through the narrativization of "the occulted position," thus revealed rather than hid- den, the hierarchy of dominant discourse and occulted discourse is, if not reversed, at least called into question. *The Mind-Body Problem* underlines

the antinomy of dominance and occlusion through a system of punctuation and quotation that structures the text into a series of chapters. The quotations (usually one, although Chapter 8, the final chapter, is prefaced by one long passage by Plato, and a shorter passage by Nietzsche) are taken from the work of various philosophers (Wittgenstein, Jean Paul Sartre, Stuart Hampshire, in addition to Plato and Nietzsche), with two exceptions, in Chapter 2, a letter from Albert Einstein, and in Chapter 6, a poem by Anne Sexton. All the passages, including the poem, are from culturally sanctioned sources—none derive from popular culture, folk culture, rock culture, etc.

This system of quotations is highly conventional, though as a rule quotations are neither as long nor as frequent as those found in *The Mind-Body Problem.* As a convention, it situates the discourse of the novel (as fiction) within an intertextual network of cultural legitimacy. If the novel itself is a melodramatic tissue of quotidian events, the quotations provide a paradigm of practice that is not fictional, not quotidian, and eminently meaningful within dominant discourse, in which philosophy functions as the keystone in the monument of Western European intellectual life. The quotations are markers, guarantors of cultural legitimacy available to the reader should she care to invoke it. Skipping the quotations does not negate their importance; the very fact of their existence acts as the guarantor of cultural value. The significance of the generative cultural formation of literacy and education (of which the quotation convention is symptomatic) is underlined in all dissertation novels. The dissertation novel is explicitly, rather than implicitly, produced by academic discourse. The novel's autobiographical subject (she who speaks) is defined through a specific historical and cultural institution, academia, which is, in turn, the object of her discourse.

This privileged relationship to the ideological apparatus of education and culture makes more obvious the nature of the novel as a site of struggle between a dominant discursive class (manifested by culturally legitimate discursive practice evoked by the quotation system) and an occulted discursive class (articulated through the practice of translating the quotidian into novelistic discourse). It would be a mistake to see this characteristic as unique to the dissertation novel; on the contrary, it is a general characteristic of the middlebrow novel, and of the woman's novel in particular, which, in opposition to a genre such as the formula romance, demands a reader who is familiar with the academic codes of cultural literacy but takes his or her pleasure in a mode of reading that is not academic.

This split is intensified in the woman's novel because of the ambiguous position accorded educated women in our society.

This split between mastery, an objective treatment of the text, and identification suggests the process of analysis in a Freudian sense, in which it is a talking through by the subject itself that produces a "cure." The subject must speak as though distanced from her symptomology but must identify with the narrative as her own; she must position herself as an "other" which she reads from yet another position. Analysis, "the talking cure," was in fact the invention of a woman suffering from conversion hysteria.[3] Her doctor discovered that if she talked through the circumstances that brought on her symptoms, the symptoms would then disappear. This process of talking through evolved spontaneously from the patient's apparent need to create a narrative of her experience, either in the form of fairy tales (which temporarily alleviated her symptoms) or in the form of an autobiographical expression of her experience (which tended to have more permanently beneficial effects on her condition), according to Freud. The analysis of Anna O., as Freud calls her in his description of her case, was never successfully completed. Nonetheless, as Bertha Pappenheim she went on to become an important pioneer in social work—a volunteer rather than a professional, in which her silent labor spoke the conditions of her disempowerment. Yet it was from her experiences as a hysteric, in other words, the work of her hysteria, with her doctor, Josef Breuer, that Freud evolved the technique of analysis.

The story of Anna O. provides a parable on the nature of feminine discourse, its power and its frailties. Her narratives and the technique of analysis grew out of the failures of a scientific discourse of mastery to control feminine experience. Psychoanalysis is founded on an experiential epistemology, a truth that cannot be replicated, generalized, or verified—a hysterical truth. The patient cannot be reduced to a systematic epistemological function. She can never be fully mastered by the analyst. It is always the patient, the analysand, who must solve the enigma of her illness, provide the truth of her experience as a narrative process. The potential that analysis might offer as a means of producing a feminine discourse of empowerment that is not a discourse of mastery has not yet been fulfilled. Recolonized by the therapist as an instrument of dominance, analysis quickly lost its latent function as a site of negotiation between dominant and occulted discourse. In a parallel move, the educated woman all too easily adopts the values and practices of her male counterpart. She disassociates herself from the hysterical moment as the feminine.

The novel produces a similar form of denial, recording a history and a knowledge largely constructed outside a dominant discourse of meaningfulness while categorizing this same history and knowledge as "novelistic," thus suspect and without "real" meaning. We might say that Anna O., and the role that she exemplifies in the history of psychoanalysis, occupies a similarly ambiguous position. Anna O. enjoyed the privileges of the educated woman. Her education, her ability to converse in several languages, her intelligence, and her diligence, all enabled her to make a valuable contribution to the development of psychoanalysis. As a woman, her name occulted, exiled from the scholarly discourse about her discovery of "the talking cure," she also represents the condition of estrangement that the educated woman must take up to constitute herself as a subject within patriarchy. Until the condition of "talking," of shrewishness, is rearticulated as cure and not as disease for women as a class, the intellectual woman will remain both the subject and the object of her own exile—until novelistic knowledge is recognized as knowledge, neither art nor trash, the novels' lessons will be lost to us as a form of unsanctioned "speaking." Yet to the extent that speaking in and of itself becomes a goal, a self-perpetuating discursive production, the speech of the novels can serve only to confirm the position of its reader, safe in the knowledge that she is not reading "trash."

The position created by the dissertation novel (and the woman's novel in general) for its reader differs significantly from that created by the Harlequin romance. If the woman's novel evokes the impossibility of closure by allowing its heroines to reflect endlessly on their romantic and intellectual predicaments from the vantage point of a privileged education, the Harlequin format emphasizes the possibility of resolution through the fantasy of erotic union. Unlike the heroine of the category romance, Rebecca Goldstein's heroine never resolves her problems with her husband or with the academic institution (at least within the novel). The woman's novel as a genre, a series of novels, recognizes the difficulties of the feminine position, but produces an endless replication of these difficulties; in a similar fashion, the romance offers an endless replication of resolution. The repetition factor in both genres undermines the position of absolute impossibility offered by the woman's novel, and the position of absolute possibility offered by the romance. In other words, the "out of category" romance in the form of the woman's novel tends to reproduce its position as out-of-category for its reader—who is thus confirmed in her "exile." The question remains: to what extent does women's literature

offer its reader another position, in which she is neither "silenced" nor "out-of-category"?

Girl Friends:

Waiting to Exhale

Both the woman's novel and the romance revolve around the issue of the incursion of masculine discourse in the construction of feminine pleasure. The centrality of the masculine position, its hegemony, is replicated through a process of reading that is centralized as a controlled chronological progression, an order that is imposed from without. Novels, whether Harlequins or the work of Charlotte Brontë, must be read from beginning to end, if we are to read according to the conventions of the genre. Neither the woman's novel nor the romance, because of the primacy of the identificatory mode, encourages the reader to construct herself, to imagine herself, as active. The process of reading the novel in ordered progression enhances the impression that the narrative "happens" to the reader. *Waiting to Exhale,* a recent middlebrow novel by Terry McMillan, challenges the homogeneity of subjectivity offered by novels such as that of Goldstein by producing a fragmentation of narrative voice and position through the creation of multiple heroines who recount a narrative that coincides but that is never unified, even in its divisions.[4,5] This fragmentation of the heroine into multiple heroines, each with her own story, offers the reader a number of different positions from which to read the novel. This fragmentation of the heroine is one of the elements in this novel that sets it apart from both the format romance, which defines femininity in terms of silence, and the dissertation novel, which gives woman a voice to the extent that she is willing to relinquish femininity as it is defined in terms of the romance.

An initial reading might suggest that in spite of differences in structure, *Waiting to Exhale* and *The Mind-Body Problem* have in common that they work against the romantic paradigm. The narrative of each novel unravels the romantic story of feminine identity, constructing a therapeutic moment in which the text constitutes a "talking cure" *sauvage* (almost a form of self-analysis) for its protagonists with whom the reader is invited to identify; however, the position each narrative offers the reader is distinct. *The Mind-Body Problem,* as the title suggests, itself produces a

binarism from which the narrative fails to escape; insofar as woman is body, she has no mind, in so far as she is mind, an intellectual woman, she must live outside/apart from the body. Because the text fails to undo the Gordian knot of feminine identity, it produces a feminine position that is finally uninhabitable. In this sense the narrative ultimately refuses the heterosexual paradigm on which the romance is based; however, it does not construct another position that might be defined as feminine outside that paradigm, leaving the feminine in a virtual space that exists only in the alternation between mind and body.

In contrast with *The Mind-Body Problem,* the importance of *Waiting to Exhale* lies in the way that it articulates a feminine discourse that does not revolve around the romantic paradigm as the founding topology of feminine discourse but that nonetheless *does not* exclude heterosexual exchange as a moment of feminine pleasure. Critical to the manner in which it offers up this possibility is its refusal to speak in terms of a mind-body dichotomy. Here, the title inscribes the terms of the feminine through a symptomology of the body, in which it is the body itself as "breath" that articulates the place of feminine identity—breath signifying both the quality of the bodily and its inseparability from agency as the necessary criterion of subjectivity. It is this body that the reader is invited to share as the textual experience of the novel. However, this body is not a monolithic moment that might be read in opposition to a "mind" as a neo-platonic ideal. Rather it is constituted through the fragmented and disparate experiences of four different protagonists, Savannah, Bernadine, Robin, and Gloria, in which narration shifts from first to third person, depending on the protagonist. This shift between third and first person enables the production of a fragmented subjectivity not only in terms of the multiple-protagonist as organizing sensibility but also in terms of a point of view that is neither inside nor outside the body. The text generates a subjectivity that is fragmented, the fragments of which function together as a community that is rendered more resilient, hence stronger through this very process of fragmentation, in which a binarism of mind/body would have no meaning. If it is the third person that guarantees the empirical reality of the body, it is the first person that ensures the complicity of the reader in the production of the text—the production of a viable body, a "breathing" body that "experiences" in both a third and first person.

Two of the protagonists address the reader directly by speaking in the first person—recounting their story or constructing their lives as story for themselves—positioning the reader as the self produced through the text.

In an eponymous paragraph near the end of the novel, in a chapter titled "New Territory," Savannah (arguably the novel's principal protagonist, though each receives equal attention from the author)[6] confesses to her other self—her girl friend Bernadine—thereby positioning both herself and Bernadine, and by extension her reader, as reader of her own text. In this crucial paragraph, Savannah explains the novel's title, appropriating it as her story. As she begins to breathe, she repossesses her "self" as a moment in which the division between mind and body could have no significance. It is this text that she invites the reader to create with her:

> To be honest with you, I do believe in my heart that I will meet *him*. I just don't know when. I know it won't be until I honestly accept the fact that I'm okay all by myself. That I can survive, that I can feel good being Savannah Jackson, without a man. I'm not holding my breath anymore, looking around every corner, hoping *he'll* be there. (McMillan, 345)

Along the same lines, rewriting but not eliminating the romantic hero, Savannah states earlier in the novel:

> If I had a man and it was your birthday and you were going to be over here by yourself all lonely and shit and Robin and Bernie called me up to come over here to help you celebrate, I'd still be here, girl. So don't ever think man would have that much power over me that I'd stop caring about my friends. (322)

The hero is no longer all powerful, but in his place; he generates only one relationship among many in a community in which the feminine dominates. This "many" constitutes the heroine of the novel as a community rather than a single individual.

Unlike the heroine of *The Mind-Body Problem*, these women produce their subjectivity through the constitution of a group, in which the primary function of the group is to talk. The core of the group is provided by the four "girl friends"; however, the group extends beyond this core to involve children, parents, co-workers, and lovers. For example, the black gay hairdressers who work for Gloria occupy a privileged relationship to the group—one perhaps best understood in terms of an alliance. Joseph, one of the male gay hairdressers, rescues Bernadine the day she learns that her husband is leaving her: he takes charge of her family until the effects of the tranquilizers she took have worn off, feeding her children, alerting her girl friends. Constructing a structure of exchange that is based in community

rather than on individual interaction, Bernadine will, in turn, support Philip (also one of Gloria's employees) financially, when his condition (he suffers from AIDS) becomes too acute for him to work. Similarly, when Gloria suffers from a heart attack, her "family" who visits her in the hospital consists of her son, her three "girl friends," and a male neighbor, marked as her potential partner. It is this "family," constituted through an amalgam of traditional and non-traditional kinship bonds, that gives Gloria the strength to continue: "Gloria smiled and looked around the room one more time before she closed her eyes. Everybody she loved was here." (McMillan, 391)

It is the ability to talk with/to each other that creates the community. This is a novel about talking, but this "talking cure" does not seek to legitimate itself in terms of an academic discourse, but rather through the way that its talk inserts itself into everyday life, the way this "talking through" attempts to speak the culture of the African-American woman of a specific class. Terry McMillan as the author of the novel generates a discourse that refuses the academy as a discourse defined by men, and more importantly "white" men. The cultural references that inform the novel are never drawn from the canon of Western European "great works." Though educated and equipped through this education to succeed economically in a world dominated by white men, the cultural life of the novel's protagonists is outside white society and its norms as signified through European "high" culture.

The discourse of the novel derives from popular culture. The lives of these women are punctuated, not by the masterpieces of Western culture, but by the quotidian culture of everyday life in the United States. For example, Bernadine is watching *Married with Children* when her daughter announces that her recently divorced husband has remarried and is expecting a child with his new wife (332). The television show's bleak vision of marriage, familiar to the novel's readers, comments ironically on Bernadine's own experience—now "divorced with children." The ubiquity of television, always mentioned in terms of its specificity as a series of texts, marks the commonality of the women within the larger context of U.S. culture. The significance of experience is understood in reference to the culture that permeates the everyday life of these women, from television to magazines; however, the book does not so much celebrate popular culture as use it to situate its heroines' lives. When Bernadine reflects on what went wrong in her marriage, she thinks in terms of this culture as well:

> Over the last five or six years, it became apparent to her that John was
> doing nothing but imitating the white folks he'd seen on TV or read
> about in *Money* magazine. At first he thought he was J. R. Ewing, then a
> black clone of Donald Trump, and finally he settled on Cliff Huxtable.
> (McMillan, 27)

Of perhaps even greater importance in the production of the discourse
of the novel are the cultural norms that these women come to designate as
properly African-American. The four women's lives are marked out by
their participation in a common culture that is specifically their "own,"
that signals their African-Americanness. At a birthday party for a third
protagonist, Gloria, the women announce their community and commu-
nality through a litany of musical names and songs that constitutes their
shared history: "Minnie Ripperton *and* Smokey Robinson" (319), "Teddy
Pendergrass singing 'Turn off the Lights'" (320).

Savannah, "going off" in Bernadine's words, sums up their relationship
to this litany in which their history is identified with this story, but also sit-
uated against it:

> "'When doves cry' by that weird-ass Prince, but it worked, right? *Ow!*
> 'The first time ever I saw you goddamn face' by Roberta Flack! And my
> man Al Green, 'Let's stay together.' I want to roll all these songs up and
> feel like this for the next thirty years. Is that asking for too much? If it is,
> why do they make these damn songs to make you think and believe and
> dream that you *can* feel like this? Huh somebody had to have gone
> through this shit in order to write it and sing about it, don't you think?"
> (McMillan, 321)

Savannah as the intellectual of the group of four women gives "voice" to
the cohesion of the group, its dual function as a critique and a reaffirma-
tion of their culture, making explicit the threads that draw the group
together—but within a vernacular discourse. These songs have a double
function in both articulating a language and a narrative (the love story) as
the defining cultural moment of these women's lives. However, through
this litany, Savannah both speaks this communality and critiques it, decen-
tering the romantic story in favor of the community that has been
produced around it. This vernacular critique is what accounts perhaps for
the novel's popularity, especially among African-American women, but
also among American women in general—it constructs a critique of the
women's position, but one that remains firmly within a feminine discourse

that is marked outside the academy, against the patriarchal voice of authority.

The cover design of the novel "speaks" this other discourse, a discourse that situates itself against the effete intellectualism of *The Mind-Body Problem*. Rather than a subdued lavender, the cover explodes with color—black, purple, turquoise, orange, yellow, chartreuse—colors outside the range of tasteful middle-class perimeters. Rather than from a blue-chip artist, the jacket art is "From the original painting *Ensemble* by Synthia Saint James," depicting three emphatically "dressed," stylish and stylized African-American women through a conjunction of simple abstract shapes.

The lack of detail, the forcefulness of the almost geometric pattern, convey vitality, directness, and simplicity—the cover does not intimidate but invites a wide range of readers. McMillan's credentials are not academic; though at the time that she wrote the novel she taught in the English department at the University of Arizona, Tucson, she is described as "an author" who "lives outside San Francisco." The austerity of this description is offset by the glamourous black and white photograph on the back of the hardback edition, in which hair style, accessories, and appearance confirm McMillan as part of the community that she describes in her novel. In contrast, Rebecca Goldstein's academic credentials figure prominently in the jacket description. She:

> received her Ph.D. from Princeton and is currently an assistant professor of philosophy at Barnard College. She recently won a grant from the American Council of Learned Societies to write a philosophical study entitled *The Concept of Body*. (back jacket—paperback edition)

McMillan's novels are not legitimated through references to an established institutionalized educated elite. Rather it is the recommendations of the African-American filmmaker Spike Lee (hardback edition) and the best-selling women's novelist Susan Isaacs (paperback edition) that guarantee the status of the book. These recommendations locate two readerships—the African-American community and women—who are not positioned as the undiscriminating consumers of popular pablum but who are situated outside the culturally legitimate discourse of the serious intellectual.

As neither the product of an intellectual discourse nor a mass culture discourse, the novel defies traditional classifications, reaffirming the paradoxical position of its protagonists as both within and without dominant culture. Too self-conscious to be considered "trash," it nonetheless consti-

tutes a "good read" that cannot be dismissed as the symptom of masculine domination, since the novel constitutes a strident diatribe against traditional gender norms. Contributing to the novel's ambiguous status is its relationship to dominant culture. The novel's discourse places the text firmly within dominant culture: these women are avid shoppers, congregate at the local black hair salon owned by one of their members, Gloria, and worry about orgasms, potential boyfriends, and husbands. Here political consciousness is firmly embedded in feminine consumer culture: these women belong to an organization called "Black Women on the Move," into which again it is Gloria who brings them. These political concerns form another link, another nexus of exchange determining their informal alliance. The women have perms, order underwear from *Victoria's Secret*, while also maintaining a sense of the political urgency of their situation. Their politics is one that takes form largely in the small decisions that they must make from day to day, and most importantly in their allegiance to a black community that excludes whites.

In this community it is the white race, in particular the white woman, who constitutes the racial and sexual other—that moment of abjection.[7] Bernadine reflects on her marriage when she learns that her husband has left her for a white woman:

> All she wanted to do was repossess her life. To feel that sense of relief when the single most contributing factor to her uttermost source of misery was gone. But he beat her to the punch. Not only was he leaving *her*. Not only was he leaving her for another woman. He was leaving her for a *white* woman. Bernadine hadn't expected this kind of betrayal, this kind of insult. John knew this would hurt me, she thought, as she tried to will the tears rolling down her cheeks to evaporate. And he'd chosen the safest route. A white woman was about the only one who'd probably tolerate his ass. Make him king. She's probably flattered to death that such a handsome, successful black man would want to take care of her, make her not need anything except him. She'll worship him, Bernadine thought, just like I did in the beginning, until the spell wore off. Hell, *I* was his white girl for eleven years. (McMillan, 26)

Waiting to Exhale responds to the romance, to its explicit and implicit ethnocentrism, by rewriting its heroine, the white woman, who submits to her lover/husband as "his white girl." The heroine who transforms her world until it coincides with that of the hero becomes a figure of abjection that symbolizes the impossibility of feminine identity except as fantasy. To

be a white woman is to assume the identity of the passive heroine of romance—rather than formulating an essentialist proposition, the novel articulates "whiteness" in terms of position as the moment of an abject feminine that the reader is encouraged to reject. Again the novel's force derives from the fact that, in the novel's terms, to be a white woman is something that no woman "is"—for to be a "white" woman is to be without cultural or racial identity except insofar as it is conferred by the hero, to be completely "his girl."

This said, it would also be a mistake to disregard the cultural identity of these women as specifically African-American, as it is produced through a specific history. Later in the novel, Bernadine meets a man who has in fact married a "white" woman, in the sense of a woman who is not African-American. But here the position of "white" woman is quite different—it acquires a culturally specific term. The woman is dying of cancer and her fate is viewed with compassion by both Bernadine and the woman's husband—who in spite of the fact that the marriage had already begun to deteriorate when she became ill remained loyal to his wife. When he turns to Bernadine for comfort, he turns not so much away from "white" culture as towards his own culture:

> James said it had been ten years since he'd held and kissed a black woman. It had been ten years since he'd been able to talk to a woman without any pretence. He said he was grateful to be standing here. (McMillan, 287)

The novel's conclusion and the happy ending that Bernadine eventually finds is not produced by the overcoming of difference, by resolving the conflict between the childlike heroine and the hypermasculinized hero. It is the acceptance of identity, the recognition of commonality, that leads to the happy union between Bernadine and James. The couple reads each other with ease, seemingly without interpretation, not because they are as one but because they are of the same community.

In spite of the sense of solidarity, of communitas, that the protagonists develop and that comes in a sense to replace the romantic paradigm, this group itself is neither uniform nor homogeneous. The group is constituted and informed by multiple subjectivities, fragmented by the stories of each woman, which both coincide and diverge, producing a pattern of identity that is uneven, crisscrossed with the diversity of experience that produces each story. The absence of a unified voice—a single story—reflects the complexity of feminine experience even within a community of women

tightly bound through common goals, and relatively uniform at least in terms of class, race, gender, and culture. All four women are college educated, born and raised outside the South, between thirty-five and forty years of age. All have moved to Arizona within their adult lives, largely for professional reasons. The traditional markers of community—region, neighborhood, kinship—are absent. The women themselves form an *ad hoc* family as a means of surviving that absence of community in the traditional sense within the mobile population of the contemporary city. Not coincidentally, the political arm of the community is called "Black Women on the Move," underlining the willed mobility of this community in opposition to more standard community values of stability and longevity.

The goal of the new community is not, however, to cut itself off from its past, nor does it see the future in terms of a return to Africa. Rather these women choose to reformulate their traditions within a more specifically "American" vocabulary. When Bernadine receives her divorce settlement, she plans to go to England.

> "We're spending New Year's in London. Don't argue with me either. Didn't you always say to me that you wanted to go to London?" She didn't give Savannah a chance to answer. "You tell those folks down at Drum Beat or whatever the name of that show's called—tell 'em you're goin to see the queen of fucking England. It is time," she said. "It is time."
> "You're crazy," Savannah said. "But I'll start packing tonight. They've got the best hats in the world in London. And I'll buy as many as I can squeeze in the overhead compartment." (McMillan, 395)

Within the *ad hoc* tradition that Bernadine and Savannah create for themselves, they reclaim United States culture as their own—United States and by extension European history (London), feminine culture (fashionable hats), United States national fantasies (meeting the Queen of England). United States culture becomes as much their "culture" as that of any other inhabitant of the United States, but their culture is inflected through their position as specifically African-American. In other words, it is not these women who have become assimilated, but rather it is United States culture that they have assimilated and transformed within their community. For the heroines of *Waiting to Exhale,* "American culture has not been a blending pot," but neither has it been "a river Lethe for all its peoples, their languages and arts" (Thulani Davis, 29). Renee of *The Mind-Body Problem* is unable to reconcile her Jewish identity and her new identity as

an educated, emancipated woman, a citizen within the terms of United States law. Bernadine and Savannah, in contrast, inflect the present with a past that creates neither a longing for the glory days of an African history, nor a jeremiad demanding recompense for the injustices of the United States of the past, of that same history. The new community recognizes the injustices of the past in order to give its members permission to take pleasure in the present—its citizenship claims above all the right to *joie de vivre*, the right to a pursuit of pleasure as part of the pursuit of happiness. Within this tradition, this new tradition is very specifically marked as African-American, by the emphasis on hats and hair for example, by Savannah's collection of work by contemporary African-American artists, and finally by Bernadine's own ambitions as a businesswoman.

> Since those white folks were making a fortune selling these damn chocolate chip cookies, she'd open up her own little shop. Sell nothing but sweets, the kind black folks ate: blackberry cobbler, peach cobbler, sweet potato pie, bread pudding, banana pudding, rice pudding, lemon meringue pie, and pound cake. She'd put it in the biggest mall in Scottsdale. Serve the finest gourmet coffee she could find: cappuccino and all those other ridiculous coffees everybody couldn't live without these days. (McMillan, 400)

In this project of reclamation, Bernadine must recognize both specificity of African-American culture (what "black folks" eat) and also its connection to a more generalized United States culture characterized by a melding of traditions (here a heterogeneous list of culinary products from sweet potato pie to cappuccino). Nor is it insignificant that she situates her "business" within the mall as an economic institution in which cultural crossroads are produced through the activity of shopping—an activity that these women have all shared as a sign of their community.

It is precisely because the novel *does* situate itself as does Bernadine herself within existing cultural and economic institutions that it will be criticized from the perspective of a feminist and political radical left.[8] However, the force of the novel evolves precisely because of the way it situates moments of resistance *within* dominant culture. In this sense the novel refuses the violence that a master narrative of revolution would inevitably produce. As such, it is an imperfect narrative, "dirty" with the compromises of everyday life in which individuals attempt to create patterns of survival for themselves and their community within a finally

hostile environment. Refusing the comfort of a political agenda that would posit an ideal but impossible solution, the novel has more modest ambitions: it concentrates on the bricolage of everyday life through which women and men attempt to pursue happiness as their inalienable right, as the sign of their full status as citizens who speak through culture and are authorized by the law of the land.

Divorce is the sign of this new citizenship—not divorce in and of itself but its treatment within the novel. McMillan does not offer a fantasy of vengeance.⁹ In winning her lawsuit against her ex-husband John, Bernadine asserts not her desire for revenge, her triumph over man, but her status as citizen within the Law to which she has full access and which will eventually speak for her, in her interests. However, this assumption of agency authorized by the Law is far from a submission to the Law as the monolithic voice of authority. The novel's faith in a legal system of retribution is tempered by a sense of justice that owes as much to a system of bricolage as to the master voice of the Law. The legal bricolage that enables Bernadine to pursue justice is another sign of the novel's refusal to articulate a master narrative of justice and social order. Bernadine's lawyer does not take her ex-husband to court—rather she bargains with him, or negotiates a legal settlement that reflects both in her eyes and in the eyes of Bernadine a just return on Bernadine's investment in the marriage. The lawyer uses not only the law but also a private detective, and finally her own sense of how to strategically confound the means by which John sought to exploit his marriage to Bernadine. Bernadine and her lawyer exploit a number of different structures of knowledge, both public (the law) and private (the detective), to ensure justice. Thus the novel constructs a moral discourse that denies a universalist definition of truth and justice, in order to achieve justice as a strategic intervention within everyday life.

Bernadine herself, by refusing the initial settlement (at her lawyer's suggestion and at great financial risk to herself), overcomes her original position as John's "white girl," a woman who submitted to marriage rather than participated in it. Her decision is not easy—Robin, her friend, is astonished that she is not willing to take John's first offer:

> "John had the nerve to offer me three hundred thousand."
> "I'm not a fool," she says.
> She sure sounds like one. If somebody offered me that kind of money, I'd take it and run. (McMillan, 158)

Bernadine is not the fool that Robin thinks she is; as she says to John: "'My pussy is worth more than three hundred thousand dollars'" (131). The "more" here cannot be measured merely in terms of money but rather in terms of Bernadine's demand that John must "account" for his marriage, that she has a legal right to a full explanation of the terms of their financial situation. As Bernadine explains to Robin: "'If I hadn't found out about all his wheeling and dealing, I might've considered settling out of court. But not now. No way.'" (158) This decision reverses her position within her marriage in which her financial acquiescence to John's directives, in spite of her own extensive qualifications as an accountant, represented her submission to an inequitable relationship. Bernadine's mother, like her lawyer and Savannah, urges her to stand up to him:

> "I've been watching how he operates. And how he managed to turn you into this sappy woman while he did whatever in God's name he pleased. . . . All I wanna know is if you're gonna get what's coming to you." (139)

In the process of the divorce, Bernadine must learn to speak for herself. John is not excused but neither is Bernadine described as a hapless victim. Rather, she discards the role of victim which she had previously occupied within the marriage to claim her rights as a citizen. She transforms herself from abused wife into an autonomous subject of the law, to which she both submits by assuming responsibility for her own actions but from whose protection she also finally benefits. Bernadine assumes responsibility, however, not only for her divorce but for her previous marriage—it is this assumption of responsibility that distinguishes these heroines from the heroines of traditional romances, or even from *The Mind-Body Problem. Waiting to Exhale* demands that women speak and act; however in so doing, it does not require that they relinquish their identity as feminine—as did *The Mind-Body Problem,* in which the only professionally successful women were those who had given up this identity. In *Waiting to Exhale,* feminine identity is reaffirmed through feminine culture and heterosexual desire—without effacing the social forces that make this difficult. McMillan's heroine speaks the anger of her heart.

Finally, then, McMillan's heroines are shrewish—they must speak out. Savannah confesses:

> I have tried being honest, telling them as diplomatically as I possibly could that they just weren't right for me, that they shouldn't take it per-

sonally because there was somebody out there for everybody. Which is how I became "the bitch." They couldn't stand the thought of being rejected, that I didn't want them, so of course something had to be wrong with *me*. I *know* I'm not perfect, but I've spent tons of energy trying to be. I wanted to tell all of them to come back and see me after they grew up or got some serious counseling. Unfortunately, most men are deaf. They hate advice. Especially if it's from a woman. They get defensive as hell if you so much as suggest that there's a few things they might try doing that would truly please you. "Fuck you" is what they ended up saying to me, because they didn't want to be told what I liked or needed; they preferred to guess. Well, I'm here to tell you that at least seventy-five percent of the ones I've met were terrible guessers. (14)

Savannah, unlike Kate, can speak her mind because her economic fate, the very ambitions on which Savannah's mother blames her unmarried state, lies in her own hands. She does not need a husband to become "productive."

Savannah also insists on her identity as a woman. However, paradoxically this insistence is made possible through an economic independence that might seemingly be in contradiction with this femininity. Nonetheless, it is this economic independence that enables her to participate in feminine culture, and it is her independence that also allows her to formulate an emphatic heterosexuality, in which she conceives of herself as neither passive heroine nor impassive hero but as an agent of her own pleasure. Significantly, it is the desire for "sex," for sexual pleasure—rather than its effacement and translation into a transcendent experience—that is a sign of femininity within the novel. McMillan's heroines assume responsibility for speaking their own desire. Unlike the heroine of romance who must hide her own desire from herself so that another may speak it for her, Savannah clearly positions herself as desiring "sex" as a specific series of actions, as opposed to a diffuse sense of "bliss," an ineffable loss of self, the moment of nonspecific erotic fusion.

And what if a man's a drag in bed? This list is too long to name names, but of course all black men think they can fuck because they all have at least ten-inch dicks. I wish I could tell some of them that they should start by checking the dictionary under *F* for "foreplay," *G* for "gentle," and *T* for "tender" or "take your time." I've wanted to tell some of them that acrobatics and banging the hell out of me is not the same as making love. I've had enough bladder infections to last the rest of my life. (McMillan, 13)

As an "out of category" novel, *Waiting to Exhale* marks out a significant moment in the construction of a properly feminine discourse. It should not come as a surprise that it is precisely the voice of a black woman that might speak the possibility of a specifically feminine position. For in their battle to claim citizenship (and cultural legitimacy) under the law, African-American women have also forged new definitions of gender. Here, McMillan's refusal of a certain kind of Western-European discourse has also produced a re-examination and reformulation of the nature of heterosexual exchange that is linked to the romantic paradigm but that also renegotiates it. The work of Terry McMillan serves as a strong testimony to the fragmentary and heterogeneous production of contemporary femininities that echoes the everyday experience of women far more clearly than do the phantasmatic scenes of format romance; however, her work does not so much reject the romance as it does put it in its place. This fragmentation of discourses, in which seemingly contradictory traditions of romance and citizenship are renegotiated, is clearly replicated in other feminine genres such as the women's magazine, which both incorporates novelistic discourse but also disperses this discourse through the simultaneous introduction of other texts that evolve out of a number of different positions that might be termed "feminine." The magazine reader must pick and choose among a number of different possible orders, and in its very format, the magazine evokes the possibility of another regime of reading, another way for the reader, herself, to conceive of the reading process, of her role as a reader. One might argue that it is the women's magazine that might serve as the most clearly paradigmatic example of feminine culture as a heteroglossic discourse, and that *Waiting to Exhale* borrows from the women's magazine in its conscious production of a textuality marked by discontinuity rather than continuity. Because, however, *Waiting to Exhale* is finally a novel, with all that this entails in terms of a regime, a process of reading, the preferred experience that it offers its reader differs significantly from that articulated by the magazine itself.

"The Subject is You": Reading Magazines

The space from which perhaps we see the most consistent and entrenched challenge to the transcendent structure of value that forms the academy as such is arguably not among feminist scholars but within feminine culture itself. The women's magazine in and of itself constitutes an

example of the way in which feminine culture both produces other narratives of value and attempts to reconcile them with the dominant structures of value.[10] This heteroglossia of "value" destabilizes any move that might produce immutable value across culture and experience.

The conflict between magazine culture and academic culture is illustrated by the response of Debora Silverman to the exhibits organized for the Metropolitan Museum of Art's Costume Institute by Diana Vreeland, doyenne of high fashion until her death. As a historian, a professor of European Culture at the University of California, Los Angeles, Silverman was dismayed by what she felt was the piecemeal and unsystematic structure of the exhibit, which developed no sense of historical context.[11] The categories of production and historicity were effaced, reduced to a common denominator of style, which is precisely the terms of connoisseurship developed by such magazines as *Vogue* and *Metropolitan Home.* (The magazine *Victoria,* in which a historical period is rewritten as a lifestyle, presents an extreme version of a discourse overwhelmed by such connoisseurship.) This genre of acquisitiveness contrasts with that, for example, of the museum collector, whose approach is historical and systematic, who sees culture as a scholarly rather than a "stylish" pursuit having as personal and domestic adornment. The following commentary by Debora Silverman, from *Selling Culture,* typifies the academic response to Vreeland's emphasis on "style":

> Vreeland's Saint Laurent show succeeded, not as museum education, but as a giant advertising campaign for French haute couture, as a public testimonial to the loyal patrons of the "dauphin" of fashion, and as a glorification of woman as an objet d'art, for whom life is an interminable round of changing from one luxurious outfit to another. (5)

Silverman singles out two fundamental problems with the show:

> The galleries at the Met were not organized according to a chronological development, befitting an artist's "retrospective." Nor did the show instruct us about the way Saint Laurent's opulent ensembles were actually made, or about the position of these haute couture productions within the complex YSL fashion empire devoted to designer mass marketing. (5)

The show did, however, have a logic that corresponds to that offered by the fashion magazine in its description of the fashionable wardrobe, in which the woman's daily life becomes the dominant trope of value.

> The galleries were arranged by color schemas and by the "timeless" divi-
> sions that structure a certain type of woman's day: "day wear" . . . ;
> "cocktail hour"; and lavish "evening wear." (5)

Initial resistance to Vreeland's approach from museum professionals not
withstanding, she gained support and power over the years of her associa-
tion with the Metropolitan Museum of Art until her death, largely because
of enthusiastic public response to her shows, both from the populace at
large and from a wealthy elite who supported the shows through atten-
dance at gala events. Thomas Hoving, director of the Musem of
Metropolitan Art, called her "Diana, the rainmaker," and described her as
"one of my top three curators" in spite of what *Vanity Fair* termed her "aca-
demically unsound entertainments" (Collins, "The Cult of Diana," 175).

Less obvious is the fact that both magazines and the Vreeland shows are
products of, and produce, a cultural reservoir that functions as literacy
within a certain arena. If Vreeland remade Millicent Rogers Mainbocher
blouses rather than using the faded and yellowed originals, it was because,
in terms of this literacy, "to be true to the original spirit, Millicent's blous-
es had to be crisp and fresh" (qtd. in Collins, 190). Truth here operates in
terms of an authenticity that violates academic curatorial standards, which
privilege the original object, in favor of a personal feminine aesthetic—the
aesthetic of "Millicent" who would prefer clean copies to damaged origi-
nals. This literacy positions itself against and in consonance with the
dominant discursive class, forming what I would like to call an occulted
dominant discursive class. I use the term occulted dominant to refer to the
position which many women may occupy, at least at some point in their
lives, in which they are objectively neither poor nor marginalized but in
which they are subjectively dependent. The occulted dominant discursive
class, and here I borrow from intellectual historian Timothy Reiss, is
defined by a set of practices "composed of widespread activities . . . that
escape analysis by the dominant model, that do not acquire 'meaningful-
ness' in its terms, that are therefore in the strictest sense unthinkable" (11).

The moment of enunciation of this discourse is most readily available
in photo-essays that feature the lifestyle of some socialite as opposed to a
covergirl (a covergirl may be the subject of such an essay, but not as a cov-
ergirl, but rather as her other "self"—the one that has dinner out, shops
for vegetables, and collects Fiesta Ware). This particular strategy of enun-
ciation is not exclusive to *Vogue*, but is typical of the way in which the
women's magazine personalizes its discourse. This moment of enunciation

is perhaps most graphically conceived of as the formal articulation of the ideal reader/consumer. During the 1980s, this consumer was often specifically interpellated in a section called "Vogue's View: Style, Ideas, Fashion Action," a regular feature by *Vogue* associate editor Kathleen Madden. A series of brief reports on different fashion news items, it appeared in every issue. This section occasionally included a description of a fashionable woman who is not in any other way a media star—thus "imaging" the moment of interpellation, connecting it to editorials and other photo-essays. This woman is at the heart of the *Vogue* readership, the woman to whom the readers aspire.

The report on "Patsy Tisch california classic," in "Vogue's View: Style, Ideas, Fashion Action," and a one-page layout of photographs and text in the 1986 December *Vogue*, illustrate this concept. Tisch's initial description as "california classic" objectifies her, placing her in a category of like objects with an epithet more appropriate to a car, a wine, or even an antique chair, than to a woman.[12] Marked in two ways, in terms of her look and her family, Tisch's status derives from her connections and her ability to personify the well-dressed, active woman. Her familial circumstances (her connections) are defined patrilineally.

> Arguably, nobody has a more public family: with producer-husband Steve Tisch's new *Soul Man* movie; father-in-law Preston Robert Tisch's new spot as Postmaster General. His brother Laurence has garnered a "new" company, C.B.S. Patsy and her father are setting up a foundation to support L.A. facilities for mental health care. (Madden, 232)

Tisch's look relies on Chanel, creating a matrilineal lineage of style, in opposition to her patrilineally defined social position. The emphasis on Chanel reiterates the tradition of femininity initially enunciated, at the beginning of the central text, through the reference to Hollywood stars that immediately follows the hook "california classic":

> Myrna Loy had it pat; so, too, did Carole Lombard: a way of looking that was well-bred, classic, comfortably Californian. Today, in L.A., Patsy Tisch adds a young woman's finesse. . . . And nobody looks better. (232)

Again Tisch functions as a transitional figure uniting the glamour of the Hollywood star of the past with a contemporary style adapted to new demands. Similarly, the style that Tisch incarnates, as described below, provides a link between the complicated artifice of the old-style star and

the more practical expedient styles of the contemporary woman. Tisch complements the Chanel image with idiosyncratic accessories as a sign of her originality and autonomy. "All add a twist to the best of Chanel," comments *Vogue* (232). She achieves her distinctive look through the combination of "a Hawaiian shirt, 'forties Mexican jewels, bicycle shorts in spandex," and Chanel, a "look" that extends to her house, "a 'Greene and Greene style' California bungalow" resulting from a collaboration with architect Don Umemoto. The text of the one-page article is surrounded by a series of photographs that takes the reader from morning to evening—a taxonomy of appropriate upper-middle class L.A. attire that is color coordinated—thus in organization and logic this layout reproduces the narrative of Vreeland's Yves Saint Laurent show (the logic of which Silverman found so un-valuable). Reading counter-clockwise—a movement that is encouraged by the "U" shape of the photo-layout, which begins in the upper left-hand corner of the page and ends in the upper right-hand corner—the photos reveal a range of clothing choices. Tisch in a menswear suit; Tisch arrested in motion as she strolls down the street in black pants, a white polo shirt, and, thrown over one arm, a black jacket; Tisch lounging on the beach in black pants and a white sleeveless top; Tisch exercising in form fitting black and red leotards; and finally, in the upper right-hand corner, Tisch in a strapless, short, red cocktail dress. The restricted color schema, black, gray, white, and red, lends homogeneity and organization to the diverse selection of styles (as did the color coordination of Vreeland's show). The subtle indications of different environments—a chair, greenery, a beach umbrella, sand—create a narrative that suggests the geographical diversity of Tisch's day, which reaches a climax with the red cocktail dress. The cocktail outfit as the sign of conspicuous femininity is positioned against the more masculine image of Tisch in a suit at the top of the page. In both photos, Tisch is seated, and each image is almost symmetrically placed on either side of the central text. The red dress returns the eye to the suit, in a process of repeated readings that seems characteristic of magazine consumption.

The four remaining photographs summarize the formulas inherent in Tisch's style as they operate in a variety of settings. The photo-commentary corresponding to these images disrupts the natural flow of the U-shape. Magazines produce a thick discourse that invites repeated readings regulated by different regimes of attention in which women may read through magazines several times, initially flipping through to gaze at the pictures, taking in the magazine in its entirety. The second time a woman

reads a magazine she may again flip through the pages, but this time more slowly, letting her gaze linger on images that interest her. Here, for example, if the initial layout intrigues her, or if an outfit catches her eye, she may return to the first photo in the series (Tisch in a suit, seated in a chair), this time reading the material that accompanies it. The reader's eye through the commentary is directed bottom left of center, top right, and finally bottom right.

This process of scattering mimics rhetorically the magazine format as a whole, which is constructed not on the model of a regulated "flow" but in terms of a disorder that is ordered by the reader. (Again we recall Silverman's critique of Vreeland's museumship). A magazine has numbered pages, hence a certain order, but it is architectured rather than narrativized—a house that readers walk through at will rather than a movie in front of which viewers sit captive. The articles and photographs may have a preferred order, but it is so unsystematically inscribed that it is only an active reader who can recreate this order, or some version of it. For example, since articles rarely appear in sequence, the reader must search out the concluding pages, in the process reading other pages, and perhaps abandoning the initial article for one that holds more interest for her. Thus, on the one hand, by disrupting any sense of natural order, the magazine accords a large degree of autonomy to its reader. On the other hand, by refusing its reader a coherent narrative, the magazine gives the reader an impression of complete freedom. There *is* no narrative against which she might situate herself to produce a "reading against the grain." There is, of course, a last determining instance, a global ideological function grounded in consumerism transformed into the signifiers of "style"—as a purely individual expression. Direct opposition to this ideological function is diffused by the heterogeneity of the magazine narrative. However, this very heterogeneity produces, for example, "gay window advertising," to borrow the terms of lesbian theorist Danae Clark—moments which encourage the insertion of homosexual readings within a largely heterosexual discourse.[13] Here I would like to suggest that this concept might be productively extended to include other forms of alternative identifications that are not clearly regulated by, or in the interest of, the patriarchal dominant. As scholars such as Rob Shields and Jim Collins have argued, a global ideology of consumerism cannot guarantee a uniformity of effects.[14] The tension between dominant and occulted, which produces the magazine as discourse, generates a discourse that by its nature opens into other discourses, a range of windows opening onto any number of possible

readings. The failure of magazine discourse to provide the kind of rigor that Silverman craves is its value within feminine culture. This lack of "rigor" in academic terms produces a permeable discourse, a permeability highlighted by the "theft" of magazine rhetoric by such avant-garde artists as Barbara Kruger and Richard Prince.

Typical of this permeable discourse is the appearance of an interview with Coco Chanel by modernist novelist Djuna Barnes in the 1992 August issue of *Self* magazine (126, 127, 168). Academics would, no doubt, deplore the lack of context—complaining that Barnes' importance as a modernist writer has been completely lost since the photographs and commentary direct us to Chanel, "Whose views on femininity influenced a century's fashions" ("Contributors," 18), notably that of Patsy Tisch described above. Yet one might also argue that this piece on Chanel under-lines Barnes' own sense of style. Her photograph ("Contributors," 18) depicts her as nattily dressed in a polka-dot scarf, a hat that lurks some-where between a 1920s cloche and a man's fedora—highlighting a side of Barnes that we may heretofore not have known and that certainly is neglected by literary historians. Because, yes, Djuna has Allure.

This recirculation in 1992 of an article written in 1931, initially reprint-ed in 1985 by Small Moon Press as a high feminist text, constitutes a nexus of feminine and feminist discourse in which we see both the collu-sion between feminist scholarship and feminine culture and their conflicting interests. The reprinting of Barnes' collected interviews, from which this article is excerpted, is a product of the academic's interest in establishing a canon of women writers. This high art project has the ancil-lary effect of legitimating the magazine as one of the outlets for women writers such as Barnes. The contemporary women's magazine reappropri-ates its legitimated past to lend value to its illegitimate present. The magazine profits from this "new" interest in its past by reinvesting this interest in terms of the interest of its readers, that is to say in "style" and its re-creation, rather than in modernist literature. The magazine and its readers give obeisance to the values of academia in the figure of Barnes while preserving their own cultural exigencies as valuable represented through the figure of Chanel, who, in the words of *Self*, "fashioned the century in her image" (126).

Significantly, *Self* reproduces a photo of Chanel that takes up an entire page, almost as much space as Barnes' text, which itself is dominated by a half-page title and lead-in that reads: "Coco talks: The immortal Chanel on the essence of style—and the importance of eight hours' sleep." Barnes'

name follows in much smaller type. Perhaps more importantly, the photo of Chanel on the opposite page has a dramatic impact that seems to overwhelm the text, which appears designed to accompany this image rather than the other way around. If "Coco talks," it is as much through her image (photographed by Alexander Liberman) as through her words, recorded by Djuna Barnes. Similarly, Chanel's interview instructs women in how to produce a self-as-image that will survive as style. Thus, in the context of *Self,* it is Chanel the designer who speaks through and over Barnes the writer in offering women a template, a model on which to construct their "self." This doubled figure of Barnes/Chanel that superimposes two feminine/feminist traditions typifies the heteroglossic discourse of the women's magazine—but it is antithetical to the discourse generated by feminist scholarship, in which only the single univocal figure of Barnes is retained.

One of the paradoxes, then, of consumer culture, is that perhaps the women's magazine does a better job of speaking for women, of empowering their voices, than does the feminist scholar who has set this as her task. I am not suggesting that we see women's magazines as some emancipatory institution, as the site of an authentic resistance to the patriarchal norm. Certainly, the reproduction of femininity as a social category, in which the women's magazine participates as one of its primary functions, serves to reserve the position of occulted class to a majority that might otherwise constitute the dominant class as a heterogeneity of voices. Thus the women in this class pay dearly for their privileges: the price, their dependency. Rather, I would like to suggest that as feminists we might learn from the women's magazine as a pedagogical model, one that meanders yet remains contained, that offers information within a heteroglossia of narratives rather than from a univocal position, that accumulates rather than replaces, that permits contradiction and fragmentation, that offers choice rather than conversion as its message.

In looking to the women's magazine as a model, I would also like to introduce a note of caution: these possibilities of dispersion are always recentered through the women's magazine's focus on the body and its definition through product usage. In the April 1987 issue of *Vogue,* a fairly long article by Rita Freedman, entitled "Looking Good: The Double Standard," articulates the problem and the pattern of displacement that circulates the feminine position through the apparent contradictions of mastery and submission, creating coherence through a repeated trajectory of denial and affirmation. The use of a small title in the upper right-hand

corner reading "Mind/Body: The New Basics" underlines this trajectory. The comment implies that the mind and the body can be reduced to a few manageable basics, like the little black skirt that, dressed up or down, can go anywhere. The use of fashion as a global signified is again symptomatic of the *Vogue* discourse, in which the rhetoric of fashion is ubiquitous, applied indiscriminately to health, culture, and education. The rubric of fashion as a global signified of fashionableness enables *Vogue* to draw together various contradictory discursive strands, lending them an effect of coherence. Thus, the "signified" fashionableness in and of itself is an empty term—a signified produced by a disparate collection of ever changing signifiers, "style," from the pattern of the material that sheathes the well-toned and slender leg to the angle and slope of shoulder—all signifying fashionableness, a lexical entry that speaks only in tautological terms of the signifiers that produce it as a signified. "Fashionableness" becomes a story waiting to be told, a fiction of coherence ready to be assembled.

Crucial to this effect are the photographs, in fact a photo-portrait, of "British model-turned-actress, Amanda Pays" ("A New Image," 356), that seemingly accompany the article. These photographs are not obviously connected to the text; however, by virtue of the conjunction of image and text, Pays becomes the visual manifestation of the philosophy set forth in the article. A full page image of her in the nude accompanies the first page of the article. This body incarnates the contradiction at the heart of the *Vogue* subject of enunciation. True, Pays's body is full-formed, fleshier than the anorectic norm promoted by the fashion model in general. Yet, at 5' 7" and 118 pounds, she is still thinner than a "medical" norm and considerably thinner than a social norm; in other words, for the majority of women she still represents an ideal closer to that of the "waif" model, criticized for promoting a body type that encourages anorexia, than that of the average woman. In addition, the photograph represents her body as completely unmarred by the passage of time, by childbearing, illness, or accident. Her features are unlined, the "hot spot" on her face burning out any irregularities—a body and face without biography. The camera has arrested Pays in a moment of perfection marked as such precisely because it is unmarked.

As in cover photos,[15] a text, this time at the bottom of the image, explains the image in terms of product usage. Though Pays is nude, she is surrounded, her image literally embedded, in consumer objects. "Body smoother, Biotherm's Enriched Body Treatment" apparently has imparted the silky gleam that clothes Pays's naked form. "Giorgio Armani's men's

pajama top" is clutched against her body, hiding the pubic area, and "Hat, Ralph Lauren Hat Attack" sits on her head (356). "Fashion Information," a section at the end of the magazine, indicates where the reader can purchase this hat: "Hat at Polo/Lauren, NYC and Birmingham MI" (399).[16] Above is a description of Pays's philosophy of life:

> Part of the Amanda Pays approach: a down-to-earth style. She doesn't lead just the life of a movie star but that of an active woman. "In between audition, acting classes, mundane chores like dropping off the laundry, there's yoga, maybe a run afterwards." She admits that her body—rounded, bosomy—isn't model-size; but, neither is she obsessed with reshaping it. And although she posed nude for us, she says there's no need for a woman to expose her body; "men rarely do." (356)

This discussion establishes Pays as a physical and behavioral model for *Vogue* readers. Pays is like her readers—she runs errands, she isn't a typical fashion model—but she is also more, an actress, photogenic, successful both in terms of career and looks in a way that is not within the reach of most readers. The sort of double talk inherent in the position to which she gives voice is characterized by her attitude towards nudity: "Although she posed nude for us [us, the *Vogue* readers as an ideological category], she says there's no need for a woman to expose her body; 'men rarely do.'" Pays, on the one hand, asserts her femininity by revealing her body—"men rarely do", thus, she is not a man. On the other hand, she asserts her control over the process as a sign of activity by claiming that "there's no need for a woman to expose her body." Implicit here is a distinction between activity, the choice to display the body for other women as a sign of feminine solidarity, and the seemingly passive display of the body for the masculine gaze. Ultimately, the issue of display remains a primary imperative, and the ability to function within a regime that privileges display is underlined as crucial to the constitution of the *Vogue* subject—the subject position that it offers its reader.

The actresses, the models, the career women depicted in the magazines, both in the ads and in the editorials, are successful *both* in economic terms and in terms of creating themselves as aesthetic objects within the regime of product usage advocated by the magazine. The concept "an active woman" summarizes this new ideal in which femininity is redefined as an active assertion of will. The dichotomy activity/passivity as an articulation of masculine/feminine subject positioning is displaced through a schema that invites women actively to assert control over their representation. This

displacement enables women to enter into a new regime of "activity" while maintaining an historical coherence to their identity as feminine. A second full page photograph follows the first; in this photograph, Pays as an image of the feminine is defined in terms of a history and a tradition.

The second photograph of Pays situates the new active feminine within the genealogy of the seductress. This photograph inserts Pays as an image within a series of images historically associated with femininity and seduction, such as Bardot and Fonda in their Vadim periods. Her hair is disheveled. Her makeup is understated except for her pouting lips colored a vibrant red, emphasizing an almost primal sexuality. "Makeup is embellished but understated" reads the description that includes an enumeration of the products and the "authors" that produced the look:

> Ultima II's Norell Red lipstick. Man's vintage cotton piqué formal vest.
> F.D.R. Drive; necklace, Matsuda. These six pages: Hair, Sam McKnight
> of La Coupe, NY; makeup, Andrea Paoletti. (358)

Around her neck is an ornament somewhere between an army medallion and the black velvet ribbon romantically associated with the turn-of-the-century demi-mondaine, by Matsuda, a famous Japanese line, touted as the expression of post-modernity. This pastiche effect is emphasized by the white vintage cotton piqué man's vest, which appears to be all that Pays is wearing—seductive because it suggests that which must be revealed outside the frame of the page, which we have recently seen on the preceding page, and because the masculinity of the vest contrasts so strongly with the femininity of Pays's appearance.

The heteroglossia discussed earlier as marking the magazine text through its deliberate fragmentation of the reading procession is replicated stylistically in the image. Here, specifically, a conjunction of contradictory propositions, from nature to artifice, from masculine to feminine, recreates the fragmentation of the reading process. This fragmentation is effected both in terms of flow (the images that precede and follow this image) and in terms of elements within the image (such as man's vest and red lips). This process of dispersion is recuperated by the apparent homogeneity of the images themselves in terms of style (lighting, composition, etc.) and materiality (in which the slick and rich paper and ink used by the fashion magazine—as opposed to the newspaper—plays a critical role). The sensuality of the image imbues the text with a material cohesiveness. This sensuality of image as material reiterates the importance of image

construction through product usage and image as "style" for the construction of the feminine—as though the luxurious image as material were the manifestation of femininity as a sensual effect.

The article itself describes with lucidity the tyranny exerted by the type of imagery of which the photographic series on Amanda Pays is typical:

> The pathology built into the feminine role (including excessive demands for physical attractiveness) remains invisible as long as a culture defines it as healthy. To enact femininity through preoccupation with appearance, for example, fosters excessive narcissism; yet failure to cultivate good looks causes insecurity and self-rejection. (Freedman, "Looking Good," 359)

This dilemma is further explicated throughout the article, which emphasizes that, in order actively to consolidate her professional and social power, a woman must submit to external norms. *Vogue* explains the source of the dilemma:

> Feminism encourages re-examination of one's identity. It fosters an active approach to problem-solving, teaches personal control through assertive behavior. . . . Eager to reshape their lives, some women focus excessively on reshaping their bodies. . . . These dynamics are evident in such disorders as anorexia, weight obsession, and compulsive fitness training, disorders that have all increased in a climate of feminist reform. (Freedman, "Looking Good," 396)

The article further elaborates:

> Camus observed that after forty we become responsible for our faces. Women who seek a surgical solution to the double standard of aging may be making a healthier response than those who withdraw into a depressive state. . . . the face-lift is being sought by many psychologically healthy females who take an active problem-solving approach to life. (397)

The article concludes with a quotation from Susan Sontag:

> Instead of being girls, girls as long as possible, who then age humiliatingly into middle-aged women and then obscenely into old women, we can become women much earlier—and remain active adults, enjoying the long erotic career of which women are capable, far longer. (397)

By citing both the existential philosopher Camus, and the contemporary intellectual Susan Sontag, *Vogue* attempts to clothe with a certain profundity the banality of its pragmatic solution to this issue of aging.[17] It is not a magazine for girls—but for women. But to be a woman, as opposed to a girl, in *Vogue*'s terms, is to become a certain type of consumer; she is active, but nonetheless a consumer, essentially representing herself through a certain type of consumption through which she produces her body as such. This situation of the feminine, between production and consumption, is one of the current preoccupations of feminist practice—a paradox that it seems unable to resolve.

5

SPEAKING THE BODY
JANE FONDA'S WORKOUT BOOK

It has become commonplace in feminist criticism to draw upon Michel Foucault's account of the production of the docile body in the eighteenth century to discuss the representation and production of a feminine body within contemporary feminine culture.[1,2] Susan Bordo in particular mobilizes Foucault's argument to articulate a concept of the feminine body as a "site of struggle where we must *work* to keep our daily practices in the service of resistance to gender domination not in the service of 'docility' and gender normalization" (Bordo, "The Body and the Reproduction of Femininity," 28). If, as Bordo asserts, "Our bodies, no less than anything else that is human are constituted by culture" ("Anorexia Nervosa and the Crystallization of Culture," 90), how is resistance "constructed" within a cultural formation that must produce a docile body? From a Foucauldian perspective, the "resistant" body, in Bordo's terms, is no less a product of cultural discipline than the "dominated" body, the body of "gender normalization." By positing the resistant body as an exception within a formation that must by definition produce docile bodies, Bordo implicitly suggests that the feminist project should be a return to a "natural" body, a body constructed outside a system of discipline and punishment. She assumes the possibility of access to a body that would appear to be outside ideology. Within Bordo's argument, the body then takes on the status of an a-semiotic category with which the feminist might have an unmediated relationship, though she herself contends as stated above that the body by definition is culturally constructed.

One might say that Bordo's argument sets up a new "repressive hypothesis" in which it is the body rather than sexuality that has been deformed or "repressed" by social practice. Her goal then would be the recuperation of a "repressed" body as the once and future unmediated natural body. Lois McNay makes a similar complaint about the work of Sandra Lee Bartky: "The implicit assumption Bartky makes is that under the 'ensemble of systematically duplicitous practices' which control the female body, there is a 'true' female body, undetermined by social constraints, that has yet to be expressed" (McNay, 38). The framework posited by Bordo and Bartky depends on the notion of a repressed body, which awaits liberation. This assumption poses a number of problems. If we read "body" in the place of "sexuality," Foucault's discussion of what he calls the repressive hypothesis holds equally true for the female body: "I do not maintain that the prohibition of sex is a ruse; but it is a ruse to make prohibition into the basic and constitutive element from which one would be able to write the history of what has been said concerning sex starting from the modern epoch" (Foucault, *The History of Sexuality*, 12). Within a Foucauldian framework it is no more possible to articulate a "natural" feminine body than to discover "natural" sexuality. The discipline of the female body described by feminists such as Bordo and Bartky is not a "ruse," a covering over of the truth. Femininity *is* the result of "disciplinary practices that produce a body which in gesture and appearance is recognizably feminine" (Bartky, "Foucault, Femininity, and Patriarchal Power," 64). However, to write a history of the female body as the univocal expression, the sign, of a pure "domination" is to fundamentally misread the complexities of feminine culture in terms of a homogeneous systematicity—rather than "a multiplicity of discourses produced by a whole series of mechanisms operating in different institutions," to borrow again from Foucault's discussion of sexuality (Foucault, *The History of Sexuality*, 33).

Conceiving of a body produced not through a binary opposition between resistance and normalization but as the result of a series of conflicting and perhaps even contradictory disciplines or procedures poses a fundamental problem for an analysis that marks itself, authorizes itself, as "feminist"; discarding the opposition resistance/normalization forces the feminist to abandon the binary opposition between feminine and masculine that is the founding moment that defines the feminine, and the feminist as such. The feminist appropriation of *Discipline and Punish* hinges on the notion that this opposition feminine/masculine is in fact the opposition that defines the body as such, an appropriation that is also a

criticism of Foucault, whose analysis fails to recognize gender as the fundamental determinant in the production of power. Bartky contends that Foucault's "analysis as a whole reproduces that sexism which is endemic throughout Western political theory" (64). Yet, the nature of the project that Foucault defines for himself in *Discipline and Punish* revolves not around gender but around the construction of a public body. In a sense the construction of the "modern body" is the production of a public body, specific to a class, a gender, and a historical period which eventually becomes the body politic, the body of the citizen. Not all bodies are subject to the same disciplines. To argue otherwise is to create universal ahistorical categories of domination that efface the actual social conditions that produce the "modern" body. It is precisely the fact that not all bodies are eligible for the discipline that will eventually produce the "modern" body that gives it its cultural identity; critical to the production of this identity are the public institutions of education and the military. Bodies excluded from these institutions at a given moment in history, whether it be due to gender, class, race, nationality, etc., are also exempted from these disciplines, and are shaped, embodied, through other cultural formations.

The female body was traditionally excluded from public education, especially from what is known as "physical education" in the United States. Indeed it is only in the last fifty years that what is known as "higher" education (after the age of sixteen) has become generally available to both men and women.[3] Women are, of course, still exempted from military service, at least in the United States, even in times of war. The female body becomes the subject of a public discipline only in so far as it moves from the private to the public sphere, a gradual process that takes place over the course of the nineteenth century, moving into the twentieth century. From the Foucauldian perspective, it is the male body and not the female body that is dominated within the public sphere. In fact we might say that within the public sphere the female body represents the undisciplined body, and as such is a threat to the public order produced by the discourse of discipline and punishment delineated by Foucault. This "threat" is contained or "disciplined" in various ways, such as the hysterization of the female body in the nineteenth century, in which, as Lois McNay explains, "a certain knowledge was established which allowed the regulation of desire and sexual relations with the ultimate aim of discipline and control of family populations" (41).

By concentrating exclusively on the notion of the "docile body" of *Discipline and Punish,* Bordo and Bartky pass over the specificity of the

production of the female body within the private sphere, which was governed by its biological reproductive function. In so doing, they can privilege the female body as the dominated body, from a traditional feminist perspective. Though the male body is similarly dominated, it is always posited as subject to less domination than the female body. To recognize the simultaneous production of the feminine and the masculine, in which the one defines the other, places the feminist in a dangerous position in which the female body can no longer be invoked as the exemplary body of the "aggrieved." Rather than speaking as a victim, she must speak in terms of social structures and positions, relinquishing her privileges as the voice of this "aggrieved." Though feminists have been criticized for taking the position in which gender is the primary determinant of social oppression (see, for example, the work of the African-American feminist bell hooks), it is always with the purpose of staking out another hierarchy of more or less dominant, more or less subjected, in which the position of the white bourgeois feminist is compared unfavorably, or rather favorably, with that of some other population—African-Americans, lesbians, etc. This hierarchy is measured against a humanist utopian model in which perfect equality and liberty might be achieved, in which the "white male" citizen is held up as the liberated ideal, the norm. He is an exemplar of privilege, of full citizenship, who is paradoxically the furthest away from alternative justice manifested as a "natural" sense of rights and freedoms because he and he alone has been accorded these rights.[4] The politics of this position is always geared toward the production of parity between the "white male" citizen and the population of the aggrieved. Thus, for example, the fight for equal wages is always determined by measuring how much less a woman, a black, a latino, etc., might earn in comparison with a white male.

But if one does indeed want to adopt a Foucauldian perspective, the well-documented discrepancy between men's and women's wages in the United States does not produce in itself relations of power; rather it is a product of the articulation of power within U.S. culture. This discrepancy is not so much a measure of Man's domination over Woman but of the technologies of discipline such as education that produce masculinity and femininity as discursive categories. A Foucauldian methodology renders problematic a politics based on a hierarchy of "aggrievements" in which privilege is accorded, as it were, in mirror image to that culture it purports to critique. To generate a feminist agenda that is based on such a hierarchy, that is to say based on the assumption of a hierarchy of the more or less

dominated, will eventually only serve to preserve that hierarchy in one form or another.

What I wish to suggest here by painting this picture in broad strokes is that perhaps as feminists we are asking the wrong questions. The discipline of the body is a given within any social formation. The questions then become: how do we articulate the stakes of the historically specific forms of a given discipline; in the service of what larger discursive structures does it operate; and finally, what are the profits and losses of this discipline as opposed to some other procedure or technology? I want to focus on the "aerobics craze" in the United States during the 1980s as a specific formulation of public discipline in which both the panoptical model of "docile bodies" and a new "culture of the self" converge to produce a feminine body. This formulation of the public body occurs precisely at that moment in United States history in which the majority of U.S. women worked outside the home. The shift from a body in which the woman's primary function was constructed in terms of biological reproduction within the private sphere, to a body that "worked" within the public, demanded a new form of discipline. As she spent less of her time caught up in the process of biological reproduction, and more of her time within the public sphere, the discipline of the female body could no longer be left in the hands of the family as the primary institution regulating the private sphere.

My analysis assumes that *Jane Fonda's Workout Book* provides a "document" that is both produced by and productive of the generation of a public body, the body of a citizen that was designated as feminine. In this sense, insofar as the "citizen" was a neutral category that did not specify gender but that implied masculine by default, the creation of a feminine citizen, embodied as "Citizen Jane" (a soubriquet attached to Fonda by one of her biographers), produced a specifically "gendered" citizen. I take as my text *Jane Fonda's Workout Book* as an exemplary moment in which exercise, previously simply a general program of fitness and good health, becomes a central discourse of feminine culture. The book documents the reformulation of an activity ("physical fitness") previously on the edges of ideology (dependent on a masculine ideal of athletic activity) as a central practice of a "self" defined as feminine. The book itself constitutes the "writing" of a more generalized, less specific, practice, exercise (fitness, calisthenics, etc.) in new terms, as a facet of the new public feminine, formulating a de facto meta-critical text in which procedures are situated in terms of larger discursive structures. As such, *Jane Fonda's Workout Book*

provides a narrative that articulates a "technology" or practice of the self. This "document" parallels the type of texts that Foucault has used to define "the culture of the self," which offer instruction in the production of a "self" to a "subject" that willingly engages in its discourse. This notion of discipline contrasts with that defined in *Discipline and Punish,* in which subjectivity is theorized only through the production of a "docile body" (McNay, 61).

As Sandra Bartky herself remarks, "no one is marched off for electrolysis at gunpoint" (Bartky, qtd. in McNay, 33). However, the virtue of a theoretical conception of a subject that takes an "active" part in his or her production, a deliberate cultivation of the "self," is that it offers not simply an explanation of why women engage in a process of self-discipline without being threatened at gunpoint, but because it also offers a model of resistance that does not fall back on some form of the repressive hypothesis (McNay, 61). If feminine culture has as its sole goal to turn women into "the docile and compliant companions of men just as surely as the army to turn its raw recruits into soldiers" (Bartky, qtd. in McNay, 33) how then would Bartky herself come to occupy a position from which she might speak against such a system? Rather it seems more accurate to see the subject as produced heterogeneously in which a degree of choice is offered her. Foucault himself suggests this possibility in the very concept of a deliberate culture of the self. According to McNay:

> The individual might exercise a degree of choice in the way in which he fashioned his existence, but the practices through which self-mastery was achieved were always conditioned and overdetermined by the socio-cultural context. At the same time, although practices of the self are defined by the social context, the way in which the individual is related to these practices is by no means reducible to such a context. (61)

Fonda offers, signaled through the use of the possessive in the title, a specifically feminine "model of self-mastery," which preserves the dichotomy masculine/feminine but reformulates the terms of this opposition. It is "her" self-mastery that Fonda "works out." In this production of "mastery," the subject resists the domestic disciplines of the family by submitting to a public discipline, or another technology or procedure of "domination." The question that Fonda's practices pose centers around this issue of resistance: in the articulation of a public practice that is linked to the discourses of consumerism and nationalism, does the workout transform tactics of resistance into strategies of domination?

Jane Fonda's Workout Book provides a first avenue of analytic access to a discursive practice wherein a specifically feminine project of self-mastery is articulated within the context of the 1980s, that is to say during the waning of Second Wave feminism, and the production of a position that has been termed erroneously post-feminism.[5] As such, the book constitutes a handbook transcribing a rhetoric of the body particular to the practice of the workout in which the strategies of domination appear to coexist with tactics of resistance.

Important to the status of this handbook is the social and cultural position enjoyed by Fonda. For more than three decades, in a range of media, Fonda has maintained her social and popular prominence. She is, in Henri Lefebre's terms, an "Idol":

> whose outstanding advantage is that they are perfectly unremarkable (neither too ugly nor too beautiful, too vulgar nor too refined, neither too gifted nor without gifts), that they lead the same "everyday" life as anybody else and that they present to everyone an image of his (everyday) life transfigured by the fact that it is not his but that of another (an Idol, therefore rich and famous). Thus it is absolutely fascinating to watch an Idol amid his satellites having a bath, kissing his children, driving his car or doing any one of these things that everybody does but as if nobody had ever done them before. (175)

In addition to representing a transition point between the exigencies of everyday life and the glamour of an Olympian existence, Fonda articulates the mutability of feminine representation. In contrast with stars such as Brigitte Bardot, Fonda's ability to transform the perimeters of her star iconography lent a peculiarly feminine cast to the construction of Jane. Unlike Madonna, who foregrounded mutability as a sign of post-feminist femininity, Fonda's presence was paradoxically fixed; she would always evoke an essential Americanness.[6] If Madonna is frequently analyzed as "problematizing the bourgeois illusion of 'real' individual gendered selves (there is nothing *but* masks)" (E. Kaplan, 149), Fonda represents the ideological integrity of the category of a "bourgeois" gendered self despite its transformations. In other words, as an icon she embodies a narrative of transformation grounded in an ideology of identity, of a fixed self—a serial authenticity and sincerity.[7]

It is precisely the changes in the perimeters of this category of American femininity, of a nationally identified, gendered self within United States culture, that her star iconographies mark out—from Barbarella, innocent

and sexually available, to anti-Vietnam activist, chastened and cynical. Peter Carroll, in his work *Famous in America*, in which he analyzes the careers of four contemporary United States public figures, attributes Fonda's significance to her ability to articulate in particular "the transformation of sexual values" in United States culture during the period spanned by her career. Carroll comments:

> Her early roles reflected a prevailing fear of sexuality: She played the parts of flirts, sexual victims, or frustrated wives. After moving to France in the mid-1960s, she symbolized a loosening of values: the acceptance of nudity, adultery, and obscenity. After 1970, her own politicization served as a model for her roles. She portrayed women as independent people. As a businesswoman, moreover, she epitomized the female entrepreneur of the 1970s, merging career, family, and social involvement. By the 1980s, sexual freedom and beauty appeared less important than concern about fitness, health, and aging. (269)

As important as her roles as an actress is the attention she has received, and no doubt encouraged, from the media. Carroll comments in a "Bibliographic Note":

> One suspects that the willingness to reveal personal information to the general public represents a basic ingredient of the personality of success in a democratic society, which might be viewed as an umbilical relationship between leaders and followers, celebrities and fans. For, if fame is its own reward it hinges nonetheless on the continued feeding of the public maw. (271)

Fonda fostered and exploited a privileged position in the public eye that she literally inherited from her father, the Hollywood actor Henry Fonda, which in a sense constituted, more than anything else, her initial cultural capital as a national Idol. Rather than occupying a passive position as public image offered for voyeuristic consumption (suggested in Lefebre's description), Fonda gave voice to a range of concerns in which she saw herself as functioning as an agent of social change while simultaneously reinvesting her cultural capital as star. As a business woman, she incarnated the image of the star as producer as well as product—that is to say that, rather than transforming her role as "star," she augmented it so that she became the producer, the distributor, of her "self." As both star and entrepreneur, she became herself her own product.

Rather than positioning herself in front of a mystified public, Fonda self-consciously exploited the process of production as well as its product. Fonda identified with her public and invited them to share with her the now demystified process of the production of glamour and beauty. Part of Fonda's status as a star is that her public recognizes her status and her function as both producer and product, as a star who self-consciously represents both to her public. Thus, *McCall's*, a women's service magazine, describes Fonda as: "The original zeitgeist woman—a sex kitten in the '50s, antiwar radical in the late '60s, feminist in the '70s, successful entrepreneur in the '80s" (Ball, 96), emphasizing her identity as one that represents the concerns of a given moment rather than a constant. An embodiment of recent feminine history and culture, this identity that is both somehow transformable and cohesive, in the sense that Jane is still Jane from one incarnation to the next, represents the possibility of a feminine position in which the woman takes control over the "self" that she produces, and transforms according to a given context. This transformability as a position of feminine empowerment is most palpable in the emphasis placed on Fonda's body.

Shape, another women's magazine, focusing on fitness, includes this notion of transformability as crucial to the Fonda image, but underlines Fonda's role in terms of her position as an idealized body that she herself has produced:

> When Jane Fonda's name is mentioned, a plethora of images comes to mind. Jane Fonda the actress, Jane Fonda the daughter, Jane Fonda the wife, and yes, we still remember Jane Fonda the political activist. No image is as strong, however as Jane Fonda as the fitness leader. . . . why is it that with all the thousands of exercise videos available, it's still this actress who has made such an impact on the world of fitness? Maybe it's the seriousness with which she addresses the subject, possibly it's her no nonsense manner, or perhaps it's because she looks so fantastic we figure if Jane can look like that at age 50, maybe, just maybe, she knows what she's talking about. (Harris, 66)

Fonda fosters this identification by downplaying her role as an "authority," and underlining her own identification as a form of celebrity counter-transference with the women who purchase her tapes. Thus she confesses to *Redbook,* another women's magazine directed towards a general readership:

"People listen to me because I've had the kind of warfare with food that they are having. . . . I thought I was fat, and so I became anorexic for a *long* time. It took me years to recover from that. Then, around 1957, I discovered the benefits of exercise. I want other people to share in this knowledge—and they have, thanks to me and my big mouth." (77)

Critical to the larger discursive function of the workout itself is the process whereby Fonda as a popular icon reproduced herself within a commodity system through ancillary texts such as the women's magazines quoted above. These larger discursive moments authorize the articulation, within *Jane Fonda's Workout Book,* of "doing Jane" as a process of self-control or self-production representing an economic and political agency integral to the practice of working out. In *Jane Fonda's New Workout and Weight-Loss Program,* Fonda gives currency to the use of this expression to signify working out according to the Fonda method:

It's very gratifying to me that "doing Jane" has had such a positive effect on so many people's lives. And as I had hoped, the results reported back to me person-to-person or in letters demonstrate not only weight loss, but also reduced stress, increased energy, more interest in nutrition, more motivation to become involved in sports, less need for medication and many other life-enhancing benefits. (89)

Important here is the distinction between "doing Jane" and "being Jane." Rather than encouraging a passive identification with an image or Idol, the expression suggests an active choice and mode of reproduction. "Doing Jane" resolves the dichotomy between a public femininity grounded in notions of political and economic agency, and a private femininity in which identification with an image is the guarantee of a gendered sexual identity. The workout phenomenon as a significant moment derives from the conjunction between Fonda as a totemic representation of a new public feminine and the generalized pursuit of a feminine body constructed through agency rather than passivity: the production of an "undocile" body that does not disrupt existing heterosexual institutions in which a woman "appears" for a man. "'In a world that is increasingly out of control,'" Fonda says, "'it's something you can control. I may dress for a man, but I exercise for myself'"(Ball, 143). The "it" that Fonda "controls" is variously her body—not the body constructed when she dresses "for a man," but the bod(ies) produced in the process of exercise, a discipline that she controls as a sign of "agency" and finally of subjectivity and citizenship.

Jane Fonda's Workout Book as a meta-commentary constitutes a documentation of these intersecting discursive practices. The book as text draws together the diverse threads that, woven together, tell "Jane's story," generated by the social ideal of the fit body and mediated through Fonda's status as a star. The book as the formal writing out of this intersection is only one element that serves to fix the practice of "doing Jane." Fonda as the advocate of a certain practice converses with women as members of a larger social body at a number of levels: through print (the books), through electronic media (records, audio cassettes, and video cassettes), and finally through exercise studios run by Fonda herself. These three levels are interconnected and permeated by ancillary media texts surrounding Fonda, which circulate the body template that she represents in its various avatars and focus the public's attention on the workout constellation. The exercise studios themselves, though initially of crucial importance in publicizing the ethos of working out through the creation of an actual physical presence, are now all closed. An attempt to launch a line of workout clothes was also a failure. The books and tapes, however, continue to sell.[8] The most explicit articulation of the workout methodology as "technology of the self" is found, perhaps, in the series of books produced by Fonda.

Jane Fonda's Workout Book, Fonda's first workout book, underlines the manner in which the workout engenders, in Timothy Reiss's words, a set of "conceptual tools that make the majority of human [here, feminine] practices meaningful" (11). Thus, the significance of the book as a text lies not only in its documentation of the exercises as a technology of the body, but also in the manner in which these exercises are situated through metonymic and metaphoric relationships to larger ideological categories. Fundamental to the constitution of these categories (such as humanism, nationalism, etc.) is the formulation of a feminine identity displayed initially through the body. The dominant focus of the book is the conceptualization and inscription of feminine norms through the body.

For those unfamiliar with this volume, let me first describe its general structure. The book is divided into five parts: Lessons Learned (I), Wholly Health (II), Being Strong (III), The Workout (IV), The Body Besieged (V). The longest section (Part IV) is devoted to descriptions of the workout exercises revolving around photos of various women performing these exercises, which isolate different body parts (arms, waist, hips, etc.). The description of the workout itself fills 141 out of the 254 pages in the book. The rest of the book (sections I–III and V) constructs an autobiographical apologia in the style of Augustine's confessions legitimating the workout as

the manifest practice of a larger discursive category—or moral and philo-sophical position. As the titles of the chapters themselves suggest, the book leads the reader to a position from which she may reclaim her body as "a body abused" and "hold" it against further attack in a social context in which, to quote Bordo, the body will always be "a site of struggle"—or in Fonda's terms, "the body beseiged." The apologia defines how the workout functions as part of a way of life—it calls forth the subject of the workout, which itself as a technology defines the body as object. Thus the book reproduces the process by which a woman is constituted as both a subject and an object within a given context, whereby a woman may aspire to a limited sense of "control" over the troubled terrain of her own body.

Here, in the detailed enumeration of the positions of the body, the dis-cipline of the workout does in fact recall Foucault's analysis of the development of a military discipline in the eighteenth century, which he describes as follows:

> it was a question of not treating the body, *en masse,* "wholesale," as if it were an indissociable unity, but of working it "retail," individually; of exercising upon it a subtle coercion, of obtaining holds upon it at the level of the mechanism itself—movements, gestures, attitudes, rapidity: an infinitesimal power over the active body. (*Discipline and Punish,* 136–137)

The details of the actual disciplinary procedure are less important than the conceptualization of a technology of power founded on a discipline of the body as a segmented and thus controlled and controllable entity, which initially suggests a marked parallel between the discipline of the workout and of military procedures. The procedure of control effected through the workout is formulaic and depends upon a regimentation and articulation of the body as an incremental process. Not withstanding that the detailed articulation of the body offered by the Workout book creates precisely such a compendium of a body broken down and reassembled, implied in this same description are the major elements that distinguish Jane's discipline from the military discipline described by Foucault. Firstly, the practitioner "does" the exercise; she disciplines herself as an individual rather than moving in a body as does the military unit. The body is very clearly her body, just as it is Jane's workout. Though women exercise in groups, they are inducted into the group not through identification with the group but through their designation as autonomous individuals who discipline themselves. The instructor offers herself as an example (as does

Jane in her book) rather than an authority. If it is Jane who "authors" the book, her authority is generated by her membership within the group to whom she speaks. She is not a professional physiologist—rather, like her reader, she is simply a subject in search of an adequate practice, a culture of the self. According to *Shape,* her "fans" claim: "that Jane is their motivator. They belived that if Jane had her name on a product, it would be a quality product" (Grant, 147).[9]

This possession of the body by its "self" is complicated by the fact that, as has been pointed out by such scholars as Margaret Morse and Susan Willis, the exerciser possesses her body through her identification with an image that is not her own image but that of the exemplary bod(ies) offered her. When exercising in a group she compares her body, which she identifies in the mirror, with those bodies previously offered her, whether in books, or on video, or in magazine spreads. When exercising with a video tape, this disjunction is further marked by the exerciser's identification with a video image that appears to mirror her own image, but that offers her an "other" body, effectively eliding her own image, which she would normally see in the studio mirror. Finally, though the woman produces her self guaranteed through the projection of an adequate image, this guarantee is effected through the generation of a topology in which she measures her image against the other image of the exemplar. The proliferation of images in the workout book, the detailed delineation of the body as image, serves to reiterate this specular relation in which the practice of exercise as the "un-imaged" moment is the linchpin in this construction of self. In order to ensure this relationship, to fix the relationship between body and image as a controlled pattern, aerobic workouts follow a highly ritualized and formulaic procedure that rarely varies except in terms of minor details.[10]

The Fonda workout ("doing Jane") is characteristic of aerobic workouts in general, of which it is the most publicized, but neither the first nor the most prevalent.[11] The formula for all workouts is similar, but certain sections, the aerobic sections in particular, are extended in advanced classes or modified in low-impact classes or other variations such as "step" or "hip-hop."[12] Regardless of these variations, the workout is always framed by a warm-up and cool down. These sections function as a means of calling into play the body and defining the liminal space of the workout itself in which the body will function differently than in the procedures of the quotidian day. The description of the workout in *Jane Fonda's Workout Book* begins with an invocation: "Concentrate on what you are doing—no

distractions—center yourself—this is your time" (74). Women variously describe the pleasure of working out in terms of this evasion from their everyday life, a return to a level of visceral involvement with the body. The workout thus provides the woman an opportunity to enjoy narcissistic involvement in her own body, but under circumstances protected by a methodology of discipline and social regulation, signaled by the moment of interpellation.[13]

As the initial moment of interpellation, the warm-up designates a series of body parts. It codifies the body by designating various areas that will be repeated in the rest of the workout—head, shoulder, side, waist, hamstring, spine, calf, inner thigh—and then returns the body to an upright position. The aerobics series articulates, rather than a specific body part, a mechanism of movement generating a norm of rhythm and rapidity. This section culminates in another brief series of stretches—back, knees, tendons, back. After this preparation or induction, the body is ready to move into a phase in which it is broken down into component parts that are isolated and disciplined and finally reassembled into the workout body.

This breakdown into body parts corresponds to a similar breakdown effected in terms of product usage, as Mary Ann Doane points out in *The Desire to Desire:*

> Commodification presupposes that acutely self-conscious relation to the body which is attributed to femininity. The effective operation of the commodity system requires the breakdown of the body into parts—nails, hair, skin, breath—each one of which can constantly be improved through the purchase of a commodity. (32)

Thus the discipline of segmentation effected through the workout engenders a narcissistic rhetoric that compliments and enhances a similar rhetoric of segmentation foregrounded through product usage, linking the workout to other aspects of feminine culture.

Each group of exercises concentrating on a specific area of the body is introduced by a photograph of Fonda, which functions as a template of physicality that is reproduced by the models who actually demonstrate the exercises, visually formalizing her role as motivator. These models are dancers or instructors at the Workout Studio, with the exception of Shirlee Fonda, who will be discussed in detail below. The models represent a range in terms of age, body type, and race. They are informally dressed and look like dancers prepared for class (work) rather than a performance (spectacle). Their hair is slightly in disarray, they are made up lightly, or not at all.

They demonstrate the exercises with a certain seriousness and seem unused to displaying their bodies for the camera, emphasizing the movement of the exercise rather than their relationship to the camera. These women, however, are not "the woman on the street." Though their bodies do not conform to the norms most generally propagated by the media—the pencil thin fashion mannequin or the voluptuous swimsuit model—as a whole they represent a certain type usually associated with professional dancers. All are fit, slim but not thin, small-breasted with small pelvises, taut without being muscular. Thus these bodies are reproduced as a sign that signifies femininity, but a femininity that is deeroticized and rendered as fragile rather than fecund—thus a body suited to public life, neither the obvious object of an eroticized masculine gaze nor a body defined by its reproductive potential.

This articulation of difference and repetition permits the formulation of the workout body as a constellation of pertinent defining features that nonetheless leaves room for a certain degree of personal variation. Though Fonda and her models bear no superficial resemblance to each other, their kinship is suggested through the signs of discipline created by the workout in terms of firmness, muscle delineation, posture, etc. Three of the models are, in fact, dancers (thus members of a profession in which the body is the primary tool necessary to its practice, in which the body's function is one of display and spectacle) and the two others receive special attention from Fonda in her introduction. Thus these cases are set apart and underlined as exceptions to which the reader's attention must be drawn—encouraging her to forget that the bodies against which she must measure her own have been constructed for public display. These are Janice Darling, a workout instructor and actress, and Shirlee Fonda, the most recent of Fonda's stepmothers. Janice Darling is black. A patch over one eye, this young woman incarnates the contradiction of empowerment and submission. Her story is carefully told by Fonda in the introductory chapters. She is depicted as a young woman of great will power who survived an auto wreck through a rehabilitation program that represented for Fonda and Darling the implementation of the control and discipline deployed by the workout. While Darling's body recovered, the patch over one eye represents the unrecuperated abuse as a difference, a defining characteristic that cannot be effaced.[14]

Darling herself is quoted in *Jane Fonda's Workout Book* as saying:

> A good physical condition is protection. Our strength comes from our
> body. The fact that I was hit by a car and not torn to pieces or killed is

proof of that. My muscles were so toned and so strong they literally saved my life (48).

Important here is that working out as a pattern of conformity and empowerment permitted Darling to overcome the result of the accident and to return within a very few months to a position of economic and physical autonomy as a workout instructor. Rather than accepting her situation and overcoming it through patience, Darling actively confronted her predicament and survived through a will to power and activity that translated into "an intensive program of self-rehabilitation" (48).

The other model "who I'm extra fond of" claims Fonda, is her stepmother, Shirlee Fonda (73). Shirlee introduced Fonda to the workout and thus occupies a special place in a matriarchal genealogy, which is further elaborated in the autobiographical sections of the book. If Janice as an icon signals the potential of the workout to recuperate the extremes of experience within a regime of normalcy, Shirlee signals the possibility of history, of a matriarchal chronology. Jane tells her readers: "Take a look at Shirlee, who works out every day and I think you'll join me in saying, "Let's hear it for forty-five and over" (73). This diversification of age, race, and body type creates a heteroglossic subject rendered homogeneous through the ritual of the exercise process as a rigid formula.

The progression of the exercises always takes the body from an upright position to a supine position. The process that initially isolates various areas of the body ends with a "cool-down," which leaves the body stretched full length upon the floor. The final position in which the relaxed body gives itself over to gravity constitutes a release from the constraints of discipline as a process of fragmentation. This architectured release permits an identification with the body as fully itself within the protected arena of discipline. Thus, the workout gives its practitioner a carefully orchestrated balance of constraint and release, of pain and pleasure—which Fonda calls "your pleasure in your own discipline" (56). She elaborates in another chapter: "afterwards [after working out] I would feel alive and revitalized. It was hard to explain this or to describe how good I felt about being disciplined" (21). We note that Fonda talks about "being disciplined" as though she were not the "author" of her discipline. Yet it is precisely, as we noted above, the power to control the body that the workout offers its practitioners. Paradoxically, Fonda's own body, in the process of constructing a "self" that is both simultaneously "master and slave," becomes that which is to be disciplined—an "it" in opposition to the "self" that controls "it."

This issue of control, in which Fonda represents a doubled figure of master/slave, coupled with that of the family, form the governing thematic of the Fonda narrative. Fonda opens her story, recounted in the first person, with the remark that she is "the product of a culture." The full quotation is: "Like a great many women, I am a product of a culture that says thin is better, blond is beautiful and buxom is best" (9). By representing herself as a product, she places herself initially in a passive position. She is an object, acted upon rather than acting. Accompanying this admission is a photograph of her family of origin. Of the five people in the photograph, we recognize three, but two are unfamiliar—Fonda's mother and her half-sister. Her mother committed suicide when Fonda was an adolescent. Her half-sister Pan, unlike her brother or father, drifted back into the mass of society from which her mother had emerged. Thus the mother, the matrilineal line, has been effectively effaced from the Fonda family as popular icon.

Fonda's next comment focuses on her mother's dissatisfaction with her body. "My mother . . . who was a rather slender, beautiful woman, was terrified of getting fat. She once said that if she ever gained weight she'd have the excess flesh cut off!" (9). Fonda continues, contrasting men with women: "men were judged by their accomplishments, women by their looks." This initial opposition between accomplishments and looks is perhaps the single most important antinomy that the workout seeks to resolve. The workout as a technology of the body transforms looks into accomplishment, thus articulating a femininity (and a feminism) that retains its identity as feminine by retaining its "looks," but that also accords agency and accomplishment to the subject that produces the "looks." (It is not he who "looks" but she who incites those looks, produces them, who becomes the agent of exchange.) Working out becomes an assertion of control that a woman makes over her looks, though her work is still her body. Fonda titles one section of the book "We Become What We Do" (17). In the Prologue she comments:

> I discovered that with common sense, a bit of studying and a good deal of commitment, I could create for myself a new approach to health and beauty: an approach which would not only *make me look better* [emphasis added], but would enable me to handle the intense, multifaceted life I live with more clarity and balance, to say nothing of more energy and endurance. (10)

This issue of looks does not disappear but on the contrary is reiterated as a major benefit of working out. By intervening actively in the process of

production, Fonda may still be a product, but she is also a producer, and she produces a better product then did the men, ranging from doctors to husbands and lovers, to whom she had previously confided her health and looks.

This move from product to producer/product is emblematic of her own professional evolution as a star, and ultimately enables her to surpass her father. Her accomplishment was officially recognized when she "gave" him the film for which he received an Oscar. In a *New York Times* article, she talked about her hopes for her father as the Academy Awards ceremony approached:

> If my father were to win, it would be the stuff dreams are made of, that I could provide for him the vehicle for which he would win the Academy award. (qtd. in Carroll, 227)

This is one of many incidents that lead popular biographers (see Carroll and Anderson) to conclude that, at least in part, behind Jane's drive for success was a desire to please her father, a point also taken up by both the general press and the women's magazine. In *On Golden Pond* (1981), a fictional daughter (Jane) is reconciled with a fictional father (Henry), by assuming a position of control over her body symbolized by the performance of a back flip from a diving board into the water. In her professional life, her success as an actress and then as a producer provided her father with the long sought after Oscar, and firmly established Jane as a Fonda in the tradition of her father, whose name, in spite of her gender, she continues to bear. It is Jane, not Peter, who formally continues the family line and tradition of independence and moral commitment, usurping the patrilineal privilege of the first son. In *Women Coming of Age*, Fonda's third exercise book, published in 1984, after her father's death, Fonda does not discuss her relationship with her father in depth, but she includes two photographs (12). The first was taken when she was a child. Her father is in uniform and holds her on his lap. In the second, larger photograph, her father is old and bearded. Swathed in a heavy sweater and an afghan, he looks ill. Jane is positioned behind him, holding his Oscar as though it were a scepter, passed from hand to hand, from patriarch to matriarch, formally signaling Jane's coming of age, and Henry's abdication.

Her relationship with her mother seems much more difficult to resolve in that it is her mother who represents "looks" that were not transformed into accomplishments. As a woman who lived out her life within a private sphere, Fonda's mother was not part of Hollywood culture in which the transforma-

tion of "looks" into accomplishments was the norm. In this sense, it is Henry Fonda (whose looks constituted his capital as a movie star) who offered Fonda her model of accomplishment. The issue of looks points to a moment of trouble within the Fonda family. As Lemoine-Luccioni explains (see Chapter 2), it is the mother's "looks" with which the child identifies, and this initial identification is disrupted by the father's look. In the Fonda paradigm, Jane must identify with the father's looks (his image) as the position from which she too might transform her looks into accomplishments. This gender trouble paradoxically does not articulate itself in terms of "gender" but in terms of "star" and "public" spectacle. Thus we see a form of gender bending in terms of a position that does not disrupt the heterosexual categorization of masculine/feminine. However, perhaps as part of her attempt to establish a matrilineal line of descent that maintains the heterosexual division of masculine/feminine, in *Jane Fonda's Workout Book* Fonda mentions only her mother. Jane's mother did not offer her a solution to the issue of control; her solution to the threat of a body out of control was to "have it cut off," a position that in its most extreme manifestation resulted in her suicide at the age of forty-two, the age at which Jane embarked on her own official pursuit of fitness and control. Carroll comments:

> Perhaps it was not coincidence that this latest preoccupation with her body—its health, image, and beauty—commenced on the eve of her forty-second birthday (the same age, almost to the day, that Frances Fonda decided that her body was too ugly to keep). (224)

By assuming control of her body, by making it over into an image that is her own, Fonda rejects a feminine heritage of passivity grounded in the helpless body, its helplessness expressed by the term "ugly" as the inability to control the body—a body that is in excess of the self that controls it—marked through reference to her mother. Carroll again comments:

> Asked if she had inherited her physical endowment, Jane believes otherwise: "I like to think a lot of my body is my own doing and my own blood and guts. It's my responsibility." (224)

I hesitate to push these issues but feel that there is a larger significance to the "Fonda family romance," in Freud's terms. The dynastic history of the Fondas forms part of a culturally produced mega-text, deployed as a cross media formation. Their lives as contemporary Olympians provide narrative templates of mythic proportion that bear little relation to traditional

forms of gossip. In this sense, Jane's relationship to both her mother and father are part of the popular domain, a public negotiation of larger issues of familial conflict. The autobiographical section of *Jane Fonda's Workout Book* is only one manifestation of a complicated network of narrative formations, which has been both produced by the Fondas but of which they are also products. Fonda uses autobiographical references, including famous movie stills, throughout *Jane Fonda's Workout Book* to ground and legitimate her regime of discipline and pleasure, which she rewrites as a history of her body. In the autobiographical section, however, Fonda recreates an itinerary that moves her from the bad body of her mother Frances to the good "wholly healthy" body, as Fonda calls it—from the "sinful body" to the "holy body." The bad body depended upon external mechanisms of control: drugs, doctors, cosmetics, and prosthetic undergarments. The good body produces itself through an internally regulated technology of control, manifested in the workout, but also in a diet of "natural" "counter-culture" foods. This process is one of self-realization in which Jane progresses from what she terms "the body abused" in her teenage years as a chronic dieter, bulimic, etc., through her attempts to reconstitute her body for a sexualized male look, to a final moment in which she takes control of her body for herself. This narrative of self-realization hinges on the strategic intervention of two women: Shirlee Fonda and Katharine Hepburn, who "stand in" for the good mother that Jane did not have.[15]

Shirlee, as mentioned above, introduced Jane to the workout. She is a good mother who offers Jane the good body as a body under control. Significantly, Shirlee demonstrates "the Prime Time Workout" in *Women Coming of Age,* a book that follows *Jane Fonda's Workout Book* and is targeted for older women. Through Shirlee and the model of femininity that she represents, Jane creates a new matriarchal lineage signaled by the dedication to her daughter Vanessa at the beginning of *Jane Fonda's Workout Book:*

> I've decided to write this book ... because I want to share what I've had to learn the hard way with other women. I only wish someone had shared these things with me earlier in my life. That's why I've dedicated this book to my daughter. (10)

This issue is underlined in *Women Coming of Age,* in which Fonda confides to her reader:

> Few of us have anyone to point the way. None of the women who peopled my earlier life shed any positive light on what was to come at this

later stage. My mother chose to take her own life when she was younger than I am now. Her doctor told me that among the many phantoms shadowing her world was the fear of youth's passing. Your mothers, like mine, may have also come upon these years fearfully. Perhaps they were uncertain of the tools needed in this new phase, which may have seemed to them the far edge of life. (19)

Through the process of self-realization described in the autobiographical passages in both books, "figured" through the workout, she arrives at a stage that she describes as "wholly healthy." This new stage is emblemized through a reconstitution of a family that resembles as much as it differs from Fonda's family of origin. The photo of the Hayden/Fonda family that begins Part II, "Wholly Health," replicates the nuclear structure of Fonda's family of origin, represented in a photo that opens the prologue (25, 10). The actual uniform of Henry Fonda on furlough from the Pacific in the original photo has been replaced by the informal uniform of the counter-culture, jeans and running shoes. In the Hayden/Fonda family there is a democratization of fashion: the entire family wears some version of this uniform, including Jane. Frances Fonda, Pan, and little Jane, in the older photo, wear ladylike dresses. Even Peter wears short pants, the sign of a different social position than that accorded his father.

The composition of each photo is significant, denoting an evolution in family structure and lifestyle. In the original photo, Henry Fonda stands behind and above his wife, who is formally seated on a large arm chair, her legs crossed in a way that is demure (her knees are covered), but that also displays the harmonious shape and form of her limbs. Henry, less formal, leans on the back of the chair. Little Jane is perched on the arm of the chair, close to her mother, and Peter sits on a stool next to a large stuffed animal. Pan, Jane's half-sister, stands behind Jane and Peter, while Henry leans protectively towards her. This structured hierarchical interior shot contrasts with the informality of the Hayden-Fonda shot.

Here, the family is seated outside on a log. Jane is next to Tom, and Troy is seated on Tom's lap. Vanessa, in whiteface like a mime, sits next to Tom, petting not a stuffed animal but a "live" dog. Jane's body is almost hidden by Troy and Tom, and her legs are covered by her jeans, like the rest of her family. The family is smiling, unlike the somewhat somber Fondas. The plants, sunlight, and dog lend the photo a sense of freedom, or outdoor casual living, unlike the well-ordered living room of the Fondas. In many ways, however, this informality is as much a reflection of changing social

conventions as it is of the personal choices of the family members them-
selves. The Fonda photo is simple, almost austere—a typical family shot of
the 1940s rather than a glamorous depiction of Hollywood life. The rag
rugs, the pinecones on the mantel, speak of a wholesome, unpretentious
"Americanness." Similarly, the Fonda-Hayden picture connotes a "whole-
someness" and lack of pretension associated with the new middle class, for
whom informality has become a way of life. The jeans, the running shoes,
even Vanessa's whiteface, denote the activities of a typical Californian fam-
ily.[16] The cute hominess of Tom's plaid shirt and Vanessa's unconventional
makeup are the 1980s equivalents of Peter's stuffed bear and the little
Santa on the mantel in the earlier photo. Both photographs reassure the
viewer of the period that this family has not been corrupted by material
wealth and that it stands behind certain ideological categories, such as
commitment and domesticity. Henry's military uniform speaks of one
type of political commitment, Jane's jeans of another. Both convey, howev-
er, the importance of moral standards (as opposed to material wealth).

In this sense, Jane Fonda can be seen as renegotiating properly
"American" values within an evolving moral climate. Thus, Jane's political
commitment has always been moral rather than practical, a commitment
to the idea of "justice" rather than to a specific political or economic agen-
da. In her activist days, she supported causes because they appealed to her
moral convictions rather than because they corresponded to a specific
world view. In *Ladies Home Journal* she is reported as saying:

> My gut-level attraction is to grass-roots organizations rather than demo-
> cratic party politics. I don't want to lose my idealism. After seeing from
> the perspective of a politician's wife, I'm more convinced than ever that
> citizens have got to do it themselves—politicians won't do anything
> unless they're pressured. (Anderson, 117)

Fonda's need to establish a sense of tradition, a lineage, is symptomatic
of her basic identification with "Americanness"—with grass-roots organi-
zations. Shirlee functions as a link between the old family and the new,
providing a replacement for the "bad" mother. Similarly, Fonda turns to
Katharine Hepburn as a means of legitimating the workout through
another type of lineage, grounded in Hollywood as the American aristoc-
racy. Hepburn is important because she represents a tradition of
independence and integrity in Hollywood as did Fonda's father. In partic-
ular, Hepburn had a reputation as a proto-feminist, one of the few female

stars to combine intelligence, success, fame, and a certain measure of financial and moral independence.

Fonda invokes Hepburn and the tradition she represents through reference to "the story of my 'Golden Pond back flip.'"[17] In *Jane Fonda's Workout Book,* this incident is described in Part II, "Being Strong," under the title "Making a Commitment" (54). As I began to suggest above, *On Golden Pond* offers an exemplary instance in which film fiction and Olympian narrative merge. In many ways, the film was publicly billed as the reconciliation of Henry and Jane, the legitimation of Jane rather than Peter as heir apparent, in which the performance of the "back flip" proves to the fictional father that a woman can do "what a woman's gotta do." In *Jane Fonda's Workout Book* no mention is made of Henry in connection with the back flip incident. Jane talks exclusively about her relationship with Katharine Hepburn, who in this other narrative, that of the *Workout Book,* directed towards an exclusively feminine readership, provides Jane with the impetus to perform the back flip. Hepburn boasted during the course of the shooting that in her youth she could perform a back flip and offers the stunt as a challenge to Jane (54). Jane explains, "I wanted her to like me, so I decided that I would try to learn to do a back flip (55)." When Jane finally succeeds, Miss Hepburn gives her approval: "Everyone should know that feeling of overcoming fear and mastering something. People who aren't taught that become soggy" (55). Here "sogginess" seems to connote the soft maternal traditionally feminine body in opposition to the hard, reformulated body produced through working out.

This autobiography, included in *Jane Fonda's Workout Book,* reveals another text than the film or even the dominant story surrounding the film, in which legitimacy is conferred matrilineally—in which the position of the matriarch is reconstituted as a positive force of control that, in an earlier subsection of Part III, called "Breaking the 'Weaker Sex' Mold" (45), Jane traces back to a pioneer ancestor, Peggy Fonda, who rebuilt the family mill to feed George Washington's soldiers. She accompanies this story with an archival photograph of a woman seated on a plow drawn by horses, wearing a sunbonnet and overalls, which in fact is taken from a 1942 seed catalogue. The image, the origins of which are unspecified (who is this woman, when, why was the photo taken?), is rewritten through its position in the workout narrative as a historic image of feminine fortitude that seeks to invoke a "universal" category of woman within the history of the United States (44). In *Women Coming of Age,* Fonda repeats and emphasizes this analogy. Midlife is "the New Frontier" for women. "To be

a midlife woman in our society is, in many respects, to be a pioneer," states Fonda (19). By invoking a history that has already been marked as "American," she claims for the woman as "citizen," now liberated from a role that was exclusively reproductive, the legitimacy of an American past, a national heritage with which she encourages women to identify and reappropriate. She concludes *Women Coming of Age* by repeating the pioneer analogy: "We are the pioneers—a first generation selfconsciously, admittedly midlife women, charting a positive new trail for ourselves and our daughters through a previously misunderstood and ignored part of life" (418). However, to come of age is also to embrace a past that legitimates the future: "There was a time when heavy physical work was an accepted part of both men's and women's lives" (*Jane Fonda's Workout Book,* 45). In the past women find the authentic femininity that has been taken away from them by the Industrial Revolution which produced a "cultural ideal" that demanded that "a desirable woman" be "delicate and decorative, like her aristocratic sisters" (45). The workout book in its production of a new femininity rejects the aristocratic as a "false" ideal that must be replaced by returning to the democratic model of the "pioneer woman who worked shoulder-to-shoulder with their men to push back the wilderness, build homesteads, plow the virgin prairies" (45).

The importance of Fonda, the workout body and its lineage, is perhaps best understood by contrasting her with Diana Vreeland, the fashion editor and writer, "the queen of the elite fashion world, whose taste and sense of style had been nurtured in over thirty years of editing *Vogue* and *Harper's Bazaar*" (Silverman, 45). As another "idol"—that of an earlier generation of women—Vreeland is the woman against whom Fonda must articulate herself, the woman, in a sense, that Fonda once was, during her days of dieting, bulimia, and self-loathing. Vreeland represents an exclusionary elitism—her objective is to maintain hierarchy; her work as a whole informed by "the idolization of aristocratic distinction and luxury" (Silverman, 107). Fonda is inclusive—her discourse invokes a utopian vision of egalitarianism, identified with a liberal political agenda. Indeed, the workout industry initially was formulated to support a liberal political cause, the Campaign for Economic Democracy. A plaque in the lobby of the first Workout Studio, in Beverly Hills, stated that profits went:

> to promote alternative sources of energy, stop environmental cancer, fight for women's rights, justice for tenants, and other causes related to environmental protection, social justice, and world peace. (Carroll, 223)[18]

Vreeland, on the other hand, was associated with the Reagans and a reactionary political regime. Debora Silverman comments that Vreeland's exhibitions "were part of an important movement of aristocratic posturing in American Culture and politics. The movement is centered in New York, with direct contact with the White House of Ronald and Nancy Reagan" (5). However, Vreeland does emphasize two important concepts—"control" and "discipline"—that also figure heavily in the discursive formulation of the new feminine exemplified through the Jane Fonda workout. Silverman explains: "Vreeland celebrates a rigorous ethic of female power and of the cultivation of a ruthless, imperial self" (118). Hence, Vreeland admired "women who used men" and who "ruled empires by their unbending will and driving ambition" (Silverman, 118). Like Fonda, Vreeland's goal was the cultivation and production of a "self" that would operate effectively within a given cultural and historical context. The crucial distinction between these two models hinges on Vreeland's rejection of the body through denial and repression. Her practice is geared towards the reproduction of a feminine grounded in the image as a fantasmatic object. Elegance is the mark of the feminine, and it is defined as refusal, claims Vreeland—refusal of the biological, of the historical, of the economic (*Allure,* 4). The pleasure in this process lies in the pleasure of denial, a pleasure founded in discipline and pain, perhaps most poignantly represented by the anorexic fashion mannequin, slowly starving herself to death.

The fleshly body is replaced by a mechanically reconstructed body, a body without organs or tissue, for which the camera and the art of photomontage constitute the primary technology. Vreeland confessed in her autobiography *D.V.:* "Then at Vogue . . . I really went to town! I put legs and arms and *heads,* and everything else together to give the perfect whole" (134). Vreeland rejects femininity as biological process, transforming it into a discourse of artifice, in which the masculine provides the "natural" against which the feminine is defined. The collection of photographs that Vreeland published in *Allure* (a "coffee table" book) revel in the cultural formulation of the female body as a process of segmentation and reformulation. The photos, largely of women by famous fashion photographers, were gathered together at the whim of Vreeland, accompanied by a stream-of-consciousness commentary in the first person, also by Vreeland. As a sequential photomontage, in which narrative chronology is a convention of the work rather than the text, the book has no order except for that imposed by the physical confines of the form (which as a

material arrangement is ordered through the conventions of reading from left to right, the numbered pages sequentially conferring a certain chronology, the implication of cause and effect, to the text).[19] The narrative, as such, is motivated by a fascination with fashion and fashionableness as categories of the image that override narrative as a logic of cause and effect, producing a fantasy scene of endless transformation.

These texts confound the reader's desire for answers and solutions, for the production of a new rational order, rather than offering the slow process of reconstruction and reappropriation that *Jane Fonda's Workout Book* delineates for its reader. In other words, both Vreeland and Fonda mobilize certain mythic structures in their production of a feminine "culture of the self." One might say that identity as continuity depends on these mythic categories of nationality, class, and gender; however, the two mythologies of aristocracy and democracy respectively are not identical in their effects. Within the constraints of the "cultures" available to a feminine subject in her "self" cultivation, the choice of Vreeland's deliberate aristocracy of taste is very different from Fonda's system of self-reliant individualism. It cannot be mere accident that the high fashion world has completely ignored Jane Fonda; though she frequently graces the covers of the popular women's service magazines such as *McCall's* and *Redbook,* she never appears on the covers of *Vogue* or *Harper's,* or more recently, *Mirabella* or *Allure.* Vreeland, who remains even after her death an idol of the high fashion world, coincidently generates a discourse that promotes the rejection of the body and a general disaffection with the material. Rather than pulling cultural threads together towards a coherent weaving of tropes and structure (as does Fonda), the Vreeland discourse operates through a system of dispersion that displaces the effects of causality, diffusing any sense of larger economic and political structures.[20] This discourse strives towards "the rootless and ruthless self-creation that simulated a style of aristocratic stability; and the aggressive substitution of fantasy for reality, the dissolution of fact by wish" (Silverman, 107) represented through an anorexic ideal, which has not disappeared, but persists as one strand within feminine culture.

The body constructed by "doing Jane" offers an alternative to the emaciated weakened body produced through a socially inscribed anorexia as the feminine norm, in which the presence of the body is consciously effaced and defaced, flattened into a two-dimensional form. Here I am speaking not of the physical condition of the diagnosed anorexic, but of her representation as the fashionable body, notably in such models as

"Twiggy" or more recently Kate Moss, who may or may not be in fact clinically anorexic or bulimic. Important is that for many women this "image," this "body," can only be produced through various forms of anorexia or bulimia. The technology of the body offered by Fonda reinstates the biological function of the body within a narcissistic regime, rather than constructing a narcissistic position grounded in a denial of the biological. The anorexic is obsessed with her body—as is the woman who works out, but the latter's obsession does not ultimately destroy or obliterate the object of its obsession, rather the body is controlled and disciplined, deconstructed and reassembled. The technology of the workout provides a means of synthesizing the two primary roles of women, as mother, who disciplines the terrifying body through which she reproduces, and as object of the gaze, as an image which loses its reproductive powers.[21] In the Fonda paradigm this is represented by the emphasis on nutrition (for the woman, but also for her family) and on exercise.

In *Jane Fonda's New Workout and Weight-Loss Program*, published in 1986, the fourth workout book, the larger political issues of the first book, such as pollution and ecology, are excised; however, the focus on exercise and nutrition is retained and amplified, fixing the links between the new public femininity and a private femininity defined within the family. Establishing a history no longer has the same urgency because this history can now be taken for granted. This new version of the workout has assumed the stability of an already established regime, for which consolidation rather than conversion is the goal. Fonda no longer needs the same sort of support from ancillary texts that situate her legitimacy as a media Olympian. As a mark of this new regime and its legitimacy within dominant patriarchal discourse, the camera treats Fonda very differently. In the 1981 book, there are two contrasting strands of images representing Fonda as an exerciser. In the first Fonda is carefully groomed and coiffed, clad in flattering leotards and tights in a covergirl mode. In these photos, as a rule, her face is turned towards the camera, emphasizing her position as on display for the photograph. In the second category, Fonda is oblivious, often sweaty, often situated within a group of women.

In the 1986 book, Fonda appears exclusively in her covergirl, or coverwoman, mode. There are no pictures of her looking sweaty and messy, even when she's jogging. Neither are there any reproductions of family and childhood photographs, or of historic publicity shots from her "starlette" days, as there were in the first volume. On the other hand, there are six photographs of Fonda, displayed horizontally for the camera in traditional

"odalisque" poses, that accentuate the full, firm lines of her figure. In twenty out of forty-four photographs of Fonda included in the 1986 volume, she is looking directly into or towards the camera, deliberately positioning her body for the photographic gaze, thus acknowledging its position of power. In the 1981 volume, only seven out of thirty-six photographs place Fonda in this position. In addition, of the seventeen photographs in the 1986 volume that depict Fonda as oblivious to the camera, two depict her looking at her male weight trainer, and one shows her being made up and coiffed by three men.[22]

This aesthetic has also been transferred to the models. In the 1986 volume, all are sleek and well-groomed, not a hair out of place. There are no Janice Darlings with a patch over one eye, or "forty-five-and-over" Shirlee Fondas (except of course, Fonda herself). The models look like hundreds of other models that sell toothpaste, shampoo, depilatories, lipstick, and other feminine grooming aids. The no make-up, slightly sloppy look of the dancers in the first volume has been discarded in favor of a more polished, groomed exterior. These women are pretty without being distinctive (unlike the high fashion model), young, well-proportioned, with shiny hair, and bright smiles that turn towards the camera, even at the price of throwing the body out of line in a given exercise. The racial and ethnic diversity of the group serves only to disguise the rigidity of the norms that it represents.

Fonda herself is fuller figured. If the fullness of her bust is underlined by a tight leotard unbuttoned to reveal cleavage, so is the muscle definition of her arms. She is heavier, more powerful, projecting an image of control and strength that makes her look almost frail in some of the earlier photographs. The seductive quality of the image is offset by the representation of power and control, a move that is perhaps characteristic of Fonda's ability to integrate behavioral extremes. Richard Dyer comments:

> It may be that her charisma—which evokes extremes of hate as well as love—can be accounted for not only in the reconciliation of radicalism and feminism with Americanness and ordinariness but also her ability to suggest (as a tomboy) redefinitions of sexuality while at the same time overtly reasserting heterosexuality. (98)

The workout book itself was not a fixed moment in the process of producing femininities. If in many ways little more than a decade later it already seems hopelessly outmoded, Fonda's function as a negotiator of

political and sexual roles for American women continues. Her marriage to Turner offers the fairy tale conclusion to a now transformed narrative of heterosexuality. Fonda offers a model through which women can reconstruct themselves as both objects and subjects that enables them to enjoy a degree of power and privilege in a culture in which heterosexuality is the norm. She pays a price: she must submit to a technology of the body, and to a ritual of product usage that will enable her autonomy to be effortlessly reinscribed as the object of masculine desire through the look (here, the camera) within a heterosexual paradigm. The move away from feminist politics as the central concern of the workout marks a necessary transition in Fonda's evolution, which eventually culminates in the dissolution of her marriage with the left-wing politician Tom Hayden and her marriage to media mogul, Ted Turner, as the correct fairy tale ending.

Because within a heterosexual paradigm, feminine narcissism can be reread as the projection of male narcissism, Fonda's feminism as an investment in the body moves her to the position of the new power wife whose goal in life is to find her corporate prince. Now Fonda's goal is no longer "control" and the cultivation of a self, but "standing by her man, media mogul and Cable News Network founder Ted Turner" (Grant, 85), a happy fate guaranteed by her strenuously produced "self." This is finally the paradox of the workout "culture of the self": Fonda's looks are her cultural capital. *McCall's* magazine comments: "Fonda remains her own best advertisement: Most of us would be pleased to look at 34 the way she looks at 54, especially in Lycra" (Ball, 96). However, Fonda's "beauty" marks her as tamed, "a Kate conformable as other household Kates." The pleasure that she takes in herself is legitimated by the masculine look, indicating her willingness to submit in the last instance to a patriarchal order regimented by a consumer economy.

The depoliticization of the workout in her fourth book is one of the primary symptoms of this shift in which the conservative function of the workout narrative is underlined; however, a number of public events even more clearly illustrate this renegotiation of Fonda's political position. Most obvious was her public apology in 1988 to Vietnam veterans on prime-time television during an interview by Barbara Walters for ABC's magazine format show, "20/20." Less obvious were the economic reasons behind this decision: demonstrations by veterans were impeding the filming of *Stanley and Iris* (1989) (Anderson, 331). Her apology was symptomatic of a reordering of priorities in Fonda's life: in 1988, her workout industry would no longer provide financial support to

Campaign California. The ties between "doing Jane" and a public com-
mitment to social change were officially severed. However, it would be
erroneous to see this movement as a return to her earlier incarnation of
"Lady Jane" (to borrow from the popular biographer Christopher
Anderson), a renunciation of her position as "Citizen Jane" (again
Anderson's term). Rather, this move presents another reformulation of
the role of the feminine "citizen"—which in vernacular terms might best
be described as the move from "activist" to "power wife" (to borrow the
terms of the popular press).

The "power wife," represented clearly in the political arena by the criti-
cal role played by Hillary Rodham Clinton in the U.S. 1992 election, takes
a secondary place to that of her husband, but is clearly established in her
own right as a full citizen. Hillary Rodham Clinton's position is guaran-
teed by her husband, but it is one that requires that she function within a
public rather than a private arena. If other "First Ladies" served a public
function, it was always to represent the private concerns of family and cul-
ture, within the public spectacle of self-governance. Though Hillary
Rodham Clinton's "work" is still tied to traditionally private concerns of
family and health care, these concerns have been professionalized, official-
ly marked as of the public domain, the concerns of public institutions
rather than that of the private institution of the family. In a country in
which health care for example is only minimally a state concern, the
appointment of Hillary Rodham Clinton to transform the public
institutions of health care constitutes a major transformation in the con-
ceptualization of the demands and responsibilities of citizenship within a
public arena. The Clintons represent, then, precisely a political position
that coincides very closely to the "new" tradition articulated within the
first Fonda workout book.

Fonda's own position as "power wife" to Ted Turner represents a similar
transformation within the public corporate sector. Turner's and Fonda's
marriage is described in the popular press as "a union of megastars"
(Grant, 85), "more a merger than a marriage" (Ball, 145). The choice of
Fonda over the more obvious array of "Marla Maples," the young docile
woman whose capital is constituted by her unmarked body and her recep-
tivity, represents a departure from a romantic ideal that has informed the
marriage plot since the publication of *Pamela* in 1748,[23] in which Fonda is
rewarded not simply for her looks but also for her accomplishments. In
other words, her marriage in her fifties signals that she has indeed trans-
formed her looks into accomplishments, and rather than confronting a

cultural capital diminished by age, Fonda as an older woman can look with satisfaction on her accumulation of wealth. *McCall's* comments, "At 54, she's got what she wants: her dream man and the freedom to 'choose happiness'" (Ball, 94). *McCall's* continues that Fonda: "has decided that, in the '90s, she'll focus on personal fulfillment. Which in this case means her new marriage. 'Right now,' Fonda explains simply, 'I'm choosing happiness'" (Ball, 96).

It is precisely the notion of the freedom to choose happiness, the inalienable right to the pursuit of happiness essential to United States ideology of the individual, that crystallizes the stakes of the discursive formation that Fonda represents within feminine culture. For Fonda the reality of the pursuit of happiness is defined by "what men think." Fonda explains:

> Well, men aren't rethinking beauty . . . and to the extent that a woman is defined by what men think then it probably isn't being rethought. But one of the positive things about the fitness movement is that women tend to define their own body image. If they feel good about themselves, they're less apt to think, Unless I'm thin, I'm not lovable. . . . It's harder for women who grew up in the '50s—and I'm one of them—to ever move away from that reality. . . . I have at various times in my life thumbed my nose at it, but it's part of what I am. (qtd. in Ball, 96)

For Fonda, the pursuit of happiness is regimented by the fact that her rights can only be maintained through the preservation of a body that she must continually reproduce. This regimentation, however, is not the result of a homogeneous coercive system but of a complex nexus of "choices" that Fonda negotiates, and that she presents as adapting to a world not yet "re-thought" by men:

> I do think there's a large segment of women who aren't bound by those strictures. . . . They don't wear makeup, and they're much more independent of the culture that says you are how you look. They don't feel it necessary to push their feet into painful high-heeled shoes to make their legs look prettier—and I take my hat off to them. . . . I go through periods like that too. Of course, I go through periods where cowboy boots are all I wear anyway. But that transition from cowboy boots to high heels. . . (qtd. in Ball, 97)

The most important aspect of this negotiation was her well-documented capitulation to plastic surgery. She reportedly has had "eyelid surgery,"

(blepharoplasty) and breast augmentation (Anderson, 325). It is rare that an article does not comment on this fact. Indeed she includes a section on plastic surgery in *Women Coming of Age,* reflecting a concern shared in particular with high-fashion magazines, whose affluent readers might find cosmetic surgery more easily available to them. As Fonda herself puts it: cosmetic surgery is about "buying yourself a few years" (Ball, 97). To return to Bordo's initial characterization of the body—for Fonda, her body is a "site of struggle," but it is also a terrain that can be recolonized endlessly for profit. Fonda's comments about her own identity can only be understood in terms of the way in which her particular "bricolage of the body" is part of a larger economic and political structure in which most women are not quite as lucky—or quite as adept at cultivating and exploiting their own bodies.

> Well, I don't pretend to be different from any other women. I'm subject to the same foibles and pressures and ups and downs—more in some ways, less in others. I have money to soften the blows, but exposure means people throw a lot of darts at me. No big deal. Life is hard, but I'm a survivor. (qtd. in Ball, 97)

Yet it is this same body that Fonda herself chastises in the original workout book when she understands that a Vietnamese prostitute could raise her prices (increase her capital) when she "Americanized" her face and body through cosmetic surgery:

> I was shocked into the realization that I myself had played an unwitting role as a movie star and sex symbol in perpetrating the stereotypes that affected women all over the world. (20)

Certainly, no one forced Fonda "at gunpoint" to undergo plastic surgery, in particular to risk the well-publicized dangers of breast implants. For Fonda this was a considered choice. Fonda explains: "What the hell is the big deal, as long as it's done carefully and with thought?" (qtd. in Ball, 97). Of course "the big deal" is the promulgation of a certain feminine ideal within an economic and political sphere. Fonda's breasts are not merely signs of her "pursuit of happiness" as an "individual," but represent "success" and "cultural capital" for women as a social category. In terms of the humanistic ideal of individual happiness, one can argue as does Kathy Davis that:

> By taking agency as a relevant feature in how women experience cosmetic surgery, the decision can itself become a radical and courageous act. By deciding to undergo cosmetic surgery, they initiate a dramatic change, becoming agents in the transformation and remaking of their lives as well as their bodies. (Davis, 35)

While agency might indeed constitute a relevant feature in the feminine experience of cosmetic surgery, this does not mean that plastic surgery ultimately has a radical or emancipatory function in terms of a social or public body. Though the woman chooses, and pays for, plastic surgery, she "submits" her body to the discipline of the surgeon who wields the knife and regulates norms of social acceptability. Her body, especially in the case of Fonda because of her self-avowed role as an exemplar of a new femininity, reproduces an existing social norm. Plastic surgery, as Davis herself demonstrates, is by its nature an ideologically conflicted act, and far from representating a departure from the initial Fonda practice of working out, plastic surgery reproduces the same paradox that informs the cultural articulation of the workout itself. The discourse produced by the workout may discourage women implicitly, or explicitly (see *Women Coming of Age*), from using plastic surgery to remold the body, but it also establishes a "culture of the self," and a logic of the self that produces plastic surgery as the rational extension of its own practice. Insofar as the workout functions in a world in which beauty is defined ultimately in terms of a marketplace that has yet to "re-think" cultural standards, "working out" will always be geared towards the reproduction of these standards. Otherwise it would not be a source of public empowerment and control. This is the paradox of the feminine culture of the body.

If we return to Foucault's work, we must recognize that neither a model of cultural production formulated in terms of penology (a coercive panopticon geared towards the production of docile bodies), nor in terms of sexuality (the culture of the self), is adequate to the formulation of a theory of the feminine body. The feminine body is perhaps best understood as a terrain in which these two modes of cultural production both contradict and support each other depending on the context. This discipline to which the feminine body is submitted is not maintained through the exercise of physical force or the institution of legal penalties; rather, the practitioner submits her "self" to a program of discipline in which she seemingly enrolls by choice. On the other hand, the rigors of this discipline as a form of punishment visited on the body, and the rigidity of the socially sanctioned

norms that this discipline reproduces, speak of a technology of social control that cannot be fully articulated as a culture of the self in which the subject submits voluntarily to specific practices in return for certain economic and social privileges. The transformations of the feminine body within the public arena, produced by a culture of the self formulated around such practices as "doing Jane," speak of the difficulties of judging the terms and stakes of a discursive formation from within that formation. We as academic feminists might do well to pursue the ways in which our own "practices" within the institutions of public education constitute a form of "doing Jane," in which we have articulated not a new body but a new body of work—that empowers women but that also acquires legitimacy through its relationship to already accepted scholarship and an existing hierarchy of disciplines.

CONCLUSION
"Femininity: Do You Buy It?"

> Is femininity merely a costume? Playing dress-up? A put-on? A female
> role in the right time of day or place, that's assumed at will? . . . Fashion
> designers talk in terms of ruffles and bows: experts say it's simply gender.
> Is femininity something in a bottle or a shopping bag . . . virtually all a
> woman is . . . or an out-of-date idea?
> —Kathleen Madden in "Femininity: Do You Buy It?"

The question of identity, seemingly the prerogative of the intellectual, of
philosophy in Rebecca Goldstein's novel, has made its way into the
women's magazine: Kathleen Madden meditates on this issue within the
confines of *Vogue* magazine, suggesting that what initially appears to have
been the preoccupation of a few postmodernist feminist scholars is a ques-
tion that pervades feminine culture as a whole.[1] Similarly, scholars and
fashion designers are equally ready to speak in response to this question:

> My philosophy has always been womanly dressing—not something
> androgynous. All women are female; not every woman is feminine.
> Femininity is an act a woman takes on, a gesture, a specific kind of
> sensuality. (Donna Karan qtd. in Madden, "Femininity: Do You Buy
> It?" 446)

Madden herself juxtaposes this mutable femininity against the stable femi-
ninity of the 1950s, the femininity of our mother's time, as an originary
fantasy that recalls the mother's image as defined by Lemoine-Luccioni.
Madden recreates this originary femininity as one of the governing tropes

of reconstruction, metonymically referencing a larger semiotic system within which femininity functioned as a "natural" element.

> Women in the 'fifties—fully "feminine"—married young, bore babies, acquired pearls and pale-blue sweaters, glass perfume bottles, girdle marks, cigarette cases, and afternoon Bourbons. (445)

But even as Madden nostalgically recreates this fantasmatic femininity as an originary scene, she slips into a discourse of constructability—the "marks" of femininity are "girdle marks," imposed from without, a consumer item that contains and defines the scene of femininity as a previously unmarked body. When Madden proceeds to cite feminist scholar Carol Gilligan, who claims that "identity for a woman requires reconciliation between femininity and adulthood" (Madden, 446), in which adulthood figures as the other of an originary femininity, as not-the-mother, it is also clear that the femininity as the originary term in this reconciliation has already slipped away.[2]

Perhaps what Madden is expressing most clearly is her own confusion—as a fashion editor, an authorial voice. What position can she take that will reconcile her desires for frills and ribbons with the economic and social autonomy that she claims as her right in her function as an authorial voice, an adult? For like Kate, Madden "is no child" and speak she will, of necessity in a profession in which she is paid by the word. But though she speaks, she is no more able to reconcile the conflicting discourses of femininity than is Jane Fonda. "Most modern women, with only themselves to please, would opt for Reeboks before netted crinolines" (Madden, 446). And yet: "Few women—liberated or not-so—think purely of themselves when they dress; most dress for men at least to some degree, at some defined moment. Very often that's a real pleasure" (446). The "real" pleasure of the woman who dresses for a man recalls the "pleasure" of Jane Fonda as the power wife, who works out for her "self" but dresses for a man as the sign of her irrevocable femininity—and thus achieves her dream: beauty and a corporate prince.

Yet, again, as in the case of Shepherd/Hayes, the spectacle of femininity works against the text that authorizes and speaks a feminine voice. The photograph that comments on Madden's article is a bust shot of a young woman. Her makeup is understated but necessary, a presence, an element in the construction of the image. The color and shape of the lips, eyes, and eyebrows are underlined, and intensified, giving the young woman's fea-

tures an unnatural precision while maintaining a subdued palette. Her hair casually falls about her face in a deliberately unconstructed style. She is wearing what appears to be a child's undershirt in a pale pink. The fullness of her breasts is suggested by the subtle lighting of the chest area. Her hand, toying with a gold chain studded with diamonds, is manicured, but again deliberately understated. The nails are blunt and without color, but their precision and their symmetry reveal the care and grooming that produced their look. The model is "back lit" from the right side, resulting in an asymmetrical halo effect. The face is burnt out, effacing any irregularities, emphasizing the eyes and mouth. The photo-commentary reads:

> New attitudes in "feminine" dressing—as elemental as trousers and a bodysuit from Donna Karan New York in paled-down pink. The only decorative edge comes in Diamonds by the Yard from Elsa Peretti for Tiffany & Co., a new "berry" lip color: Here, from Elizabeth Arden, Wild Lily lip pencil, Tenderberry Luxury lipstick. Hair by Christiann; makeup, Mary Greenwell. (144)

At one level, the photograph provides a certain amount of practical advice as did *Harper's Bazaar*'s commentary on Cybill Shepherd. "Femininity" *can* be achieved with a minimum of effort for a certain socio-economic class able to afford the consumerism invoked through the image. A consumerism of display regulated by the cultural codes of taste and class affiliation does operate as a mode of empowerment. The false promise lies in the impossible physical standards imposed by the model and all that this entails in terms of a displaced narcissistic investment. Yet again the image imposes a tyranny that the text appears to deny, question, and negotiate. The image ultimately says that a woman's worth still resides in her "looks," displayed as such through elaborate consumer strategies. The text asks to what extent do we as women buy this statement. The image suggests that we've already bought it, wrapped it up, and taken it home—a *fait accompli*.

A Continuing Conversation

The above commentary should not suggest, however, that women, or the women's magazine, is content to let the matter rest. The issue is reopened each month. In this sense, the magazine, unlike the political diatribe,

reflects the woman's struggle on a daily basis with the taken-for-granted-ness of her existence. The struggle is never over. The magazine accords its reader a position of circumscribed autonomy from which she is assumed able to engage in a constant renegotiation process with the taken-for-grant-edness of her everyday life. The reader is recognized as complicit in the system of consumerism that constitutes her as a subject. But she is actively rather than passively engaged in the process of her own constitution as sub-ject. She is that subject who represents herself for herself, but she is also another subject who consciously creates, manipulates, and compensates for the figurability of an imaginary subject that projects cohesiveness as its founding assumption through a fictional body. This fictional body is created element by element as part of a narrative process grounded in product consumption. The woman as subject is invited to take control of the process whereby she represents herself. At the same time, she is constantly reminded that she must submit to a regime that externalizes figurability through product usage.

In this sense, the women's magazine calls into question the new recon-structable body as a means of speaking the feminine. Thus the women's magazine is far from positing, in Susan Bordo's terms, "a new, postmodern, imagination of human freedom from bodily determination" (*Unbearable Weight*, 245). Rather, popular discourse, exemplified by Madden's commen-tary above, is skeptical of a freedom that must be realized through product usage and effected through a predetermined discipline of the body that results in a play of difference that is inevitably a spectacle, an array of images. On the other hand, typically illustrating its cultural switchboard function, which constructs diverse discourses of femininity within an interlocking grid, the women's magazine does not trivialize the feminine imperative to "image" a "self." Certainly it does not claim, again in the words of Bordo, that: "If we are never happy with ourselves, it is implied, that is due to our female nature, not to be taken too seriously or made into a political ques-tion" (*Unbearable Weight*, 253). Rather, women's magazines, and feminine culture (as in the case of Terry McMillan's *Waiting to Exhale*), displace the political from its position as part of a metacritical discourse onto the minute decisions of a contingent day-to-day practice in which absolute categories cannot be maintained from moment to moment. Feminine culture empha-sizes a process of investment and return, of negotiation, in which the value of a given articulation of pleasure is always measured against its costs, the inevitable price of an invitation that is never extended freely, never absolute-ly, the terms of which change from day to day, from place to place.

Again it would be incorrect to summarize the process of investment and return that characterizes feminine culture as: "The general tyranny of fashion—perpetual, elusive and instructing the female body in a pedagogy of personal inadequacy and lack . . . a powerful discipline for the normalization of all women in this culture" (Bordo, *Unbearable Weight*, 254). To do so is to forget that, though feminine culture has a history, this history is subject to reappropriation and rewriting. The "hair" culture of the African-American woman may have its history in the oppression of the African-American race, but though this history cannot be denied, it can be reclaimed. Thus in *Waiting to Exhale*, the hairdressing salon run by Gloria is the center of the black female community that the novel describes— "black" hair, its specific needs and qualities, are signs of "racial difference" but also of the cohesion and the specificity of black feminine culture today. Their hair may set these women apart, but it also is the mark of their common identity. Thus to censure "hair" culture as does Bordo when she states that "mediating a black woman's 'choice' to straighten her hair, is a cultural history of racist body-discriminations such as the nineteenth-century comb-test" is to demand a political agenda that depends on clear, distinct categories (*Unbearable Weight*, 254). Bordo, characteristically of many feminist scholars, would appear to seek a master narrative that might clearly answer Madden's questions with an unequivocal yes or no.

Feminine culture demands another logic—the logic of a conflicted overdetermined practice in which answers are and/and—a logic that does not confine itself to the obsessional trajectories of analysis but that also embraces a hysterical symptomology that, as Avital Ronell explains, "breaks up continuities, produces gaps and creates horror—refusing conformity with *what is*" (131). Again, in the words of Avital Ronell: "If you read Freud, you find that creativity and hysteria are linked. Hysteria is stimulating—it's not to be repressed. And it's funny that women have internalized that censorship of hysteria as though it were an unwelcome disease . . . whereas it should be welcomed as part of the work force" (131). Indeed we might say, strange as it may initially seem, that McMillan's middle-class black protagonists and the radical avant-garde feminist Avital Ronell have in common a commitment to what bell hooks terms "a transformative feminist vision,"[3] in which the reconstructability that postmodern culture offers its subjects is exploited as the potential to reappropriate feminine culture, and all that this entails in terms of sexualities. Here, rewriting is not a process of denial but rather reclaims the symptom and the pleasure that it might offer its subject. Hysteria rewrites

a body that through analysis will speak itself—"the talking cure" is then a reclamation of the body as voice. Yet reclaiming this voice/this body can only be effected through a transformative politics that is both contingent and incomplete, itself subject to rewriting as the conditions of its production. The goal of this project then has been to trace, to claim, and to rewrite feminine culture—to embrace the symptomology of femininity not as disease but as an attempt to seek out, in the words of Ronell, "a feminism that is joyous, relentless, outrageous, libidinally charged" (127)—that does not deny but rather reaffirms the feminine, not as a monolithic moment but as a productivity of femininities which speak the heteroglossia of experience, its movements, its contradictions, its repetitions, and its reclamations.

NOTES

Preface

1. See Dean MacCannell and Juliet Flower MacCannell.
2. See Rita Freedman in *Beauty Bound.*

1. Speaking Out: Shrewish Behavior

1. I use the terms feminine and masculine to emphasize the cultural construction of these categories, except when referring to a specifically biological trait or when quoting another writer who does not make this distinction.
2. The positioning of a masculine subject of enunciation is equally intricate, but involves issues outside the scope of this discussion.
3. See Tania Modleski's discussion of the soap opera in *Loving with a Vengeance.*
4. For a fuller discussion of *Moonlighting* as quality television, see J. P. Williams, "'When You Care Enough to Watch the Very Best': The Mystique of *Moonlighting.*" For a general discussion of quality television, see Jane Feuer, ed., *MTM 'Quality Television.'*
5. "Atomic Shakespeare." Writ. Jeff Reno, Ron Osborne. *Moonlighting.* Created by Glenn Gordon Caron. Dr. Will Mackensie. Prod. ABC Circle Films. 1986–87 season. The following is a brief description of the episode.
 The episode "Atomic Shakespeare" consists of a prologue and epilogue (the frame) and four sections or "acts": the exposition ("Padua, Italy, 1593, or just an incredible facsimile"); "The Courtship"; "The Marriage"; and "Da Big Finish." Each act is announced by an inter-title representing the page of

181

a large old-fashioned (but certainly not Elizabethan) book. These inter-titles refer back to the frame, for the pages are turned by the hands of a young boy introduced in this section, which takes place before the title sequence.

The episode begins as the camera zooms out to reveal a woman in contemporary costume turning off the television set. A young boy objects. The boy would like to watch *Moonlighting*, but his mother insists that he study Shakespeare instead. The boy describes the program as "the show about the two detectives—a man and a woman." "And they argue a lot and all they want to do is sleep together. Sounds like trash to me," she replies. The boy reluctantly goes upstairs and opens his Shakespeare book. Throughout the sequence we never see the faces of the woman or the boy.

The first inter-title appears as the theme song from *Moonlighting* shifts from its usual jazzy mode to a vaguely Renaissance sound (connoted by horns and trumpets) announcing the title of this episode as "Atomic Shakespeare." After the credit sequence, the words "Padua, Italy, 1593, or just an incredible facsimile" are superimposed over a bustling Renaissance square, a picture from the book which comes to life. We quickly recognize characters from the Blue Moon Detective Agency (the site of the typical *Moonlighting* episode) while absorbing backstory. Lucentio falls in love with Bianca (we identify them as Blue Moon office workers), but learns that she is unavailable until a suitable husband is found for her older sister Kate. Kate is played by the indomitable Cybill Shepherd who, as Maddie Hayes, heads the Blue Moon Detective Agency. Act I ends when Lucentio discovers that Petruchio (Bruce Willis, who as David Addison, the detective, works for Maddie) is in search of a rich wife.

In Act I, "The Courtship," Baptista agrees to give Petruchio twenty thousand crowns if he will marry Kate. Petruchio is undeterred by Kate's hostility. In Act II, "The Marriage," Kate, bound and gagged at the altar, is married off 'midst the applause and cheers of the townspeople. During the rest of the act, Kate and Petruchio come to terms with each other. Here we notice a significant departure from the Shakespearean model, in that the adjustment appears to be mutual.

Finally in "Da Big Finish," Act III, Petruchio and Kate return to Padua for Bianca's wedding. Baptista requires that Petruchio prove that he has "tamed" Kate. Rumor has it that it is Petruchio who has been tamed. Petruchio attempts to maintain the semblance of dominance, but at the last moment breaks down. The episode ends, not with the capitulation of Kate to masculine supremacy, but with a plea from Petruchio for better understanding among men and women.

Kate then takes Petruchio in her arms and they kiss. A voiceover informs us that they lived life long and full, though Kate and Petruchio's last words are: "We hate iambic pentameter."

We then return to the frame; the boy shuts the book. He trudges downstairs as the final credits and theme music from *Moonlighting* fill the living room television screen. His mother turns off the set, informing him that the show was not very good.

6. Viewers who do not normally watch the show reported watching this episode because of the topic.

7. One might say that there are many canons, each specific to a given subculture. As a rule, here I will reserve the term canon to refer to the construction of competency and cultural literacy within academia, and by extension within the class it represents, unless I specify otherwise.

8. See *Uncommon Cultures: Popular Culture and Post-Modernism* by Jim Collins for an elaborate discussion of the multiplication of hierarchies that characterizes contemporary culture.

9. The move in the other direction, from literature to fashion, from philosophy to baseball, is just as common.

10. This move towards class consolidation is always already rewritten by the specificity of a gendered positioning and thus is fundamentally duplicitous in that it is a move that appears to "de-gender" but does in fact not challenge traditional gendered positions.

11. See Henry Giroux in *Border Crossings* for a more elaborate discussion of the issue of cultural literacy.

12. For example, during the exposition, Lucentio has difficulty in persuading a fellow actor to listen to a long speech designed to provide background, one of the conventions of Shakespearean drama that now seems outmoded and artificial.

13. In her function as novelist, French does in fact come to occupy a very different position, outside the authority of the canon as it is represented by Shakespeare. Perhaps she has proven less influential as a feminist critic than as a novelist because she was unwilling to make this same move within academic discourse.

14. French uses the term "inlaw" (as opposed to outlaw) to describe the position of the women *within* patriarchal law.

15. See Rachel Blau DuPlessis in *Writing Beyond the Ending: Narrative Strategies of Twentieth-Century Women Writers* for a discussion of the centrality of the marriage plot in women's fictions.

16. See the work of Monique Wittig, Alice Jardine, Carol Gilligan, etc.

17. For a discussion of the centrality of the Cinderella plot to women's fiction see Huang Mei, *Transforming the Cinderella Dream.*

18. It is this desire for love and protection, to be nurtured, that Janice Radway

and Tania Modleski see as one of the overriding thematics of the modern paperback romance. See Chapter 3.

19. See *Loving with a Vengeance* by Tania Modleski for a fuller discussion of this issue in the format romance.

20. Hence we saw the resistance to the personal voice and women's studies in general within traditional critical perspectives as antithetical to the class interests of the academic.

21. The fact that Sly uses the word "boy" in addressing the Hostess indicates that he may have been more self-conscious than he initially appears. On the other hand, the correct interpretation of this word has been a subject of some dispute. John Pafford suggests that the word "bor" from the word neighbor might make more sense.

22. I would like to thank Ewa Ziarek for drawing my attention to this passage and its relevance to feminist criticism.

23. See Chapter 3 for a discussion of this issue (the naming of the heroine) in the context of the popular romance.

2. The "New Woman" and Her "Self"

1. This admonition to act as her own Petruchio (help) to her own Kate (self) suggests that, from a traditional Freudian perspective, Price is aiding the reader in strengthening not the "ego" but the "superego"—personified through Petruchio as the masculine voice.

2. In Lacanian terms, she is enjoined to internalize the name-of-the-father, to produce the ego ideal that Freud identifies with masculine development within a specifically feminine cultural construction of identity.

3. We assume, in addition to an improved disposition, Judith's dedication to music, the "vast amounts of time practicing," has curtailed her evening escapades, or whatever other allegedly aberrant behavior her condition had produced.

4. In this context, it is important to note the ambiguous place that *Jane Eyre* occupies in the canon of English literature. As a classic it occupied a marginalized position within the formal study of literature until it was transformed into the cornerstone of a new feminist canon by such scholars as Sandra Gilbert and Susan Gubar. Thus, *Jane Eyre* is a doubly legitimate text, a classic, and a feminist classic.

5. See in particular Gilbert and Gubar, *The Madwoman in the Attic,* and Gayatri Spivak, "Three Women's Texts and a Critique of Imperialism."

6. Interestingly enough, *Wide Sargasso Sea* is the third text in Spivak's article, cited above, to which she devotes a substantial portion of her analysis.

7. See Gayatri Spivak in the article cited above for a fuller discussion of the colonialist and racist implications of the novel.

8. For a more detailed discussion of "romantic fusion" see Chapter 3.

9. I borrow the term excorporate from John Fiske (*Understanding Popular Culture*, 15).

10. I discuss the contradictions inherent in the formulation of the romance, in particular in terms of its relationship to feminine subjectivity, at great length in Chapter 3.

11. Roseanne Barr must be considered the exception that proves the rule. The problems encountered by Delta Burke when she gained weight are more typical of television's attitudes towards large women.

12. See Chapter 5 for a discussion of the body as a site of feminine transformation and discipline.

13. Here I draw upon the approach evolved by the École Freudienne (rather than the American Psychoanalytic school) because it directly addresses the issue of representation.

14. We recall that this "specular image" has as its originary moment a misrecognition of the body of the Other as the "moi."

15. Eugénie Lemoine-Luccioni, *Partage des femmes* (Paris: Editions du Seuil, 1976), 85. Translation by Stephen Heath in Stephen Heath, "Difference," *Screen* 19:13 (1978), 92.

16. Lemoine-Luccioni states: "It is to the Father that she then gives herself to be seen." (C'est au Père qu'elle se donne alors à voir.) Translation mine.

17. Heath translates "elle préfère basculer dans l'image" as "she prefers to tip over into the image" ("Difference," 92). There is a finality in this translation that is not in the original French, in which "basculer" as an intransitive verb means "to rock," "to seesaw," imparting a sense of oscillation that is clearly rearticulated as such in the notion of the "inverted fort-da" ("Fort-Da renversé").

18. The female stars of *Cagney and Lacey*, who have a very different relationship with the camera, demonstrate that this is not a necessary result of the televisual medium.

19. By feminine, I am referring to a libidinal position that preserves the dichotomy feminine/masculine as the founding moment of difference.

20. The recent proliferation of specialized grooming products for different parts of the body (hands, feet, elbows, knees, nails, throat, eyelids, etc.) indicates the potential for consumer eroticization of any part of the body.

21. See Freud, *The Standard Edition,* 19:30, 19:46.

22. The emphasis on grooming for men, for example the introduction of skin-care lines for men, etc., within the consumer arena suggests that masculine narcissism can also be rearticulated through, in the absence of a better term, a consumer "lack" that harks back to the mother's body—opening up the possibility that even in our discussions of male narcissism too much emphasis has been placed on the role of the father.

23. See Chapter 5 for a full discussion of this reconstructability of identity within feminine culture.

24. I discuss the relationship between consumerism and fetishism at greater length in "Pretty Is As Pretty Does: Free Enterprise and the Marriage Plot," in *Film Theory Goes to the Movies.*

25. The self-hatred that accompanies the pleasure of such activities as shopping or aerobics is another avatar of this "battle."

26. My own translation. (La femme est belle par définition, puisque si elle se sait ou se déclare laide, elle n'est plus une femme. C'est du moins ce que l'on entend en analyse, où ces propositions ne vont généralement l'une sans l'autre.)

27. See Sarah Kofman, *The Enigma of Woman: Woman in Freud's Writing,* for a fuller discussion of this issue.

28. Recall that Petruchio/Dave cures Kate/Maddie with his love in "Atomic Shakespeare."

29. Marketing experts such as Rena Bartos deliberately exploited this concept in their attempts to "open up new markets."

30. Alan Sheridan translates this phrase as "the monumental construct of his narcissism." However, implied in the French version is the notion of a monument to the subject's narcissism, as opposed to that narcissism itself.

31. The use of the masculine pronoun in French is a function of the linguistic gender rather than a "gendered" attribute of the antecedent. Thus I avoid the use of the masculine possessive adjective favored by Sheridan in his translation as potentially misleading to an English speaking reader.

3. "A Dream of Thee"

1. I would like to thank R. L. Rutsky for his comments on sections of this chapter.

2. That the romance can be read as a symptom of the mastered feminine voice explains in part the suspicion with which heterosexuality (so closely allied with the romantic problematic) has been viewed within feminist scholarship. See the work of Shulamith Firestone for a characteristic "second wave" feminist reading of heterosexuality and the romance. See the work of Sue-Ellen Case for a rereading of this position from the perspective of the lesbian feminist, or more specifically that of "queer" theory.

3. A logical outcome given the field's origins in literature departments was the emphasis on the romance in its more traditional forms (see for example Helen Pashivily, Gilbert and Gubar, Nina Baym, Rachel Brownstein). Less self-evident was the critical attention elicited by contemporary popular romances. For example, the Harlequin romance became a topic of scholarly research during the same period in which it became an object of mass consumption. Scholars such as Ann Douglas, Margaret Jensen, Tania Modleski, Kay Mussell, Leslie Rabine, Janice Radway, Lillian Robinson, Carol Thurston, Ann Snitow, Valerie Walkerdine, among others, seemed as drawn to the romance as were its readers, and within a similar time frame.

4. The proliferation of genres within the romance industry since the early 1970s is both complex and somewhat confusing to those who are not "fans." And if the parallel development of newsletters, the goal of which is to guide women in their reading choices, is an indication, even fans seem to need some sort of guidance. Carol Thurston, in *The Romance Revolution: Erotic Novels for Women and the Quest for a New Sexual Identity,* provides a comprehensive introduction to the romance industry. She adumbrates current usage of the term category within publishing:

 > The word "category" is one of the most ambiguous in the romance publishing business, used variously by both editors and agents to mean genre or formula writing (as when a book is said to be "out of category"), as well as to refer to series romances that are written to publisher-specified guidelines, which are issued together and in a given number at the same time each month. (footnote #5, 32)

 I use the term category in its largest sense, unless I otherwise specify that I am referring to a "romance line or series," also called "brand-line books."

5. Why the feminist critic might "pass over" the figure of the shrew is an interesting question that calls out for further investigation. Initially, however, one might say that the feminist critic, in her anxiety that she too might be dismissed as "the shrew," distances herself from that position. To defend the shrew is to run the risk of becoming the shrew. There are notable exceptions, feminist critics such as bell hooks, Jane Marcus, Rosalind Coward, Annette Kolodny, Tania Modleski, among others, who do not hesitate to "talk back."

6. Michael Silverstein describes the referential function of language in the following terms: "the function of pure reference, or in terms more culturally bound than philosophical, the function of descriptions or 'telling about.'" He elaborates: "communication by propositions—predications descriptive of states of affairs—subject to verification in some cases of objects and events, taken as representations of truth in other" (Silverstein, 15). This property of speech is also described in terms of "semanticity" as the aspect of speech that revolves around "abstract reference and description" (15). It should be noted, however, that no speech act (including the textual act as an extension of the speech act) can be subsumed under one category. In other words there is no act of pure referentiality and no speech act is completely without a referential function. In the case of the Harlequin, it is more appropriate to think of the referential function as diminished rather than effaced. (For a useful elaboration of these terms in the context of performance, see Daniel Sheerin, "*Sonus* and *Verba:* Varieties of Meaning in the Liturgical Proclamation of the Gospel in the Middle Ages," to whom I owe the above definition.)

7. Constance Penley borrows her definition of fantasy from the French psychoanalysts Jean Laplanche and J.-B. Pontalis. See Jean Laplanche and J.-B. Pontalis, "Fantasy and the Origins of Sexuality." See Elizabeth Cowie for a fuller explanation of the notion of fantasy and its implications for feminist theory and film studies.

8. The degree of repetition (brand-line romances exhibiting an extremely high degree of repetition, for example) varies from format to format. All category romances demand a high degree of repetition if they are not to fall "out of category." Thus readers of erotic historicals frequently read the beginning and the end of a novel to ensure that it conforms to the pattern before actually "experiencing" the novel (Radway, *Reading the Romance*, 199–200). These variations, however, should serve to caution us against using the notion of regression too literally. Romance readers do not regress, rather they participate in a fantasy of regression.

9. These are the terms in which the Harlequin tip sheet, generated for prospective writers by the company, describes the format of this "brand-line" romance.

10. It is important to recall here that "familiarity" is a desired attribute, rather than a dismissive epithet, within the genre.

11. For an explanation of the "fort-da" game, see Chapter 2. See also below.

12. Modleski quite aptly analyzes the format as enabling a fantasy of control for the reader in which the reader, because she knows that the spool will return from there to here, because she knows that the heroine and hero must come together at the end of the novel, can imagine that the hero is always already

in the process of being brought to his knees by the heroine, "that all the while he is being so hateful, he is internally groveling, groveling, groveling" (*Loving with a Vengeance*, 45). However, she sees this mode of repetition as related to a symptomology characterized by regression and hysteria (57).

13. See below for a fuller description of the prelinguistic state.

14. This diversification of product was part of an effort to recapture the substantial share of the U.S. market that Harlequin lost to competing lines during 1981–1983 (Thurston, 56–65). It must be noted that this apparent reduction in readership was not a reflection of romance readership in general but of the increasing competition from other series lines ("Harlequin Romances," *Business Week*, 157, 169).

15. *Bronze Mystique* was originally published as a Harlequin Temptation (a "sensuous" Harlequin line), but was reissued under the author's name because of Delinsky's reputation and popularity as an especially sought-after author. See Carol Thurston for a description of the evolution of the format genre and its function as an institution.

16. *Bamboo Wedding* is typical of what are now known as "sweet romances" (as opposed to an erotic romance such as *Bronze Mystique*) which dominated the romance market in the 1970s. During this period, it was the format as a specific formula that was emphasized, as opposed to the work of an individual author. The hierarchy of authors that characterizes romance marketing in the 1980s and 1990s was not yet a factor, though certain authors such as Janet Dailey, who continue at the top of readers' lists of favorite authors (Thurston, 171), were already developing a reputation that would come to supersede the reputation of the imprint itself. Currently, though marketing by imprint or brand-lines is still significant, increasingly emphasis is placed on author recognition as a factor in determining readers' choices. It seems likely that this emphasis on the author has evolved in response to the demands of both authors and readers, since it could only work to the detriment of the company's control over the process of production and distribution. Indeed Harlequin works very hard to discourage the development of a specific "author position" controlled by the writer herself (Linden and Rees, *Forbes*, 73).

17. "*infans:* unable to speak." See Colin MacCabe, "On Discourse," 193.

18. The fantasy generated by the romance hinges on this pain/pleasure structure. See the next section for a more developed explanation of this relationship.

19. Roumelia Lane, *Bamboo Wedding, passim.*

20. The use of the necklace, marked as Asian because of the carving and the jade, is typical of the way in which "local" color within the romance func-

tions largely to underline the heroine's position rather than to offer insight into the cultural diversity that might be suggested by "exotic locales" in the vocabulary of the Harlequin tip sheet. See below for a fuller discussion of this issue.

21. Radway describes this transparency of the popular text in terms of an emphasis on the referential function of language; I argue that the repetitive nature of the formula, though offering a fantasy of referentiality, produces a quite different effect (see above).

22. Recall that these are the terms in which the Harlequin tip sheet, generated for prospective writers by the company, describes the format of the "brand-line" romance.

23. In this context, Radway suggests that *Green Lady*, a novel marketed as a romance which focuses on the mother/daughter relations, operates as a "shadow text" (my terms) of the romance in general (*Reading the Romance*, 152–156); the privileging of the mother/daughter dyad in this romance elucidates the centrality of the quest for "the lost mother" within the romance in general (156).

24. For example, in Kathleen Woodiwiss's *So Worthy My Love* (1989), the union of the hero and heroine occurs a little less than two-thirds of the way through the 689 page novel. The final third of the novel is devoted to re-establishing the position of the hero within society and the matrilineal line of the heroine, whose dead mother was originally a foundling. Here the recovery of a grandmother takes the place of the recovery of the mother. (See the following section for further discussion of this novel.)

25. The work of Gaylyn Studlar offers a notable exception to this trend.

26. See the work of sociologist Carol Gilligan, *In a Different Voice*, for a sympathetic explanation of feminine ethical superiority derived from Chodorow's theories but based on ethnographic research.

27. Deleuze insists that the psychic construction of the sadist and the masochist is defined by distinct libidinal economies (41). Here I use the term sadist to designate the masochist's object of libidinal attachment. I argue that within the scenarios of desire and pleasure described above, the subjectivity of the sadist is not at stake. Within the romance and its avatars, the hero as sadist serves only as part of the mise-en-scène of the heroine's desire. Within the romantic paradigm, Deleuze's remark about "the woman torturer of masochism" would seem to apply to the romantic hero, because his primary function (as is that of "the woman torturer") is to be "an integral part of a realization of the masochistic fantasy" (41) rather than to represent a desiring subject. Even in Anne Rice's pornographic novels (discussed later in this section), which explore both masochistic and sadistic scenarios, *Beauty's*

Release and *Exit to Eden* conclude with the submission of the heroine to the hero in a marriage articulated through an invocation of a masochistic scenario in which the heroine occupies the position of the desiring subject.

28. In the novel, neither hero nor heroine, nor any other character except "for a kid named Jimmy," are "named." In the film of the same title, characters are given first names only—in the case of heroine and hero, Elizabeth and John. I use the terms "hero" and "heroine" to designate the positions in the novel "named" as John and Elizabeth in the film. Thus the hero is only the hero because of his narrative function—I do not mean to suggest that we should ascribe to him the characteristics of moral superiority, strength, etc., often associated with the term hero.

29. See discussion of the prelinguistic above.

30. In the film of the same name, this connection between feminine consumer culture and the masochistic scenario is maintained through the heavily stylized mise-en-scène, echoed by an actual shopping spree at "Comme des Garçons"—an expensive Soho boutique that features the creations of designer Rei Kawabuko in the same neighborhood as "Elizabeth's" gallery. The choice of employment, location, and designer all reflect the glamourization of the 1980s art scene and its incorporation into the fashion world in which artists such as Julian Schnabel, David Salle, and most notably Jeff Koons, are used by magazines as icons of the fashionable life.

31. I discuss the issue of chastity at greater length in "Pretty Is As Pretty Does: Free Enterprise and the Marriage Plot."

32. The issue is complicated in Rice's novels because, unlike the category romances, or *9 1/2 Weeks*, her texts produce a multiplicity of subject positions that cross both gender divisions and the divisions of masochism and sadism as described by Deleuze.

33. This period, the late seventies and the early eighties, produces an intense interest among feminists in *The Story of O*, which is referenced in *9 1/2 Weeks* and in *Exit to Eden* (another pornographic novel by Anne Rice, written under the pseudonym Anne Rampling), and at a more literary level in the work of Angela Carter. This scholarly interest seems to parallel the above novels' investment in the same scenario. Typical of the ambiguous place occupied by such work is the respect and the controversy generated by the writings of Carter, for example. (See, for example, Elaine Jordan, "The Dangers of Angela Carter.")

34. Thurston claims that "by the end of the 1970s they [erotic historical romance novels] were being read at an average rate of four or more per month by at least one out of every six American women over the age of fifteen" (88).

35. Thurston claims that the popularity of the erotic historical novel climaxed in the 1970s and that "by 1981 had burned down to glowing embers" (22). However, in 1982 and 1985, Woodiwiss was still at the top of lists of "favorites named by readers" (Thurston, 171).

36. For a discussion of rape in the erotic historical romance, see Thurston, 78. It is significant that, although rapes are common in historical romances, they are not part of the idiom of contemporary category romances such as Harlequin Presents, or even the "hot" categories such as Harlequin Temptation.

37. Given the romance industry's emphasis on the "dream" that underlies the romance format, it is notable that these are the terms that Freud sees as governing representation within the dream proper. (See *Interpretation of Dreams,* also Laplanche and Pontalis.)

38. Here I recall another point made by Penley (who again borrows from Laplanche and Pontalis) about the psychoanalytic concept of fantasy: "There is no separation between conscious and unconscious fantasies but rather a profound relationship and continuity between the various fantasy scenarios—'the stage setting of desire'" (493, footnote #2).

39. Woodiwiss's rendition of Captain Nicholas's German-Austrian accent is one of the many anachronisms that characterize the novel.

40. Lines such as "'tis I who must suffer the stones and arrows of this most outrageous farce" [*sic*] (Woodiwiss, 177), the inclusion of a character named Katarina who in the words of Nicholas "has always spoken her mind quite vell" (354), suggest that the novel is making explicit reference to Shakespeare.

41. The second half of the novel is devoted to the reconstruction of Elise's family, and the restitution of the family's economic holdings and social status.

42. "Bodice" in its association with the verb "to rip" recalls of course various "feminine" undergarments and the ritual of their removal, typically associated with scenarios such as those involving high-heeled shoes, stockings, and garter belts described in *9 1/2 Weeks*. (See above.)

43. This use of the fur, which recalls *Playboy* magazine of the 1950s rather than Renaissance England, should not be confused with the use of the fur in the prototypical masochistic scenario described by Sacher-Masoch in "Venus in Furs."

44. The use of the past tense signaling a return to "adult" life contrasts with the present tense used to describe the "9 1/2 weeks" proper couched in the eternal immediacy of pleasure.

45. Forbes reported in 1992 that romance novels constitute "46% of all mass market paperbacks sold in the U.S." (Linden and Rees, *Forbes,* 71).

46. The film version allows Elizabeth an autonomy denied the nameless heroine. It is she who makes the decision, turning her back on John, preserving the fantasy's relationship with the possible. The novel, on the other hand, under-lines the impossibility of the fantasy as the condition of its status as fantasy.

47. In contrast, the heroine of the novel holds an unspecified corporate posi-tion; her work is thus completely disconnected from her "erotic" life, a discontinuity that the novel emphasizes, situating the corporate within the world of the "adult."

48. The film attempts to salvage a certain cultural status by ensuring that this romance does not have a "happy ending." However, it refuses the complete deconstruction of the romance effected in the novel by attributing the fail-ure of the romance not to the structure of the fantasy but to a tragic flaw in the hero, who cannot "love" because of an unhappy childhood.

49. *Essence* magazine reports that in 1980 the "first African-American romance novel featuring Black leading characters was published by a major publish-ing house" (*Entwined Destinies* by Rosalind Wells under the Candlelight Romance imprint); however, this inaugurated only a "trickle of Black romance novels," as the exceptions that prove the rule (Agyemang-Badu, "Graffiti," 124). These novels are so much of an anomaly that an African-American reader who routinely reads these romance novels reported never having encountered a romance novel revolving around Black characters, though she also said that she would have sought out such novels should they have been available to her.

50. Originally published as a Harlequin SuperRomance in 1984, the novel was reissued under the author's name in 1989 by Jove Books. As a designated "favorite author," and an innovator in the area of the erotic romance, Spencer has been categorized as a "gatekeeper on romance" (Thurston, 166–183). The biography included on the inside of the back cover of the Jove edition exploits this status to lend "value" to the book: "Known in the romance field as 'the gatekeeper of Romance,' LaVyrle is a four-time winner of the Golden Medallion Award for Best Historical romance, two-time win-ner of the Waldenbooks Bestseller Award, and recipient of *Affaire de Coeur*'s Silver Pen Award." The status that Spencer's work enjoys suggests that her characterization of race and gender are neither idiosyncratic nor insignifi-cant, and that the romance is not without a certain influence in the production of race and gender as intersecting cultural categories.

51. The cover illustrations of erotic historicals are strangely misleading in this sense. Frequently in "bodice rippers" the heroine may have large breasts, but they are always accompanied by some other attributes that indicate her childlike physique. (See Jude Deveraux, *The Duchess*.)

52. The Harlequin tip sheet informs the prospective writer: "Harlequin readers . . . like to learn about local food, dress, and customs" (from tip sheet). This

statement is borne out by Janice Radway's research, which indicates that romance readers see their books as a means of expanding their knowledge of the world (*Reading the Romance*, 86–118).

53. See Chantal Mouffe, quoted in Chapter 2.

54. The large international market for category romances indicates the importance of this issue on an international as well as a national scale.

4. Private Entertainments

1. It is perhaps not insignificant that a number of feminist theorists such as Julia Kristeva, Cathérine Clément, Elizabeth Wilson, among others, have become novelists, and that others such as Hélène Cixous and Monique Wittig have historically divided their efforts between theory and fiction. Certainly the work of Simone de Beauvoir offers that most striking example of a feminist whose work took a number of different discursive forms.

2. I am deeply indebted to Angela Ingram for her thoughtful discussion of my analysis of *The Mind-Body Problem*.

3. For a detailed account of the case, see "Anna O. (Bertha Pappenheim): Her History" (Rosenbaum).

4. I would like to thank Kara Keeling for introducing me to the work of Terry McMillan and helping me to understand her significance within African-American culture.

5. I do not mean to suggest that this multiple narrative is a stylistic innovation on the part of McMillan; however I would suggest that this deliberate fragmentation situates the novel in the tradition of such overtly political writers as John Dos Passos.

6. Of the 28 chapters, six are devoted respectively to Savannah's, Robin's, and Gloria's stories, three concern all four protagonists, and seven revolve around Bernadine's story. The final chapter, "Back to Life," though nominally Bernadine's "happy ending," in which she receives a very advantageous settlement from her ex-husband, also ties up the stories of the three other protagonists, as they all plan a group celebration.

7. The denigration of the white woman reverses the relationship between white woman and woman of color in the traditional romance. See Chapter 3 on the romance.

8. See, for example, Thulani Davis's discussion of McMillan's second novel, *Disappearing Acts*, in "Don't Worry, Be Buppie: Black Novelists Head for the Mainstream" (in *V.L.S.*, May 1990, 26–29).

9. Olivia Goldsmith's *First Wives Club*, in which a number of divorced women pool their forces to destroy their ex-husbands, constitutes a counter-example in which the destruction of the ex-husbands becomes the significant conflict of the narrative. In contrast, the focus of *Waiting to Exhale* is exclusively on the women and their lives, the constitution of their new community rather than the destruction of the old.

10. I would like to thank Kathy Psomiades for sharing her magazine reading experiences with me.

11. Silverman's perspective reflects current trends towards a scholarly emphasis among museum personnel as a rule. Vreeland's approach reflects an earlier sense of the museum's functions as overtly associated with femininity and culture as the prerogative of a certain class.

12. The idiosyncratic use of lower case letters is typical of the *Vogue* typesetting and punctuation style, which stresses visual effect rather than grammatical continuity, complementing the fragmentation of the magazine narrative discussed below.

13. See also the work of Diana Fuss and Cathy Griggers.

14. Thus, finally, Danae Clark is cautious in her appraisal of the effects of consumer empowerment on the political cohesion of the lesbian community (123).

15. See earlier discussion of Cybill Shepherd.

16. Beneath, at the very bottom of the page, is the photographer's name, Denis Piel; however, the authority that his name might have implied is overwhelmed by this list of consumer objects.

17. In excerpting sections of Freedman's book entitled *Beauty Bound*, and positioning them against a series of photographs in the article described above, *Vogue* completely rewrites the emphasis of the book. Freedman's study is, in fact, a well-researched, politically committed treatise by a practicing clinical psychologist on the negative effects of the behavior patterns advocated precisely by such magazines as *Vogue*.

5. Speaking the Body

1. See Foucault's *Discipline and Punish*.

2. I would like to thank Kathleen Pyne and Joe Buttigieg for their on-going discussions of the issues raised in this chapter.

3. The notion of "education for all," crossing the boundaries of race, gender, class, and ethnicity, cannot be viewed as a simple emancipatory and democ-

ratic strategy, but must also be seen as the extension of the panoptic control of the public body to all segments of a given population.

4. There is a certain strand of feminism that privileges the feminine as generating an ethical ideal, which men should learn to emulate. (See the work of Carol Gilligan for an example of this position.) However, the goal of this new ethical model is still to ensure that women then benefit from the same rights and freedoms that do men—or more accurately, within the United States, "white" middle-class and upper-class males.

5. The proclamation of "Third Wave Feminism" by such popular authors as Naomi Wolf, credited with coining the term, and Susan Faludi, underlines this anachronism.

6. I use this term to describe an ideologically produced national identity within the United States that is used to designate a group of attributes that, within this ideology, define that which belongs to and characterizes dominant United States culture.

7. Tessa Perkins in "The Politics of 'Jane Fonda'" sees Fonda's reconstructability, the transformability of the Fonda narrative, as "a sign whose meanings have been, and continue to be, the subject of contestation" (237). She continues, "it is this contestation that constitutes the politics of 'Jane Fonda'"(237). I would argue that these transformations are "politically" effective to the degree that they are tied to the public spectacle of Jane's "sincerity." This sincerity suggests that there is a continuity, which "appears" to underlie these transformations. This appearance of continuity is a necessary component of Jane's "political nature."

8. The original *Jane Fonda's Workout Book* sold 1.25 million copies in two years (Carroll, 226)—an unusually high number for a hardcover book.

9. This information was reported by Julie LaFond, Fonda's partner, as the result of "extensive marketing research" (Grant, 147). *Jane Fonda's Workout Book for Pregnancy, Birth, and Recovery* is not in fact even written by Fonda, who however introduces the "method."

10. It is necessary to "know" the pattern in order to properly perform the exercise in which alignment, balance, position, etc., signal accomplishment. This aspect of the workout is carried over from dance techniques. It is not insignificant that Fonda studied ballet for many years before evolving the workout. (*Jane Fonda's Workout Book*, 21).

11. The workout specifically referred to below corresponds to the beginner's workout in *Jane Fonda's Workout Book*.

12. The practice of the workout, at the studio or on the cassette, is extremely repetitive. In fact, there is very little variation from studio to studio regardless of the "method" employed. All the studios at which I did research for this

chapter (in Berkeley, California; San Francisco; New York City; Pittsburgh, Pennsylvania; South Bend, Indiana), whether they offer Jazzercize or more personalized instruction, follow the same basic format detailed here, popularized as "doing Jane." The importance of "doing Jane" is the way in which Fonda came to represent the aerobics phenomenon as a whole.

13. One of my sources, a woman in her mid-thirties who manages a bookstore, told me not to forget the joy in movement, the pleasure in the music itself that working out affords her and her group. She exercises with a group of women from a variety of professions, from shopgirl to university professor, rather than at home with video or audio cassettes. "Doing Jane" or any of the various other forms of aerobic workouts, as well as traditional forms of exercise, appear to give women a certain type of pleasure through movement that until very recently was denied them. The constrictions imposed by certain garments as well as modes of behavior prevented mature women of the middle classes from enjoying sustained physical activity. Though exercise was initially popularized in the early twentieth century (Banner, 202–203), aerobics represents an extension and systemization of this phenomenon for a wider, more varied demographic segment of the female population.

14. The body of the pregnant woman is treated similarly as an anomalous body that must be "worked" back into an acceptable range. See De Lyser's *Jane Fonda's Workout Book for Pregnancy, Birth, and Recovery.*

15. Here it seems important to distinguish between Fonda's life, to which we as readers have little access, and the narrative that she constructs of this life, the Olympian mega-text of public domain.

16. Whiteface makeup was in vogue for children and adolescents at fairs and other types of weekend events during that period in California. Children would pay a dollar or two to have their faces made up. Nonetheless, it seems significant that Vanessa, to whom the book is formally dedicated, should be "whited out," a blank, the enigma of a new yet uncharted femininity, and at the same time, "made up," a ghost of some former femininity.

17. The back flip incident is among the few reiterated in *Jane Fonda's New Workout and Weight-Loss Program.* "I've told the story of my 'Golden Pond back flip' in my first book but I think it bears repeating," states Fonda, underlining its importance in the narrative of the new matriarch (69).

18. The Workout is no longer owned by the Campaign for Economic Democracy, subsequently retitled Campaign California.

19. This ordered disorder recalls the structure of the women's magazine.

20. Vreeland asserts proudly that there are no pictures of poverty in *Allure* (7).

21. At a certain point, anorexics become infertile. The anorexic body, whether fertile or not, represents a feminine that is not fecund, thus not mature, not

powerful in a way that might be especially threatening to men since it is a power not available to them.

22. The remaining photographs are ambiguous.

23. I discuss this issue more fully in "Pretty Is As Pretty Does: Free Enterprise and the Marriage Plot," in *Film Theory Goes to the Movies*.

Conclusion

1. I would like to thank Gerry Berk for sharing his thoughts on some of the issues that I raise in this section.

2. Clearly, Gilligan's own theories of feminine and maternal identification are not adequate to the complexities of *Vogue*'s discourse.

3. For a fuller discussion of this concept and its implications, see bell hooks in "bell hooks."

WORKS CITED

Books

Andersen, Christopher. *Citizen Jane: The Turbulent Life of Jane Fonda.* New York: Henry Holt and Company, 1990.

Banner, Lois. *American Beauty.* New York: Knopf, 1983.

Barthes, Roland. *Mythologies.* Trans. Annette Lavers. New York: Hill and Wang, 1972.

Bartos, Rena. *The Moving Target: What Every Marketer Should Know About Women.* New York: Free Press, 1982.

Berger, John. *Ways of Seeing.* London: Penguin Books, BFI Publishing, 1972.

Bordo, Susan. *Unbearable Weight: Feminism, Western Culture and the Body.* Berkeley: University of California Press, 1993.

Bourdieu, Pierre. *Distinction: A Social Critique of the Judgment of Taste.* Trans. Richard Nice. Cambridge, MA: Harvard University Press, 1984.

Brontë, Charlotte. *Jane Eyre* (1847). Ed. Q. D. Leavis. Harmondsworth, Middlesex: Penguin, 1966.

Brown, Helen Gurley. *Sex and the Office.* New York: Pantheon, 1964.

———. *Sex and the Single Girl.* New York: Bernard Geis, 1962.

Carroll, Peter N. *Famous in America: Jane Fonda, George Wallace, Phyllis Schlafly, John Glenn, the Passion to Succeed.* New York: E. P. Dutton, 1985.

Cartland, Barbara. *The Best of Barbara Cartland: The Proud Princess, The Magnificent Marriage, The Bored Bridegroom, Kiss the Moonlight, The Devil in Love.* New York: Grosset and Dunlap, 1978.

Certeau, Michel de. *The Practice of Everyday Life.* Trans. Steven Rendall. Berkeley: University of California Press, 1984.

199

Chodorow, Nancy. *The Reproduction of Mothering: Psychoanalysis and the Sociology of Gender.* Berkeley: University of California Press, 1982.

Collins, Jim. *Uncommon Cultures: Popular Culture and Post-Modernism.* New York: Routledge, 1989.

Coward, Rosalind. *Female Desires: How They Are Bought, Sought, and Packaged.* New York: Grove Press, 1985.

Cranny-Francis, Anne. *Feminist Fiction: Feminist Uses of Generic Fiction.* New York: St. Martin's Press, 1990.

Cvetkovich, Ann. *Mixed Feelings: Feminism, Mass Culture and Victorian Sensationalism.* New Brunswick, NJ: Rutgers University Press, 1992.

De Lyser, Femmy. *Jane Fonda's Workout Book for Pregnancy, Birth, and Recovery.* New York: Simon and Schuster, 1982.

Delinsky, Barbara. *Bronze Mystique.* Toronto: Harlequin Books, 1992.

Derrida, Jacques. *Positions.* Trans. Alan Bass. Chicago: University of Chicago Press, 1981.

Deveraux, Jude. *The Duchesse.* New York: Pocket Books, 1991.

Doane, Mary Ann. *The Desire to Desire.* Bloomington, IN: Indiana University Press, 1987.

Douglas, Susan J. *Where the Girls Are: Growing Up Female with the Mass Media.* New York: Random House, 1994.

DuPlessis, Rachel Blau. *Writing Beyond the Ending: Narrative Strategies of Twentieth-Century Women Writers.* Bloomington, IN: Indiana University Press, 1985.

Dyer, Richard. *Stars.* London: BFI Publishing, 1986.

Eco, Umberto. *Postscript to The Name of the Rose.* Trans. William Weaver. San Diego, CA: Harcourt, Brace, Jovanovich, 1984.

Eliot, George. *Adam Bede.* Boston: Houghton, Mifflin, 1968.

Feuer, Jane, ed. *MTM 'Quality Television'.* London: BFI Publishing, 1984.

Firestone, Shulamith. *The Dialectic of Sex: The Case for Feminist Revolution.* New York: Morrow, 1970.

Fiske, John. *Understanding Popular Culture.* Boston: Unwin Hyman, 1989.

Fonda, Jane. *Jane Fonda's New Workout and Weight-Loss Program.* New York: Simon and Schuster, 1986.

———. *Jane Fonda's Workout Book.* New York: Simon and Schuster, 1981.

———. *Women Coming of Age.* New York: Simon and Schuster, 1984.

Foucault, Michel. *Discipline and Punish: The Birth of the Prison.* Trans. Alan Sheridan. New York: Vintage Books, 1979.

———. *The History of Sexuality: Volume 1, An Introduction.* Trans. Robert Hurley. New York: Pantheon, 1985.

———. *The History of Sexuality: Volume 2, The Use of Pleasure.* Trans. Robert Hurley. New York: Pantheon, 1985.

———. *The History of Sexuality: Volume 3, The Care of the Self.* Trans. Robert Hurley. New York: Vintage Books, 1988.

Fox, Stephen: *The Mirror Makers: A History of American Advertising and its Creators.* New York: Vintage Books, 1984.

Freedman, Rita. *Beauty Bound.* Lexington, MA: Lexington Books, 1986.

French, Marilyn. *The Bleeding Heart.* New York: Summit Books, 1980.

———. *Shakespeare's Division of Experience.* New York: Summit Books, 1981.

———. *The Women's Room.* New York: Summit Books, 1977.

Freud, Sigmund. *The Standard Edition of the Complete Psychological Works of Sigmund Freud.* Vol. 14. Vol. 19. Trans. James Strachey. 24 vols. London: Hogarth Press, 1955.

Gilbert, Sandra, and Susan Gubar. *The Madwoman in the Attic: The Woman Writer and the Nineteenth-Century Literary Imagination.* New Haven, CT: Yale University Press, 1979.

Gilligan, Carol. *In a Different Voice: Psychological Theory and Women's Development.* Cambridge, MA: Harvard Press, 1982.

Giroux, Henry R. *Border Crossings: Cultural Workers and the Politics of Education.* New York: Routledge, 1992.

Godwin, Gail. *The Odd Woman.* London: Penguin Books, 1974.

Goldsmith, Olivia. *First Wives Club.* New York: Pocket Books, 1992.

Goldstein, Rebecca. *The Mind-Body Problem: A Novel.* New York: Laurel, 1983.

Heath, Stephen. *The Sexual Fix.* New York: Schocken Books, 1984.

Hirsch, E. D., Joseph F. Kett, James Trefill. *The Dictionary of Cultural Literacy.* Boston: Houghton Mifflin, 1993.

Hirsch, E. D. *Cultural Literacy: What Every American Should Know.* Boston: Houghton, Mifflin, 1987.

hooks, bell. *Talking Back.* Boston: South End Press, 1987.

Kaplan, Louise. *Female Perversions: The Temptations of Emma Bovary.* New York: Doubleday, 1991.

Kofman, Sarah. *The Enigma of Woman: Woman in Freud's Writing.* Trans. Catherine Porter. Ithaca, NY: Cornell University Press, 1985.

Kristeva, Julia. *Desire in Language.* Trans. Thomas Gora, Alice Jardine, and Leon S. Roudiez. New York: Columbia University Press, 1980.

———. *Revolution in Poetic Language.* Trans. Margaret Waller. Ed. Leon S. Roudiez. New York: Columbia University Press, 1984.

Lacan, Jacques. *Écrits.* Paris: Editions du Seuil, 1966.

———. *Écrits.* Trans. Alan Sheridan. New York: Norton, 1977.

———. *Feminine Sexuality.* Trans. J. Mitchell and J. Rose. New York: Pantheon Books, 1982.

———. *The Language of the Self.* Trans. Anthony Wilden. New York: Dell, 1968.

Lane, Roumelia. *Bamboo Wedding.* Toronto: Harlequin Books, 1977.

Laplanche, Jean. *Life and Death in Psychoanalysis.* Trans. Jeffrey Mehlman. Baltimore: The Johns Hopkins University Press, 1976.

Laplanche, Jean, and J.-B. Pontalis. *The Language of Psychoanalysis.* Trans. Donald Nicholson-Smith. New York: W.W. Norton and Company, 1973.

Lefebre, Henri. *Everyday Life in the Modern World* (1950). Trans. Sacha Rabinovitch. New Brunswick, NJ: Transaction Books, 1984.

Lemoine-Luccioni, Eugénie. *Partage des femmes.* Paris: Editions du Seuil, 1976.

Llewelyn, Sue, and Kate Osborne. *Women's Lives.* London: Routledge, 1990.

Lodge, David. *Small World: An Academic Romance.* New York: Warner, 1984.

McMillan, Terry. *Waiting to Exhale.* New York: Pocket Star Books, Simon and Schuster, 1993, 1992.

McNay, Lois. *Foucault and Feminism.* Boston: Northeastern University Press, 1992.

McNeill, Elizabeth. *9 1/2 Weeks.* New York: Berkeley Books, 1978.

Mei, Huang. *Transforming the Cinderella Dream.* New Brunswick, NJ: Rutgers University Press, 1990.

Modleski, Tania. *Loving with a Vengeance: Mass-produced Fantasies for Women.* New York: Methuen, 1982.

———. *The Women Who Knew Too Much: Hitchcock and Feminist Theory.* New York: Methuen, 1988.

Oates, Joyce Carol. *Marya: A Life.* New York: E. P. Dutton, 1986.

Price, Susan. *The Female Ego: The Hidden Power Women Possess But Are Afraid to Use.* New York: Rawson Associates, 1984.

Rabine, Leslie. *Reading the Romantic Heroine.* Ann Arbor, MI: University of Michigan Press, 1985.

Radway, Janice A. *Reading the Romance: Women, Patriarchy, and Popular Literature.* Chapel Hill, NC: University of North Carolina Press, 1984.

Reiss, Timothy. *The Discourse of Modernism.* Ithaca, NY: Cornell University Press, 1985.

Rice, Anne. (Writing as A. N. Roquelaure.) *Beauty's Punishment.* New York: Penguin Books USA Inc., 1984.

———. *Beauty's Release.* New York: Penguin Books USA Inc., 1985.

———. *The Claiming of Sleeping Beauty.* New York: Penguin Books USA Inc., 1983.

———. (Writing as Anne Rampling.) *Exit to Eden.* New York: Dell, 1986.

Robinson, Lillian. *Sex, Class, and Culture.* Bloomington, IN: Indiana University Press, 1978.

Schaeffer, Susan Fromberg. *Falling.* New York: Macmillan, 1973.

Shakespeare, William. *The Taming of the Shrew.* The Folger Library General Reader's Shakespeare. Eds. Louis Wright, Virginia Lamar. New York: Simon and Schuster, 1970.

Shaviro, Steven. *The Cinematic Body.* Minneapolis: University of Minnesota Press, 1993.

Silverman, Debora. *Selling Culture.* New York: Pantheon, 1986.

Sontag, Susan. *Against Interpretation.* New York: Dell, 1961.

Spencer, LaVyrle. *The Hellion.* New York: Jove Books, 1989. Original Harlequin edition, 1984.

Steinem, Gloria. *Revolution from Within: A Book of Self-Esteem.* New York: Little, Brown and Company, 1992.

Thurston, Carol. *The Romance Revolution: Erotic Novels for Women and the Quest for a New Sexual Identity.* Urbana, IL: University of Illinois Press, 1987.

United States Commission on Civil Rights. *Window Dressing on the Set: Women and Minorities in Television.* Washington, DC: The Commission, 1977.

Vreeland, Diana. *Allure.* Garden City, NY: Doubleday and Company, 1980.

———. *D.V.* New York: Vintage Books, 1985.

Wibberly, Mary. *A Dream of Thee.* Toronto: Harlequin Books, 1981.

Willis, Susan. *A Primer for Daily Life.* New York: Routledge, 1991.

Wolf, Naomi. *The Beauty Myth: How Images of Beauty Are Used Against Women.* New York: William Morrow and Company, 1991.

Woodiwiss, Kathleen. *So Worthy My Love.* New York: Avon Books, 1989.

Articles

Agyemang-Badu, Nana Akua. "Graffiti." *Essence* April 1992: 124.

"America's 10 Most Beautiful Women." *Harper's Bazaar* September 1986: 388–419.

"America's 10 Most Beautiful Women Reveal Their Beauty Secrets." *Harper's Bazaar* September 1986: 32.

Andersen, Christopher. "Jane Fonda: I'm stronger than ever." *Ladies Home Journal* October 1989: 112, 114, 115, 117.

Ball, Aimée Lee. "How does Jane do it?" *McCall's* March 1992: 94, 96, 97, 143, 144, 145.

Barnes, Djuna. "Coco Talks." *Self* August 1992: 126, 127, 168.

Bartky, Sandra. "Foucault, Femininity, and the Modernization of Patriarchal Power." *Feminism and Foucault: Reflections on Resistance.* Eds. Irene Diamond and Lee Quinby. Boston: Northeastern University Press, 1988. 61–86.

Bloch, Ruth. "Untangling the Roots of Modern Sex Roles: A Survey of Four Centuries of Change." *Signs* 4:2 (1978): 242–254.

Bordo, Susan. "Anorexia Nervosa and the Crystallization of Culture." *Feminism and Foucault: Reflections on Resistance.* Eds. Irene Diamond and Lee Quinby. Boston: Northeastern University Press, 1988. 87–118.

———. "The Body and the Reproduction of Femininity." *Gender/Body/Knowledge.* Eds. Alison M. Jaggar, Susan R. Bordo. New Brunswick, NJ: Rutgers University Press, 1989. 13–33.

Cahiers du Cinéma. "John Ford's *Young Mr. Lincoln,* A Collective Text." *Movies and Methods.* Ed. Bill Nichols. Berkeley: University of California Press, 1976. 493–528.

Case, Sue-Ellen. "Towards a Butch-Femme Aesthetic." *Discourse* 11.1 (1988–89): 55–73.

Clark, Danae. "Commodity Lesbianism." *Camera Obscura* 25–26 (1991): 182–201.

Collins, Amy Fine. "The Cult of Diana." *Vanity Fair* November 1993. 174–183, 188–190.

"Contributors." *Self* August 1992: 18.

Cowie, Elizabeth. "Fantasia." *The Women in Question.* Ed. Parveen Adams, Elizabeth Cowie. Cambridge, MA: The MIT Press, 1990. 149–196.

Davis, Kathy. "Remaking the She-Devil: A Critical Look at Feminist Approaches to Beauty." *Hypatia* 6.2 (1991): 21–43.

Davis, Lorraine, ed. "The Subject Is You: *Vogue*'s 12th Annual American Woman Symposium." *Vogue* June 1987: 172–179.

Davis, Thulani. "Don't Worry, Be Buppie: Black Novelists Head for the Mainstream." *V.L.S.* May 1990: 26–29.

Deleuze, Gilles. "Coldness and Cruelty." *Masochism.* New York: Zone Books, 1989. 1–142.

Fineman, Joel. "The Turn of the Shrew." *The Subjectivity Effect in Western Literary Tradition.* Cambridge, MA: MIT Press, 1991. 120–143.

Fiske, John. "Cultural Studies and the Culture of Everyday Life." *Cultural Studies.* Eds. Lawrence Grossberg, Cary Nelson, and Paula Treichler. New York: Routledge, 1992. 154–173.

Freedman, Rita. "Looking Good: The Double Standard." *Vogue* April 1987: 357, 359, 396, 397.

Fuss, Diana. "Fashion and the Homospectorial Look." *Critical Inquiry* 18 (1992): 713–737.

Garner, Shirley Nelson. "The Taming of the Shrew: Inside or Outside of the Joke?" *"Bad" Shakespeare: Reevaluations of the Shakespeare Canon.* Ed. E. Maurice Charney. Rutherford, NJ: Fairleigh Dickinson University Press, 1988. 105–118.

Grant, Roberta. "Jane Fonda: Her toughest challenge is slowing down." *Shape* February 1993: 85, 147, 152.

Griggers, Cathy. "A Certain Tendency in the Visual/Cultural Field: Helmut Newton, Deborah Turbeville, and the *Vogue* Fashion Layout." *Differences* 2.2 (1990): 76–104.

Hall, Stuart. "Cultural Studies and the Centre: Some Problematics and Problems." *Culture, Media and Language.* Eds. Stuart Hall, Dorothy Hobson, Andrew Lowe, Paul Willis. London: Hutchinson, 1981. 15–47.

Hansen, Miriam. "Adventures of Goldilocks: Spectatorship, Consumerism, and Public Life." *Camera Obscura* 22 (1990): 51–71.

"Harlequin Romances." *Business Week* 5 December 1983: 157, 169.

Harris, Catherine McEvily. "Fonda at 50." *Shape* November 1987: 66, 68.

Heath, Stephen. "Difference." *Screen* 19:13 (1978): 51–112.

Hirsch, E. D., Joseph F. Kett, and James Trefil. "William Shakespeare." *Dictionary of Cultural Literacy.* Boston: Houghton, Mifflin, 1988. 132.

hooks, bell. "bell hooks." *Angry Women.* Eds. Andrea Juno and V. Vale. San Francisco: Re/Search Publications, 1991. 78–97.

Huyssen, Andreas. "Mass Culture as Modernism's Other." *Studies in Mass Entertainment.* Ed. Tania Modleski. Bloomington, IN: Indiana University Press, 1986. 188–208.

Irving, Jane. "My Thinner Thighs Gave Me a Broader Outlook." *Mademoiselle* June 1994: 164.

"Jane Fonda." *Redbook* February 1988: 76–79.

Jordan, Elaine. "The Dangers of Angela Carter." *New Feminist Discourses*. Ed. Isobel Armstrong. London: Routledge, 1992. 119–131.

Kagan, Elizabeth, and Margaret Morse. "The Body Electronic, Aerobic Exercise on Video: Women's Search for Empowerment and Self-Transformation." *Drama Review* 32:4 (1988): 164–179.

Kaplan, E. Ann. "Madonna Politics: Perversion, Repression, or Subversion? Or Mask and/as Master-y." *The Madonna Connection: Representational Politics, Subcultural Identities, and Cultural Theory*. Ed. Cathy Schwichtenberg. Boulder, CO: Westview Press, 1993. 149–166.

Kaufman, Joanne. "Whose Breasts Are They, Anyway?" *Mademoiselle* August 1987: 70.

Kennedy, Marilyn Moats. "Job Strategies, Discrimination against Fat Women: A Reality in the Workplace." *Glamour* March 1988: 152.

Laplanche, Jean, and J.-B. Pontalis. "Fantasy and the Origins of Sexuality." *The International Journal of Psycho-analysis* 49:1 (1968): 1–18.

Leach, William. "Transformation in a Culture of Consumption: Women and Department Stores, 1890–1925." *Journal of American History* 71.2 (1984): 319–342.

Levine, Lawrence W. "William Shakespeare and the American People: A Study in Cultural Transformation." *Rethinking Popular Culture: Contemporary Perspectives in Cultural Studies*. Eds. Chandra Mukerji and Michael Schudson. Berkeley: University of California Press, 1991. 157–197.

Linden, Dana Wechsler, and Matt Rees. "'I'm Hungry. But Not for Food.'" *Forbes* 6 July 1992: 70–74.

Lyne, Adrian. *9 1/2 Weeks* (1986). With Kim Basinger and Mickey Rourke.

MacCabe, Colin. "On Discourse." *The Talking Cure: Essays in Psychoanalysis and Language*. Ed. Colin MacCabe. New York: St. Martin's Press, 1981. 188–217.

MacCannell, Dean, and Juliet Flower MacCannell. "The Beauty System." *The Ideology of Conduct*. Eds. Nancy Armstrong and Leonard Tennenhouse. New York: Methuen, 1987. 206–238.

Madden, Kathleen. "Femininity: Do You Buy It?" *Vogue* March 1987: 445–446.

———. "*Vogue*'s View: Style, Ideas, Fashion Action: Patsy Tisch, California Classic." *Vogue* December 1986: 232.

Morse, Margaret. "Artemis Aging: Exercise and the Female Body on Video." *Discourse* 10.1 (1987–88): 20–54.

Mouffe, Chantal. "Radical Democracy: Modern or Postmodern." *Universal Abandon? The Politics of Postmodernism.* Ed. Andrew Ross. Minneapolis: University of Minnesota Press, 1988. 31–45.

Mulvey, Laura. "Visual Pleasure and Narrative Cinema" (1975). *Feminism and Film Theory.* Ed. Constance Penley. New York: Routledge, 1992. 57–68.

"A New Image: Amanda Pays—the Many Sides of Modern." *Vogue* April 1987: 354, 355, 356.

"On the Cover." *Harper's Bazaar* September 1986: 10.

Pafford, John. "*Shrew,* Induction, 12. For Boy? Read Bor." *Notes and Queries* 37:235:2 (1990). 172–173.

Penley, Constance. "Feminism, Psychoanalysis, and the Study of Popular Culture." *Cultural Studies.* Eds. Lawrence Grossberg, Cary Nelson, and Paula A. Treichler. New York: Routledge, 1992. 479–500.

Perkins, Tessa. "The Politics of 'Jane Fonda.'" *Stardom: Industry of Desire.* Ed. Christine Gledhill. London: Routledge, 1991. 237–250.

Radner, Hilary. "Pretty Is As Pretty Does: Free Enterprise and the Marriage Plot." *Film Theory Goes to the Movies.* Eds. Collins, Radner, Collins. New York: Routledge, 1993. 56–76.

Radway, Janice. "The Aesthetic in Mass Culture: Reading the 'Popular' Literary Text." *The Structure of the Literary Process: Studies Dedicated to the Memory of Felix Vodicka.* Eds. Peter Steiner, Miroslav Cervenka, Ronald Vroon, F. W. Galan. Amsterdam/Philadelphia: John Benjamin, 1982. 397–429.

———. "Women Read the Romance: The Interactions of Text and Context." *Feminist Studies* 9.1 (1983): 54–77.

Ronell, Avital. "Avital Ronell." *Angry Women.* Eds. Andrea Juno and V. Vale. San Francisco: Re/Search Publications, 1991. 127–153.

Rosenbaum, Max. "Anna O. (Bertha Pappenheim): Her History." *Anna O.: Fourteen Contemporary Reinterpretations.* Eds. Max Rosenbaum and Melvin Muroff. New York: Free Press. London: Collier Macmillan, 1984. 1–25.

Sacher-Masoch, Leopold von. "Venus in Furs." *Masochism.* New York: Zone Books, 1989. 143–293.

Sheerin, Daniel J. "*Sonus* and *Verba:* Varieties of Meaning in the Liturgical Proclamation of the Gospel in the Middle Ages." *Ad litteram: Authoritative Texts and Their Medieval Readers.* Eds. Mark D. Jordan, Kent Emery, Jr. Notre Dame, IN: University of Notre Dame Press, 1992. 29–69.

Shields, Rob. "The Spaces for the Subject of Consumption." *Lifestyle Shopping.* Ed. Rob Shields. London: Routledge, 1992. 1–20.

———. "The Individual, Consumption Cultures and the Fate of Community." *Lifestyle Shopping.* Ed. Rob Shields. London: Routledge, 1992. 99–113.

Silverstein, Michael. "Shifters, Linguistic Categories, and Cultural Description." *Meaning in Anthropology.* Eds. Keith H. Basso, Henry A. Selby. Albuquerque: University of New Mexico Press, 1976. 11–55.

Spivak, Gayatri Chakravorty. "Three Women's Texts and a Critique of Imperialism." *"Race," Writing and Difference.* Ed. Henry Louis Gates Jr. Chicago: The University of Chicago Press, 1986. 262–280.

Studlar, Gaylyn. "Masochism and the Perverse Pleasures of the Cinema" (1985). *Film Theory and Criticism.* Eds. Gerald Mast, Marshall Cohen, Leo Braudy. New York: Oxford University Press, 1992, 4th Edition. 773–790.

———. "Masochistic Performance and Female Subjectivity in *Letter from an Unknown Woman.*" *Cinema Journal* 33:3 (1994): 35–57.

Williams, J. P. "'When You Care Enough to Watch the Very Best': The Mystique of *Moonlighting.*" *Journal of Popular Film and Television* 16:3 (1988): 90–99.

INDEX

AIDS, 118
Abby, 33. *See Knots Landing*
African-American culture, 119–120, 122–125, 144, 179
Allure, xiii
Althusser, Louis, 68
analysis, 12, 16; feminist, 26–27, 31–32. *See* Anna O.
Anna O. *See* Pappenheim, Bertha
anorexia, 165, 166–167. *See* bulimia
"Atomic Shakespeare." *See Moonlighting; Shepherd, Cybill; The Taming of the Shrew*
Atwood, Margaret, 106
autobiographical voice, 35–36, 44
auto-eroticism, 59–60, 63

Balthus. *See* Rola, Balthazar Kossowski de
Bamboo Wedding. See Lane, Roumelia
Banner, Lois, 197n13
Barnes, Djuna, 134–135
Barr, Roseanne, 185n11
Barthes, Roland and inoculation, 17–18, 19, 24, 31–32
Bartky, Sandra, 142, 143–144, 146
Bartos, Rena, 186n29
Baym, Nina, 187n3
beauty, 11–12, and femininity, 63–65; and Fonda, Jane, 171. *See* "beauty fix"; "beauty myth"; "the beauty system";

body; femininity; Lemoine-Luccioni, Eugénie
"beauty fix." *See* Freedman, Rita
"beauty myth." *See* Wolf, Naomi
"the beauty system," xi–xiv
Beauvoir, Simone de, 194n1
Bendel's, 89
Berger, John, 2, 77
Berk, Gerald, 198n1
Bloch, Ruth, 49
bodice ripper, 92–93. *See* category romance
body, xi–xiv, 1–3, 11–12, 141–174; and enunciation, 136; and maternal body, 61–65; and reading, 116; and reinscription, 61, 110; and self-esteem, 64; as site of struggle, 152, 173; and women's magazine, 135–136. *See* Bartky, Sandra; beauty; Bordo, Susan; Doane, Mary Ann; Fonda, Jane; Foucault, Michel; Hepburn, Katharine; language; plastic surgery; Shepherd, Cybill; Vreeland, Diana
Bordo, Susan, 141–142, 143–144, 152, 178, 179
Bourdieu, Pierre, 6, 7
Breuer, Joseph, 133
Brontë, Charlotte, 115; and *Jane Eyre,* 14, 45–49, 184n4
Brookner, Anita, 106, 107

209

Brown, Helen Gurley, xi–xiii; and *Sex and the Office,* xi, xii
bulimia, 164, 167. *See* Fonda, Jane
Burke, Delta, 184n11
Buttiegieg, Joseph, 195n2
Byatt, A.S., 106

Cagney and Lacey, 185n18
Cahiers du Cinéma, 68
Campaign California (Campaign for Economic Democracy). *See* Fonda, Jane
Campaign for Economic Democracy. *See* Fonda, Jane
Camus, Albert, 139
canonicity, 3–7, 10, 5–17, 20, 43, 46; and great works, 6, 15–20, 24; and a technology of reading, 23–24; and inoculation, 31–32
career woman, 40–41, 58, 86–87, 91–92; and romance, 98. *See* Douglas, Susan; "power wife"
Carter, Angela, 191n33
Cartland, Barbara, 14
Case, Sue-Ellen, 187n2
catalogue, 96
category romance, 14, 68, 82, 187n41, 188n8, 188n10, 188n12, 189n14, 189n15, 189n16, 191n34, 192n35, 192n36, 192n45; as "bodice ripper," 92–93; and Nancy Chodorow, 85; and ethnicity, 101–104; as proto-feminism. *See* Cranny-Francis, Anne; Delinsky, Barbara; Deveraux, Jude; formula romance; Harlequin romance; Lane, Roumelia; Radway, Janice; Rabine, Leslie; the romance; the romantic paradigm; Thurston, Carol; Spencer, LaVyrle; sweet contemporary romance; sensuous series romance; Woodiwiss, Kathleen
Chanel, Coco, 134–135
Chodorow, Nancy, 85–86
Cinderella, 13
citizenship, 144, 147, 150, 151, 164, 170. *See* femininity; Fonda, Jane

Clark, Danae, 133, 195n14
class structure, and gender, 12–13
Clinton, Hillary Rodham, 170
Collins, Amy, and "The Cult of Diana," 130
Collins, Jim, 133, 183n8
community, 107; *ad hoc,* 118, 122–124; and femininity, 117; and hero, 117; and popular music, 118; and romance, 118, 122
consumer culture, xi. *See* femininity
consumerism, 53–65, 96, 146; and femininity, 140; and ideal consumer, 131; and masochism, 89, 191n30; and the romance, 78; and style, 133; and women's magazine, 136–137. *See* Doane, Mary Ann; Collins, Jim; product usage; Shields, Rob; women's magazine
contingency. *See* feminist criticism
cosmetic surgery. *See* plastic surgery
Cosmopolitan, xii. *See* Brown, Helen Gurley
covergirl, 53–65; 167. *See* Fonda, Jane; Shepherd, Cybill
Coward, Rosalind, 42–43, 187n5
Cowie, Elizabeth, 188n7
Cranny-Francis, Anne, 67, 68, 70, 104
cultural capital, 6–7; and the body, 171. *See* Bourdieu, Pierre
cultural literacy, 7–11, 13, 24, 45–46, 52; and fashion, 130; and Shakespeare, 15–16, 23–24, 31; and women's magazine, 140. *See* Hirsch, E.D.
cultural reclamation, 123, 124, 179
cultural studies, 108
Cvetkovich, Ann, 41, 42

Davis, Kathy, 172–173
Davis, Thulani, 123, 194n8
Deleuze, Gilles, 82–84, 190n27
democratic tradition, 43. *See* Mouffe, Chantal
Derrida, Jacques, 26–27
desire, 25–26; and ethnicity, 100–104; and ethnocentrism, 103; and language

James, Henry, 33
Jordan, Elaine, 191n33

Kaplan, E. Ann and Madonna, 147
Kaplan, Louise, xiii, 83
Keeling, Kara, 194n4
kiss, and the romance, 75, 76
Knots Landing, 33
Kofman, Sarah, 63

Lacan, Jacques, 184n2, 186n30, 186n31;
 and the ego, 64–65; and language,
 56–57, 76–77; and the Name-of-the
 Father, 22–23
Ladies Home Journal, 162
Lady de Winter, 33
Lane, Roumelia, and *Bamboo Wedding,*
 76–75, 78, 102–103
language, referential function of, 70,
 188n6; play of, 80. *See* femininity
Laplanche, Jean, 21, 30
Laplanche, Jean, and J. B. Pontalis, 188n7
Law and death, 21–22; narrative, 21; and
 the Name-of-the-Father, 22–23. *See*
 Lacan, Jacques
Lee, Spike, 120
Lefebre, Henri and the "Idol," 147
Lemoine-Luccioni, Eugénie, 56–64,
 159, 175, 185n16, 185n26, 185n17,
 186n26
Levine, Lawrence W., 15
liposuction. *See* plastic surgery
literacy, 53. *See* canonicity; cultural liter-
 acy; education
Llewelyn, Sue, and Kate Osborne, and
 Women's Lives, 49–52
Lodge, David and *Small World: An
 Academic Romance,* 111
Lyne, Adrian, and *9 1/2 Weeks,* 99–101,
 191n28, 191n30, 193n47, 193n48

MacCabe, Colin, 76–77, 189n17
McCall's, 169, 171
MacCannell, Dean, and Juliet Flower
 MacCannell, x; and "the beauty sys-
 tem." *See* "the beauty system"

McMillan, Terry and *Waiting to Exhale,*
 115–128, 178–179. *See* African-
 American culture; cultural
 reclamation; shrew
McNay, Lois and Foucault, 142, 146
McNeill, Elizabeth, and *9 1/2 Weeks,*
 84–94, 96–101, 104, 191n28, 191n30,
 192n42, 192n44, 193n46, 193n47,
 193n48
Mademoiselle, 1–2
Madonna, xiii, 147
madwoman, 44–47. *See* Mason, Bertha
magazines. *See* Barnes, Djuna; *Harper's;
 Money; New York Magazine;* women's
 magazines; *Vanity Fair*
Mainbocher, Millicent Rogers, 130
make-up, xi
male feminist, 11
"mammy" figure, in romance, 101–102
marriage, 12, 29, 57, 170; and divorce,
 125–126; and misreading, 103; and
 professionalization, 108; and silence,
 48. *See* heterosexuality, "marriage
 plot," "power wife," romance
"the marriage plot," 13. *See* DuPlessis,
 Rachel Blau
Married with Children, 118
masculine gaze, xiii–xiv, 29, 58, 59–60
masochism, 82–84, 84–107; and fairy
 tale, 92; and language, 97; and
 romance, 87. *See* body; consumerism;
 Deleuze, Gilles; heterosexuality;
 McNeill, Elizabeth; masquerade; plea-
 sure; pornography; Studlar, Gaylyn
Mason, Bertha, 47–48. *See* Brontë,
 Charlotte
masquerade, xi–xiv; and desire, 24–25;
 and language, 33; and masochism, 83;
 and social class, 22, 26; and *The
 Taming of the Shrew,* 21–29. *See*
 Fineman, Joel
maternal, melodrama and romantic par-
 adigm, 85; relationships, 85. *See*
 maternal male, oral mother
maternal male, 68, 69, 82, 85, 88. *See*
 hero; oral mother

"mattering map," 108
Mei, Huang, 183n17
misreading, 70, 72, 81–84, 84–104, 190n27
modernism, 6
Modleski, Tania, 12, 68, 69–70, 77,
 181n3, 183n19, 184n18, 184n19,
 187n3, 187n5, 188n12
Money, 119
Moonlighting, 1–13, 16, 17, 26, 33, 37,
 53–65; and "Atomic Shakespeare,"
 181n5. *See* Shepherd, Cybill; television;
 Shakespeare, William
Morse, Margaret, 153
Mouffe, Chantal, 43–44, 52
Ms., 45, 46
Mulvey, Laura, 5

narcissism, and femininity, xi, 1–5; and
 romance, 87; primary, 76–77. *See* auto-
 eroticism; Freud, Sigmund;
 masochism; product usage
narrative economy, 72
national literacy, 7–9, 13, 15–18, 26
"new woman," 1–3, Chapter 2
New York Magazine, 45
Nietzsche, Fredrich, 112
9 1/2 Weeks. See Lyne, Adrian; and
 McNeill, Elizabeth
novel, middlebrow, 105–115; and
 romance, 114; and repetition, 114; as
 site of struggle, 112, woman's,
 105–128. *See* category romance, disser-
 tation novel, Harlequin romance,
 romance

Oates, Joyce Carol, 106; and *Marya: A
 Life,* 111
occulted discourse, 107, 109, 130
Oedipal narrative, 22–23. *See* Freud,
 Sigmund; Lacan, Jacques; prelinguistic
 state
One Thousand and One Nights, and
 pornography, 90
oral mother, 82–83
"orientalism," and the romance, 102–103
Osbourne, Kate. *See* Llewelyn, Sue

Pafford, John, 184n21
Pamela, 13, 170
Pappenheim, Bertha (Anna O.), 113–114
parody, 5, 12
Pashivily, Helen, 187n3
patriarchy, 3, 20, 29, 41, 49, 57, 68; and
 marriage, 70. *See* marriage
Pays, Amanda, 136–138
Penley, Constance, 70–71, 188n7,
 192n38
Perkins, Tessa, 196n7
Piel, Danis, 195n16
plastic surgery, xii, 4, 172–173; and Jane
 Fonda, 171–173, 176; liposuction, 1.
 See Davis, Kathy
Plato, 112
pleasure, and discipline, 156; and narcis-
 sism, 154; and pain, 165; and reading,
 72; sexual, 24–25, 127; and space of
 fiction, 91; of the text, 24. *See* auto-
 eroticism; heterosexuality; masochism;
 narcissism; Vreeland, Diana
popular culture, 79–80, 112, 118, 120. *See*
 cultural reclamation; high culture;
 modernism; television
pornography, 84–104
postfeminism, 4–5, 64–65. *See* Wolf,
 Naomi
postmodernism, xiv, 2, 32
"power wife," 2, 170. *See* Clinton, Hillary
 Rodham
Pratt, Annis, 20
prelinguistic state, 75–77
Pretty Woman, 13, 198n23
Price, Susan and *The Female Ego,* 33,
 35–44, 184n1, 184n2, 184n3
Prince, 119
Princeton, 120
product usage, 53–65; and enunciation,
 60; and femininity, 139; and narcis-
 sism, 139; and women's magazine,
 138–139. *See* Doane, Mary Ann;
 Shepherd, Cybill
Psyomiades, Kathy Alexis, 195n10
pursuit of happiness, 171
Pyne, Kathleen, 195n2